MOUNTAIN BIKING
THE MANUAL

A WAVEFINDER Publication

Steve Peat

World Champion 2009

I rode my first bike when I was around three years old and I was very soon chasing my older brothers through our local park. It was always good to ride with them and when I was still really young they would teach me new things - how to do a jump or ride down a hill and most importantly, pull wheelies and skids!

I think it was this early healthy competition that set me up for the rest of my racing career. I have always wanted to beat people and to this day I still love to race. I like everything about racing, figuring the different tracks out during practice, getting my bikes dialled in to suit all kinds of terrain, feeling the pressure in the start hut, hearing the start beeps and the noise from the crowds as I try to get to the bottom of the hill quickly.

I have raced many times over nearly two decades and am proud to say I managed to win the World Championships in 2009. It feels good to be finally wearing the stripy jersey and it also means a lot to me to be able to write this Foreword, as I still love to just get out and ride my bike. I might be gooning around with friends, ripping up a downhill track, going for an XC spin or playing on some jumps. Whatever style it is, I still just enjoy time on the bike. Hopefully people realise this from the way that I race and ride. I love riding.

I have had much help over the years from many great riders and now all of you guys can have the same kind of help from this book.

The Manual has a lot of awesome tips, insights and secrets from some of the greatest racing talent on the planet. How and where these pros ride is constantly pushing the boundaries of just what is possible on a bike. They have travelled the world, competing at the highest level

> **In The Manual, the pros tell you what they learnt along the way.**

and freeriding the most technical terrain. Even so, they still spend a great amount of time studying their own style and working at different aspects of their riding in order to gain the valuable 1000ths of a second that some races can be won or lost by.

The instructions in this book have something for everyone and the explanations make it simple to understand. From the first timer on a mountain bike to a fully-fledged racing snake, there is knowledge here for all. The Manual will show you the fundamentals, the in-between bits and the moves to make your family proud of you. You will all be better riders for it.

There are technique pages on core skills like getting a balanced body position, pulling the perfect wheelie or bunny-hopping clean and high. There are trail tips for hitting off-camber corners flat out and fluid, sticking the right line through switchbacks, coping with gnarly root sections or daring deep drop-offs. Then there is the more adventurous stuff: clearing big gaps and hitting hip jumps.

There are also chapters telling you how to set up your bike for your type of riding, how to get the best out of your body as well as your bike and how to kick into a racing career. All of it with insights from those who do it best.

There are lots of books out there that will tell you how to ride a bike but there are few that have advice from the riders who are at the top of the game. Read on and mountain biking's elite will help you along the way.

So read, learn and hopefully go as fast as us pros!

Cheers.

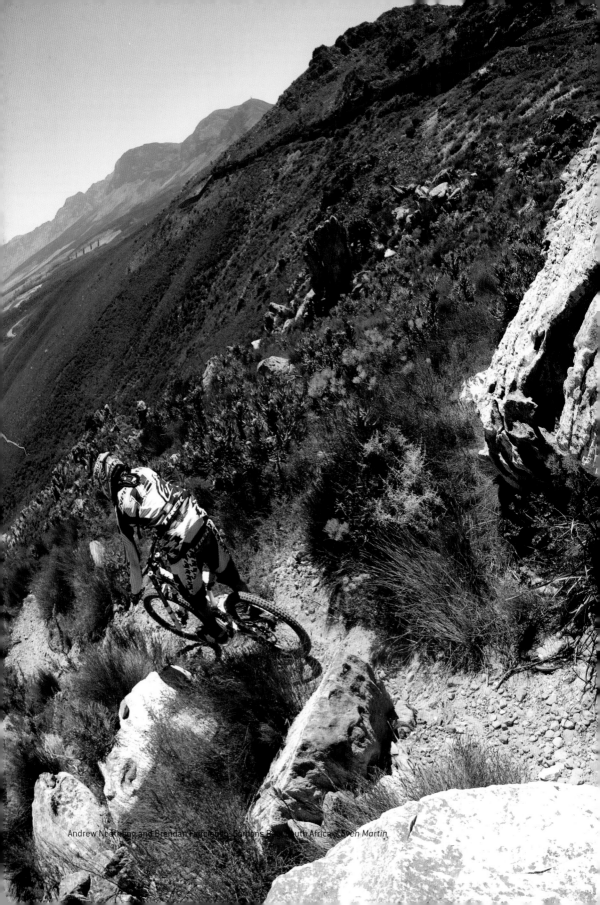

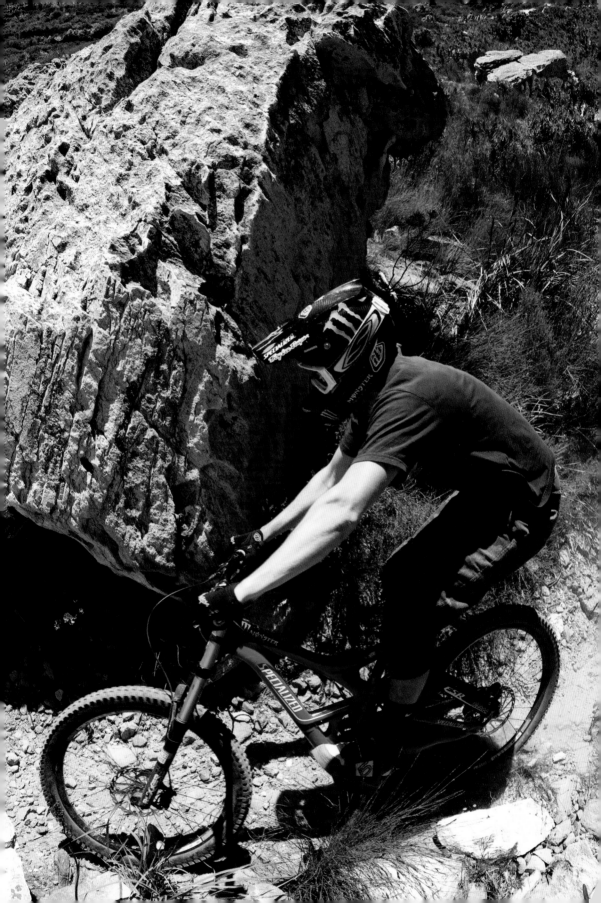

Chris competed in over 30 World Cup events and is now the UCI Technical Delegate for the DH & XC races, along with owning an MTB skills school in Scotland..

It's been a long road. It's been an interesting road and a road that is still throwing up surprises. On graduation day, I had thought that the days of being buried under books were behind me. Back then, all I knew was that I was going to go and ride my bike. It was June 2006 and the sun was shining. Fourteen months later I was at the start line of the Ft William World Championships wearing a Great Britain windbreaker and telling Ruaridh Cunningham he was going to win. After a filming trip with Alex Rankin for Earthed 4 had ended in a knee injury I started coaching from crutches. Working with others took me in a direction I hadn't expected and developing the sport from the other side of the race tape became an interesting and inspiring avenue to follow.

Fast forward to 2008 and I was working with the UCI, Scottish Cycling and Dirt School. I was helping shape the sport in any little way I could. That October, whilst standing under a tree, in the rain and beside a dirt jump, the phone rang. Sometimes it is good to be contactable 100% of the time. Wavefinder Limited wanted to produce Mountain Biking The Manual. It sounded great and work began that winter.

Having put all I have learnt to date into the following pages I hope you find something in here that answers one of your questions, gives clarity to a situation or helps you out in some way, big or small. What I hope even more is that you are inspired. Inspired to ride and inspired to try something new - either by the incredible photographs or the tips from the pros themselves.

I must thank all the contributors who have taken time to add untold value to my words. The mountain bike community is a small, close-knit bunch whose approachability and down to earth nature never fails to amaze me. The sport is constantly growing as more and more people discover the wide-ranging benefits of being a mountain biker. People say hello on the trail, weather no longer seems like such an issue and accessto the most remote of spots suddenly becomes feasible.

Stick this book in the glove box of your van, on the bedside table or next to the kettle. Dip into it as often as you can and see if together we can make you get the most from your time on the bike. Read, ride, repeat.

Chris Ball

Author

You can always be better at something. I know, because despite the fact that I have been riding mountain bikes since the early '90s, I am still very average in the saddle. So, this book is for anyone who, like me, wants to be better on a bike: for old dogs who are determined to learn a new trick or two, for someone who's never been off-road in their lives or even the lord of the local terrain park who want to break into the pro circuit.

Yes, there are other "how to" books on the shelves, but this one has something different. These lessons come from the mouths of the elite. Here, the best in the sport tell you the techniques that have taken them to the top. It is their insight that makes this book better than all the rest, their enthusiasm to teach and their generosity to share their hard-earned knowledge. They give this book a credibility and value that would be impossible to achieve without them.

But this is not simply a collection of quotes hung together with pretty pictures. Like all the Wavefinder titles, it is a good, strong read in its own right. The lessons here are delivered through the clear, intelligent voice of one of the best coaches in the business. I asked Chris to write this book because he is an excellent teacher, a talented rider and as if that wasn't enough, he's a damn good writer too. Working with him has been a pleasure.

I have learnt so much. Even this old dog now has a new trick or two to perform. See you on the trail.

Huw J. Williams

Editor

Garret Buehler sliding around in Utah / *Sven Martin*

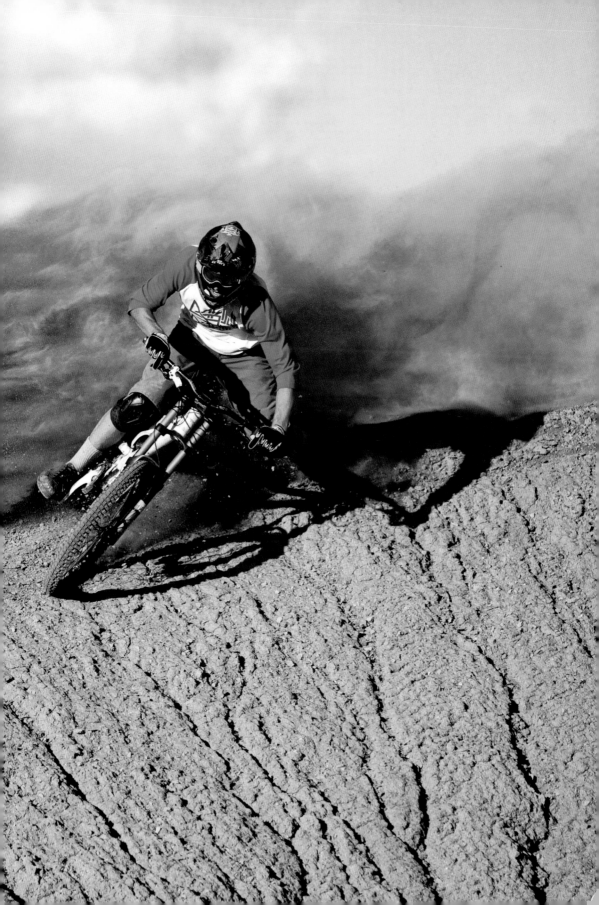

Steve Peat

Little can be written about Steve that hasn't been said already. As the 2009 UCI Downhill World Champion, Peaty took the 2009 season by storm, also taking the title for the most World Cup wins - at a total of 17 no less. From his humble beginnings in Sheffield, UK, Steve has become one of the most inspirational mountain bikers of all time. Adding three World Cup series wins, two European championship golds, eight Lisbon downtown wins and 50 World Cup podiums to his X Games gold medal and eight British National titles he is probably the most celebrated downhiller of all time. Married with two sons, Steve is now Dr Peat after receiving an honorary doctorate in 2009 from Sheffield Hallam University. A living legend.

Joe Breeze

Joe Breeze, 57, is one of the founding fathers of mountain biking. Along with Gary Fisher, Tom Ritchey and Charlie Kelly, Joe is widely considered to be one of the inventors of the mountain bike and is credited with having built the first mountain bike frames. He kick-started his own company, Breezer Bikes, and continues to promote the huge benefits of the bicycle. He was inducted into the Mountain Bike Hall of Fame in 1988.

Gee Atherton

As the middle of the three famous Atherton siblings, Gee burst onto the world stage as a rapid junior. Seldom seen without his brother Dan and sister Rachel by his side, Gee set a new precedent by winning the 2008 Andorran Downhill World Cup on the same weekend Rachel won the women's race and older brother Dan took the gold in the men's 4X. That year Gee also took the rainbow stripes in Italy to add a World Championship gold to his European and UK National titles and two World Cup downhill wins. As the member of an elite few, Gee is also seen lighting up freeride comps including the Red Bull Rampage and World Cup 4X events, where he has also won gold.

Sam Hill

Famous for his distinctive style and massive winning margins, Sam started young with wins at the 2003 Australian National Championships, the US Open and the Junior World Championships. A man of few words, Hill speaks through his riding and has the ability to take seconds out of other top competitors. An icon for a new generation of young riders, Sam is famous for his lack of body armour, flat pedals, charging style and corner speed like no other rider on the planet. The recipient of the Australian Cyclist of the Year Award every year from 2004 to 2007, Hill is no stranger to titles. In 2007, he stood on the podium at every World Cup including three wins and took his second senior World Championship gold. Never one to rule out, Sam Hill is one of the most focused, dedicated and skillful riders the world has ever seen.

Greg Minnaar

The 28 year old South African rider needs little introduction. With a family bike shop in Pietermaritzburg, South Africa, Greg has stayed true to his family's cycling heritage, winning the South African National Championships in 1998. Moving to UK shores, Minnaar spent his formative years at Animal Orange, regularly riding with other UK World Cup riders including Steve Peat and Rob Warner. Staying with Orange bikes, Greg moved to the legendary Global Racing team to ride alongside household names including Mick Hannah and Missy Giove. Moving to another legendary team, Greg rode the cutting edge Honda RN01 before moving to

Santa Cruz Syndicate in 2006, creating a powerhouse team that still includes Peaty and Bryceland. World Champion in 2003, multiple World Cup winner and twice winner of the World Cup series, Greg is one of the most consistent, stylish and inspirational riders on the World Cup circuit.

Christoph Sauser

Hailing from Switzerland, Christoph competes at both World Cup cross country and marathon events and has been equally successful in both. Taking the gold in the marathon World Championships in 2007, 2008 and 2009, Sauser has clearly got the endurance credentials to match his cross country World Championship win, taken under the blistering heat of the Italian sun in 2008. An Olympic medalist, Sauser took bronze in Sydney 2000 and has won fourteen World Cup titles. It's fair to say that this man is one of the dominant figures in the cross country world.

Josh Bryceland

The fresh-faced, energy-filled Bryceland is one of the super-fast youngsters making it on the world scene. A new kid on the block, Josh's often BMX inspired style is impossible to miss and his bike handling and flair know no bounds. One of the most recently matured of Peaty's protégés, Josh has grown up in a culture of speed and professionalism and fills the young apprentice's role on the Santa Cruz Syndicate. With team-mates like Greg Minnaar and Steve Peat, Josh's youthful exuberance is matched with a mature approach to his sport. 2008 Junior World Champion, Bryceland has had a taste of the podium and will almost certainly be seen on the big step soon.

Danny MacAskill

'You Tube legend' Danny MacAskill, is a Scottish rider who showcased his personal take on 26" wheel trials in a film that became an internet phenomenon. From the second his short video hit the Internet, Danny's stylish mix of BMX and mountain bike inspired trials made major headlines everywhere. From Lance Armstrong's Twitter feed to the National News Headlines, Danny's skill, devotion and nerve have left thousands speechless. A nominee for the prestigious 2009 Laureus Action Sport Star Award, Danny MacAskill has plans to work with his sponsor Red Bull on a number of projects that will further fuse mountain biking with trials.

Tracy Moseley

An Ambassador of women's mountain biking, Tracy Moseley has been at the top of her game since she started racing in 1994. The first British female to win a Downhill World Cup, Tracy has gone on to win twelve rounds of the World Cup series and took the overall World Cup series win in 2006. Twice the silver medalist at the World Championships, Tracy has yet to win her rainbow stripes but her smooth style and consistent performances continue to dominate the women's field. Tracy will always be promoting the sport and pushing boundaries.

Rene Wildhaber

Swiss born marathon racer Wildhaber is known globally for his strong performance in endurance events. The master of the infamous Mega Avalanche in Alpe d'Huez, France, Rene has taken the win there six times. His power and competitive edge are as distinctive as his sportsmanship and experience in the sport, leading to domination across the French organised Avalanche series. Wins in the Urge Kenya race and the Renunion Island Avalanche Cup in 2009 showed that Rene still has what it takes after more than a decade of competition. Joining

Trek bicycles for his second year, Rene Wildhaber's future involves bike development, remote expeditions and more races planned.

Chris Kovarik

Australian rider Chris Kovarik's aggressive, charging style is unmistakable. Holder of one of the biggest winning margins ever seen in downhill mountain biking, Chris Kovarik, 31, became a legend at the 2002 Fort William World Cup, where on a brutal, wet and gruelling Scottish hillside, he decimated the field to win by 14 seconds. Multiple Australian National Champion, Kovarik had a near miss when a motocross smash almost ended his career in 2004. After months of rehabilitation and a long time off the bike, Chris came back to take fifth at the World Championships in 2005 and has returned to become a solid World Cup challenger.

Cam McCaul

A freeride prodigy, Cameron McCaul has brought his own style to the mountain bike dirt jump, freeride and slopestyle world. Not a man to be held back, Cam has an energy that often projects to those around him and is evident in his creative and progressive riding. As winner of comps ranging from 26trix, the Bearclaw Invitational, Red Bull District Ride and podium spots at Crankworx Slopestyle and Monster Park, McCaul has shown his ability to throw down tricks when it counts. Cam's film segments in Roam, Seasons and the New World Disorder Series continue to inspire riders worldwide.

Ruaridh Cunningham

The 21 year old Scottish born rider has had a short but packed career to date. After winning the Junior World Championships on home soil in 2007, Ruaridh became the first British male to win a downhill World Championship title. Post-season training later that year resulted in a knee injury which kept the young Cunningham out of the running in 2008 and after an ACL operation, Ruaridh is set to show his Irish based Chain Reaction Cycles team what he's got in the year to come. With the Scottish Borders as his base, Ruaridh is one of the young Brit pack with his eye on World Cup success.

Sven Martin

Seldom do you meet a man with the enthusiasm, drive and energy that Sven Martin displays in his day-to-day life. The South African ex-pro skateboarder, turned World Cup mountain biker turned professional photographer isn't someone that does something by halves. His images have graced the covers of iconic magazines, from Dirt to Decline, and are seen in adverts across the globe. As a rider himself, Sven's ability to capture the emotion of the moment is second to none. Often found lying in the dust, mud or bushes, mountain bike imagery wouldn't be the same without this man. *www.svenmartinphotography.com*

Victor Lucas

A quiet, unassuming and talented Irishman, Victor Lucas has the ability to capture a scene and create incredible pictures from within it. The stress of the moment doesn't seem to affect his work as Victor has shot cover images from World Championship finals to backcountry, big mountain environments. The consummate professional, Victor doesn't even like taking the chairlift,

instead relying on his own steam and leg power to get him into his chosen spot before any rider has even set their tyres on the track. I've been lucky to work with Victor in years past and even luckier to have his iconic images in the pages of this book.

www.victorlucas.com

Gary Perkin

Gary Perkin's pictures have inspired thousands around the world. A man capable of bringing art to our sport, Gary has shot some incredible images over the years. Raising his young family in Cape Town, South Africa, Gary has worked with almost every professional rider there is, covered almost every UCI mountain bike event and captured jaw dropping images week after week. Gary Perkin, or Flipper as he's better known, has used his huge experience in photojournalism to great effect and is an asset to the sport.

www.flipper.co.za

Huw J. Williams - Title Editor

Huw J. Williams is a journalist, a writer and a photographer. He has covered what the media unimaginatively call "extreme" sports since the mid 90s. In that time he has written articles, produced radio programmes and made films on mountain biking, snowboarding, BMX, skateboarding, skiing, surf-

ing and windsurfing. He is a better observer than participant, though at one time or other he has tried all of the above, with varying success and significant bodily injury. He has been a near religious rider since his father removed the stabilizers from his first bike back in early 70s. He started mountain biking in the days when bar-ends were radically new technology and wearing day-glo lycra was acceptable in public, although he swears he never succumbed to either. He owns three mountain bikes, and his pride and joy is a black, hand-built original Keith Bontrager Race - pre Trek and allegedly made by the man himself.

The Wavefinder Team:

Nicholas Rink: *Managing Director*
Huw J. Williams: *Editor*
Stéphane Rouget: *Art Director*

Wavefinder would like to thank everyone who has put so much of their time, effort and passion into this book. Chris and all the contributors for their words and remarkable insight. Sven, Victor and Gary for their truly amazing images. Huw for having the idea in the first place, Rose for making the final checks and to Steffo for bringing it all so perfectly together. Thanks to all.

Author's Acknowledgements

There is simply not enough space in this book to thank Kate for her ongoing support, encouragement and inspiration. It's fair to say that without her I simply wouldn't have done what I have done to date. For everything, thank you Kate.

The constant inspiration I draw from Dr Geraint Florida James, his knowledge of all things sport, his sheer toughness and his dedication are also things i have to thank. Over the years of lecturing, coaching and mentoring me, Geraint has become a great friend. Thank you Dr G.

I must also thank Seb Ramsey. Without his support, hours of reading, direction and the odd joke this whole project would've been far harder. Whether on a bike, skis, snowboards or just his feet, Seb knows how to do it and do it well. Seb, thank you.

Finally, thanks to all of my family, friends, Huw the editor, Nick at Wavefinder and of course the contributors. Whether or not you know it, your support has been immeasurable. Thank you.

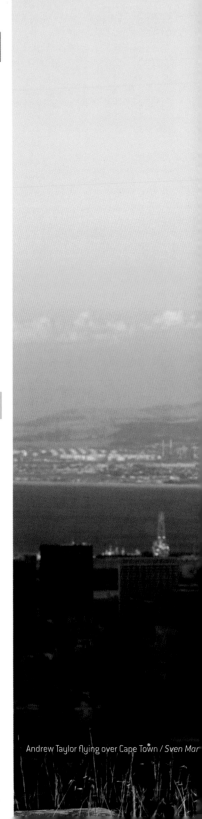

014 CONTENTS

Andrew Taylor flying over Cape Town / *Sven Mar*

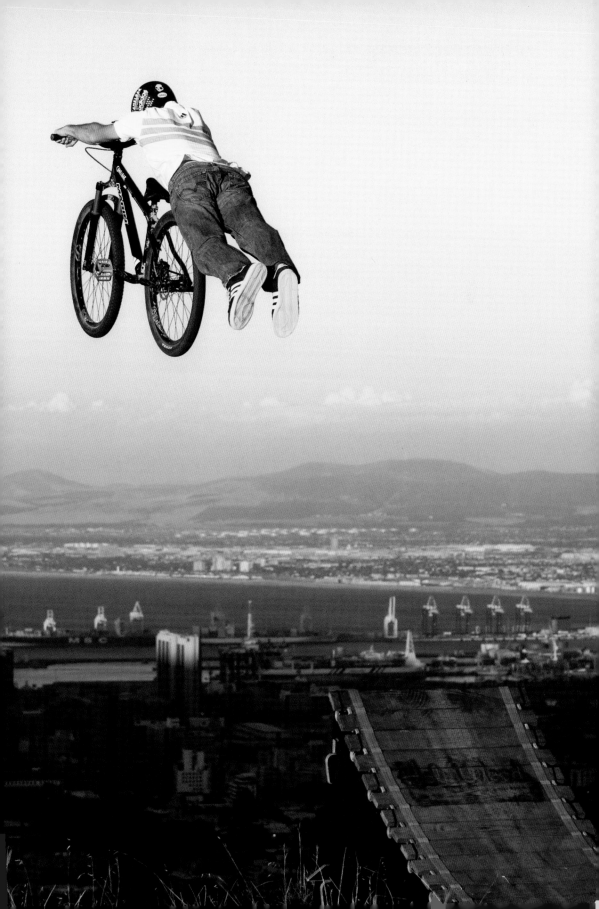

CONTENTS

Seb Ramsey in the air at Ft Bill / *Chris Ball*

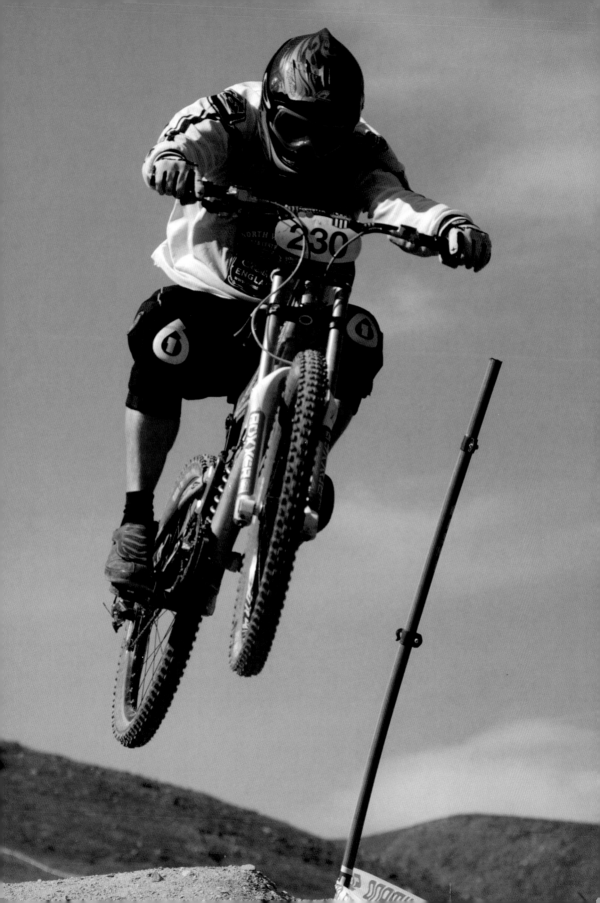

CONTENTS

168 PART FOUR. **ADVANCED**

210 PART FIVE. **BIG MOUNTAIN**

226 PART SIX. **SURVIVAL**

236 PART SEVEN. **COMPETITION**

Rowan Sorrell on the trail in Slovenia / *Victor Lucas*

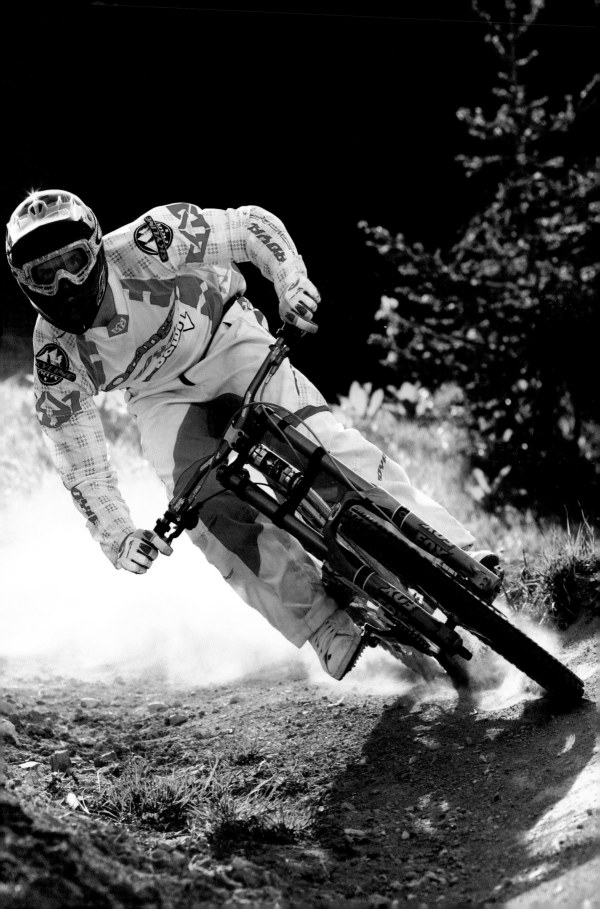

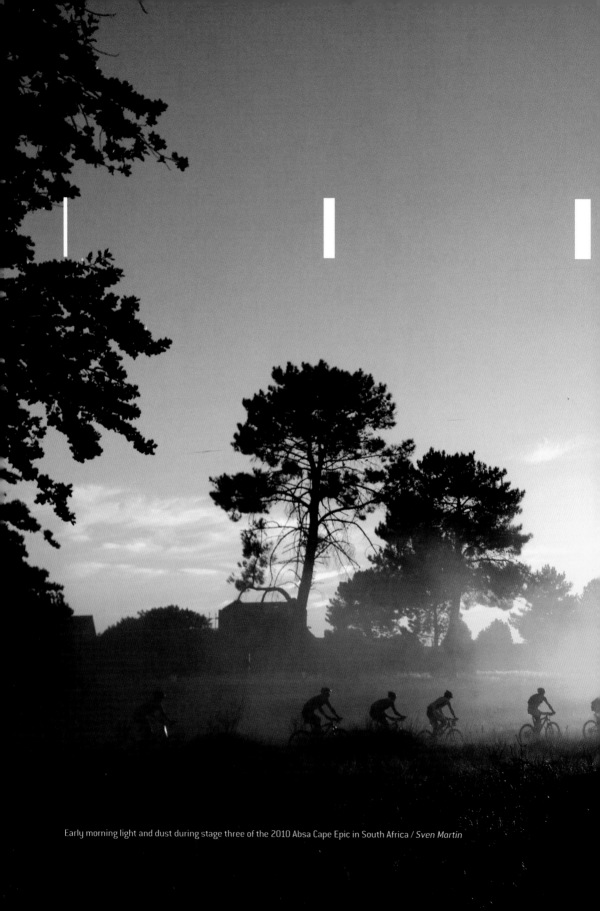

Early morning light and dust during stage three of the 2010 Absa Cape Epic in South Africa / *Sven Martin*

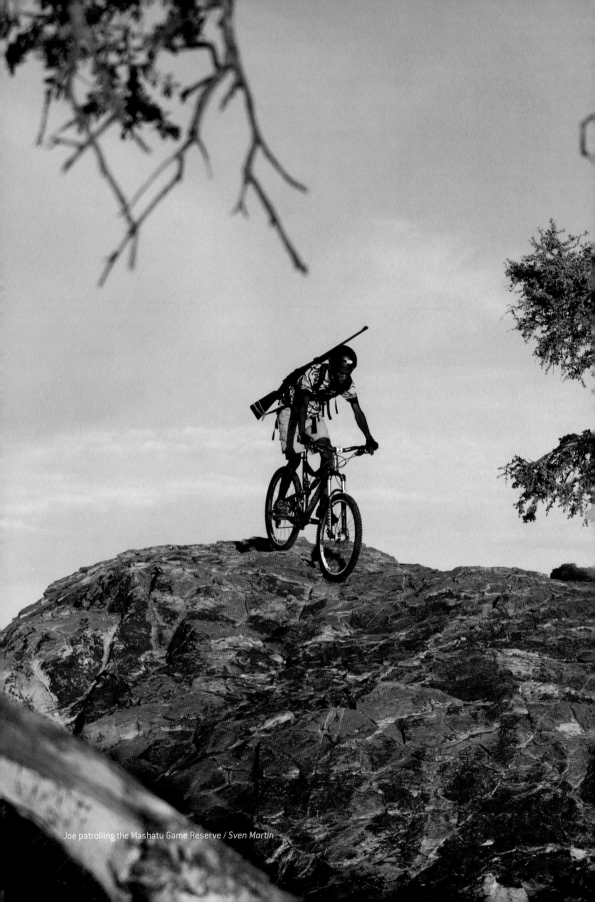

Joe patrolling the Mashatu Game Reserve / *Sven Martin*

A BRIEF HISTORY
Mountain biking hasn't been around long, but it's grown up fast.

Mountain biking, as we know it, is a child of the 70s. It was born in California, USA when Joe Breeze, Gary Fisher and Charlie Kelly raced down the Repack dirt tracks of Marin County. The bikes were primitive by today's standards and safety gear was a pair of extra wide denim flares.

The sport has changed a lot since those long haired 70s daredevils threw themselves down hills on their fat tyred steeds. The bikes have developed into engineering masterpieces, riders have become professional athletes and the sport itself has split into the individual disciplines we have today.

All this has come as a surprise to **Joe Breeze**, the founder of Breezer Bikes and original Repack racer. *"It was apparent early on that our fat tire bikes found a sweet spot. Friends - including non-cycling friends - would take them for a quick spin and always return incredulous, wondering, exclaiming, "Where has this bike been?"*

"That the bike would spill beyond the bounds of the USA and find similar reception in more bike-savvy lands was a surprise. Obviously mountain biking means a lot to me as a sport - the outdoors adventure with its discoveries, a little dancing on the edge. Most satisfying to me is the fact that mountain bikes have introduced so many people to cycling, which is a joy whether out in the woods or back in town."

Riders are grouping under various banners. From the lean, endurance based cross-country types to the big mountain riders and dirt jumpers, influences are being pulled from BMX, motocross and snowboarding. While the huge expansion in endurance events is attracting more and more hill runners, triathletes and adventure racers, mountain biking is now one of the most accommodating and far-reaching sports in the world.

One man who has seen the sport flourish is **Mike Rose**. As editor of the iconic Dirt Magazine, he's featured and followed the cutting edge of the sport for years. Mike explains: *"For me the great thing about the sport is that for the whole of its life it has been evolving and growing, both technically and riding wise. The roots of it all are still the same, just having fun blasting around on your bike in the dirt, but the sport has developed beyond what most people would ever have imagined."*

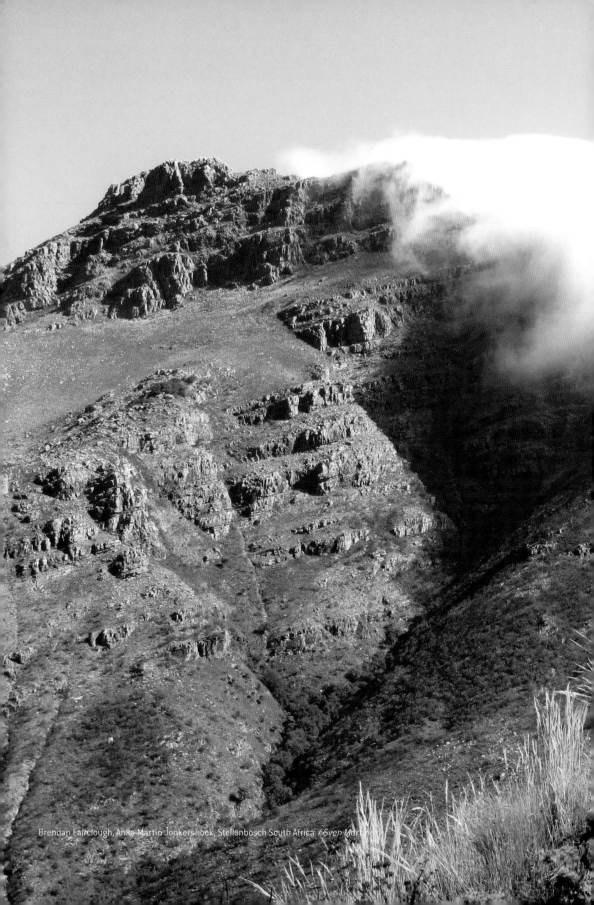

Brendan Fairclough, Anka Martin Jonkershoek, Stellenbosch South Africa / Sven Martin

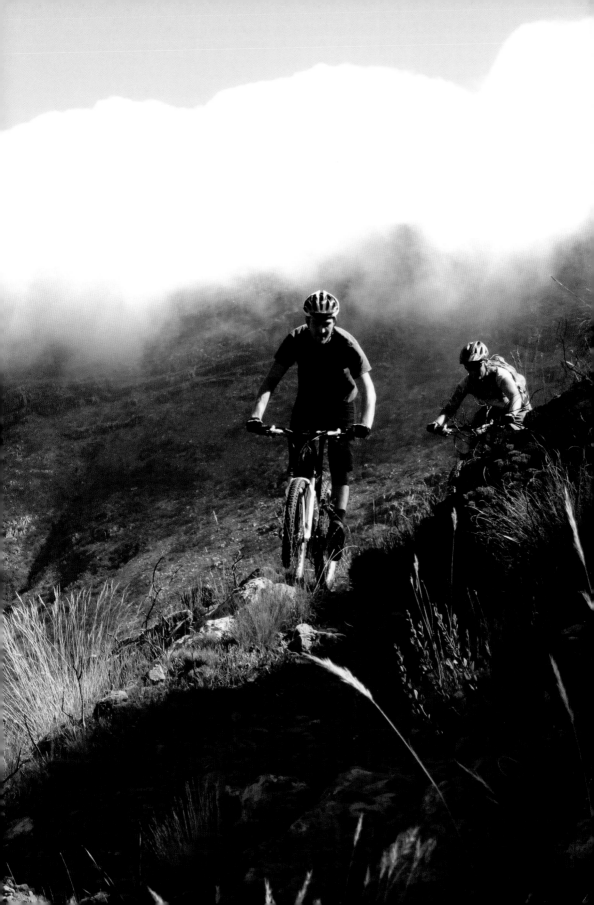

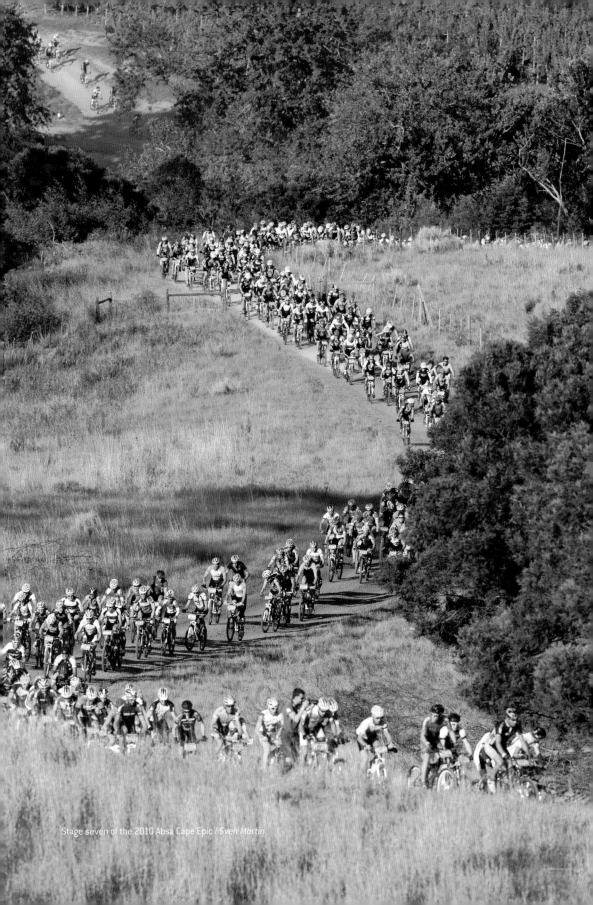

Stage seven of the 2010 Absa Cape Epic / *Sven Martin*

THE CROSS-COUNTRY RACER
This is pretty much where it all began.

Cross-country was once simply known as 'mountain biking'. It's the only Olympic discipline in the sport, having been incepted into the Olympics in Atlanta 1994. Cross-country riders are now considered hardcore fitness fanatics as competition demands incredibly high aerobic endurance. Cross-country also has the closest cultural ties with road racing. A modern cross-country racer shares a very similar build to a road rider, with a strong emphasis on cardiovascular fitness. In fact, the demands placed on the riders at international level have shown that a World Cup cross-country racer can now cut it in the Road Pro Tour. Cadel Evans is one such rider. Having spent years racing cross-country, Evans has proven his worth in the Tour de France, placing second in the 2007 and 2008 events.

It was once the case that a rider would race cross-country on a Saturday and then downhill the following day. However, the dedication now needed for both disciplines means the days when legendary riders such as John Tomac or Greg Herbold could power their way to the top of both the cross-country and downhill podiums are long gone.

TALENT

Julien Absalon has become the dominant force in cross-country, taking two Olympic golds and four UCI World Championship titles. Swiss rider Christoph Sauser provided much of the competition for Absalon over the past decade and younger riders such as Burry Stander are now close on his heels.

KIT

Over long distances, every gram counts so riders opt for lycra clothing and ultra light equipment. Carbon and titanium are the materials of choice for everything from handlebars and fork crowns to cranks and seatposts.

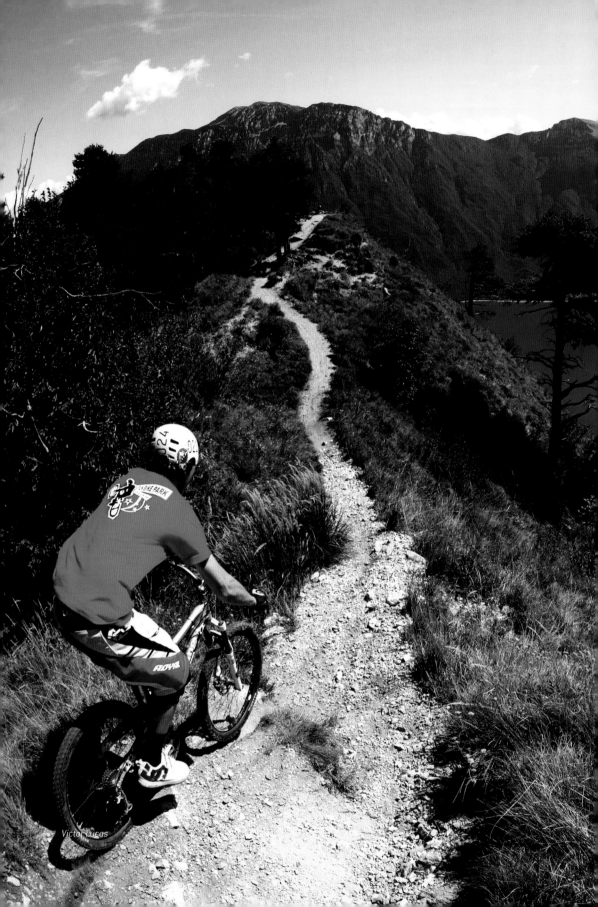

Victor Lucas

THE TRAIL RIDER

Trail riding is what it says it is: it's people riding trails for enjoyment with minimal fuss.

Essentially, trail riding is a toned down combination of every other discipline. The UK has led the way in terms of development of facilities with purpose built trail centres across the country. These purpose built trails use a combination of technical descents, switchback climbs, berms and small jumps.

TALENT

The vast majority of riders would probably define themselves as trail riders. They usually have no thirst for formal competition but a keen hunger for good fun. If they do compete it will be at informal events that focus more on the riding than the winning.

KIT

Despite their non-competitive tendencies, trail riders still demand quality equipment that works well. They are generalists and don't require anything too spe-

cific, but they do want performance and comfort from their equipment. Clothing is technical but loose fitting, designed to keep the wearer warm, dry and comfortable after several hours in the saddle. In terms of the look, there's often an emphasis on blending into the pub crowd straight from a ride in the hills.

Bikes range from the fully rigid to those with 5" or more of travel. Their desire is generally for something to handle most situations, efficient on the climbs and light yet stable on the descents. Trail bikes are often a compromise between the light and fast technology used in cross-country coupled with the strength, suspension range and braking capability of downhill bikes.

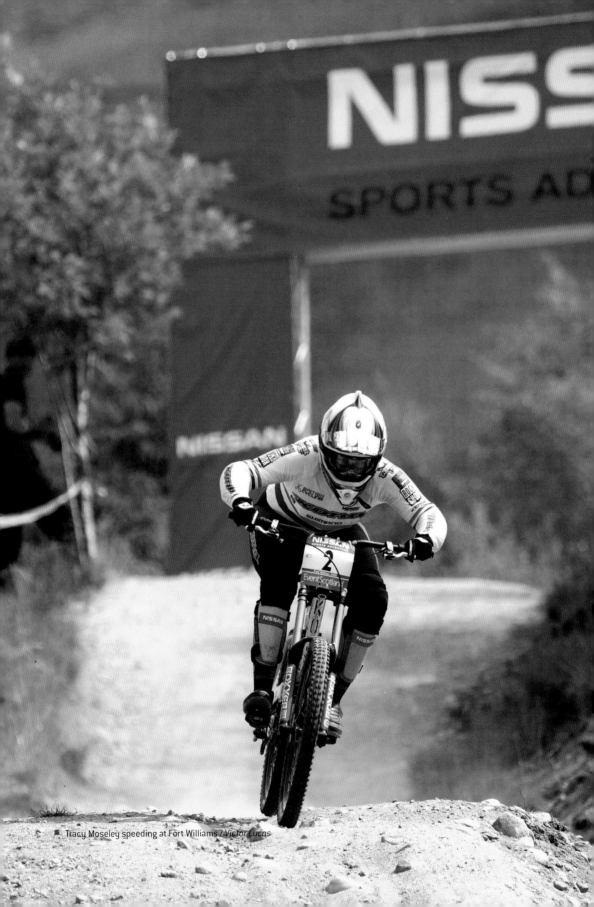

Tracy Moseley speeding at Fort Williams / Victor Lucas

THE DOWNHILLER

Downhill emerged as an official discipline at the 1990 Mountain Bike World Championships in Durango, Colorado.

It is a time trial sprint on a highly technical course with downhill gradient. Riders are often ferried to the summit by chairlifts or trucks. Bike handling skills, sprint fitness and bravery are tested to the highest level and fast jumps, drops and technical sections are the name of the game. Since its inception, downhill tracks have reduced in length and finishing times for elite riders keep getting closer and closer. In fact, as they continue to push themselves, margins of as little as 1/100th of a second can separate riders.

TALENT

The world-class downhill rider is now a honed athlete, requiring not only incredible technical ability but also a good endurance base, a powerful sprint and a strong upper body. In a similar fashion to moto-cross, a downhiller needs to develop their upper body far more than that of any other cycling discipline. Core stability and muscular endurance are the keys to success here.

One rider that's been in it from the start is Steve Peat. Right from the early downhill days when hardtail bikes could cut it, to the era of specialist high tech full suspension bikes, Steve has seen it all and dominated throughout.

KIT

Downhill is often regarded as the Formula One of cycle sport. The equipment is specialist and developed. Weight and strength are paramount in a sport that now works to the tightest tolerances and demands the most from every part of the bike. Modern bikes have come a long way from the early days of downhill when rim brakes and 80mm travel forks could race in the World Cup.

The modern day downhill bike utilses cutting edge technologies in carbon and aluminium to combine precise handling with anything from 7" upwards of bump absorbing suspension travel. Forks mimic those on a motocross bike by clamping both above and below the steerer tube for strength and control, whilst new rubber compounds and tread patterns push the boundaries of tyre performance.

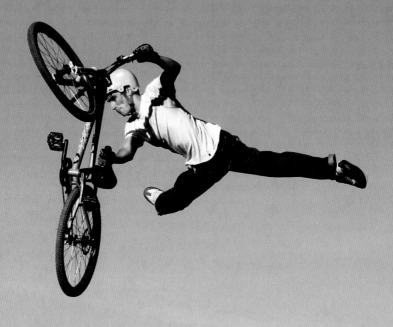

Grant Fielder at the 26trix Dirt Comp in Leogang, Austria / *Victor Lucas*

THE FREERIDER
Freeriding is the hybrid of high mountain sports.

Born out of a cross between the go-anywhere spirit of backcountry snowboarding, the development of lift access bike parks in ski resorts and one off pro-spectacular events like the Red Bull Rampage, Freeride grew out of a need to break free, from competition rules and course boundaries.

Freeriding was created by riders who desired to ride whatever lines their imagination could conjure. Riders who wanted to conquer the mountain and not the clock. Many of these pioneers lived amongst the immense mountains of British Columbia in western Canada and the sport has grown from a few guys playing in the wilderness to competitions watched by thousands. Freeride competitions are usually judged by a panel that gives points for style, amplitude and tech-nicality. The standard of riding is awe inspiring with tricks and jumps not far from those of freestyle moto-cross. Whistler's famous Crankworx festival and Red Bull's Rampage are the pinnacle events.

TALENT

Andrew Shandro and Wade Simmons are some of the pioneers of the sport whilst talent like Cam McCaul and Darren Berrecloth continue to push the boundaries of what's possible. There are some riders who use their abilities to cross over from other disciplines. Gee Atherton and Cedric Gracia are two of the best, racing downhill one weekend and competing in a big air comp the next.

KIT

Equipment choice is dictated by trend as much as technology. Riders wear loose fitting kit with strong ties to the skate and BMX culture. Bikes range from hardtails to mid-travel machines that can take a beating. Strength is crucial, as heavy landings from large jumps or drops are pretty common - you really wouldn't want your headtube popping off when landing a 60ft gap jump. Speeds tend to be relatively low, so the head angles are often a little steeper than downhill bikes and the bottom brackets a bit higher. It's not uncommon for bikes to run two chain rings and a bash guard, as freeride is the discipline where the climb is slow and the descent stylish.

Victor Lucas

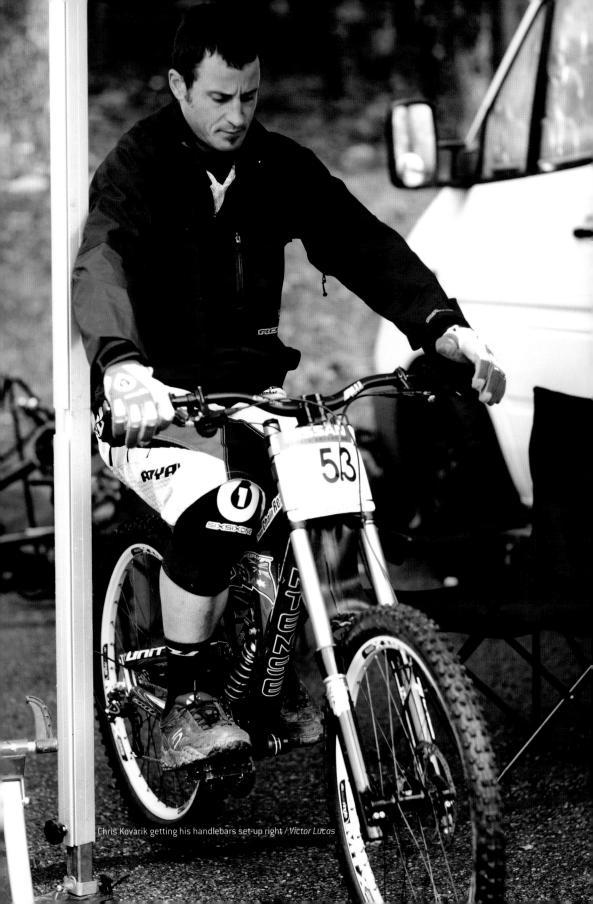

Chris Kovarik getting his handlebars set-up right / *Victor Lucas*

BIKE SET UP

HANDLEBARS / STEM

The elemental point of contact between you and the bike, handlebars come in various widths, rises and sweeps and can all dictate the handling, balance and comfort of your ride. It's crucial that you get a bar that fits you and puts you in the correct riding position. A bar raked far forward can put too much of your weight over the front, a narrow bar will give twitchy handling that's hard to control at speed. However, the correct set-up is ultimately subjective. Bar dimensions and angles can vary greatly, yet still be suitable for different riders. Use these pointers as a guide, but be led by what feels right when setting up your own bike.

the rider to use more of their upper body - shoulders and arms - to drive the bike forward when pedalling out of the saddle. A flat bar also places the rider in a more aerodynamic position and puts weight over the front wheel on steep climbs - stopping the front wheel from lifting.

Although raising the handlebars can make steep climbs harder and less efficient, a riser bar is far better suited to steep downhill terrain. Favoured amongst riders looking to ride challenging terrain, the riser bar, even a low rise, is the bar of choice amongst downhillers, dirt jumpers, freeriders and trail riders.

1.FLAT OR RISE?

Mountain bike handlebars fall into two groups: flat bars favoured by cross-country racers, or riser bars, predominantly used for more technical riding. Most modern day mountain bikes come fitted with a riser bar. The rise will likely range from 1"-2.5" although the lower-rise bars are the standard for most riders.

Flat bars put more rider weight on the front end producing a lower, more aggressive ride position. A low front end is valuable on steep climbs and allows

2.POSITION

The position you put your handlebars in is often overlooked; yet it can have a major impact on your riding. A good starting point is to try and get the rise and sweep in a neutral position - with the rise as vertical as possible. From here, gradually increase the lean either forwards or back until you are satisfied. Getting used to any new bar position can take a few rides so don't necessarily rush to judgment.

Bars generally sweep both up and backwards. A straighter bar with less sweep may push your elbows further out - into a more aggressive position - increasing your stability in rough situations. It's likely that the sweep will increase with the width of the bar to maintain rider comfort. It's claimed that more sweep provides a more ergonomic and stronger position for your wrists and arms. With all this in mind, everyone's preferences, demands and anthropometrics vary greatly so try out a few to get the right one.

3.WIDTH

Traditionally, road handlebars were chosen to match the width of the rider's shoulders, improving aerodynamics, comfort and efficiency. Mountain biking demands very different requirements: a mountain bike bar needs to be wide to maintain stability when moving fast over rough terrain. Just how wide depends on the discipline: downhill bikes tend to have wider bars that provide a better platform whereas those on a cross-country bike will be narrower so as not to compromise climbing efficiency.

PRO TIP: CHRIS KOVARIK

Your bars should reflect how tall you are and what your build is like. The position and width of your bars is really important to your style and performance on the bike. For instance, if your bars are rolled forward, too wide and sweeping upwards at the ends you are going to be over the front and in an attack position on the flat. But on steeper terrain you'll struggle when you try to get your weight off the back of the bike. So it's really important to find a happy medium in bar position and width.

Current trends in downhill have seen bars of up to 750mm becoming the norm on the World Cup circuit. This is in stark contrast to the 560mm flat bars often preferred by elite cross-country racers.

BRAKES

Brakes have come a long way from the drum or cantilever brakes and motocross levers used by the clunkers down Mount Tamalpais in the mid 70s. After years of development of rim brakes, the industry is setting the hydraulic disc brake as the gold standard. Sealed from the elements and with a consistent lever feel, the hydraulic system meets the demands of mountain biking perfectly. However, regardless of the brakes you use, getting your levers in a position so that you can comfortably and quickly reach them will definitely give you one less thing to think about when things start to get interesting. In fact, it's been seen time and time again that having reliable brakes set up in the correct way boosts rider confidence and can have an astounding effect on rider speed and ability.

Hope Technology, having developed disc brakes since 1989, put correct brake set-up and selection high on their list of priorities. **Neil Arnold** from Hope Technology believes you first have to get your lever in the right place, *"Both the lever blade and the master cylinder position can affect how comfortable you are. Too high and you can suffer from aching arms and an uncomfortable position for your wrists, and too low and you might be unable to reach the lever when descending. Generally, about in line with your arms when in your natural riding position is about right as a starting point."*

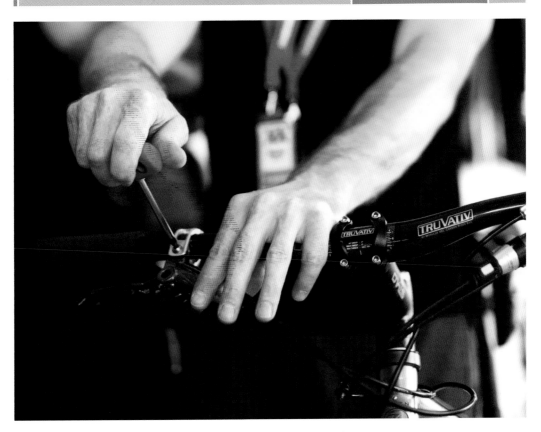

Martin Kirchner, SRAM XX Launch Italy / *Victor Lucas*

Brake lever position aside, the brakes you choose to fit will also affect your performance. With a market now brimming with brakes, varying in everything from rotor size to piston numbers it can be hard to choose the right one for you. **Neil Arnold** adds *"Although a lightweight XC brake with small rotors may work fine on a big descent for some people, others may struggle with heat build up and pad glazing - leading to a wooden feel and power loss. Generally a slightly bigger, more powerful brake will be more consistent and offer better pad life. Bear in mind that some brakes are dedicated to doing a specific type of riding. If you want super light cross-country brakes you need to make sure you fit the right rotor size for your riding type to get maximal performance. On the other side,* a DH brake can offer lots of power, but maybe only when it's 'squeezed'. Alongside your riding type, think about the conditions you'll be using the brake in before you make your final decision."

PRO TIP: NEIL ARNOLD, *Hope Technology*

Equal feel between your brakes is crucial for control in difficult situations. Adjust the brakes using reach and bite point adjustment to feel comfortable and safe. Sometimes too far out and you will lose control of the bar itself, and too close you can trap your fingers or not get enough 'squeeze' on the lever.

SHIMANO

Victor Lucas

SADDLE

1.HEIGHT

The height of your saddle is very important for pedalling efficiency. Too high and your pelvis will rock side to side when pedaling, giving you lower back pain and a loss of power. Too low a saddle and you'll find that you again lose power. It can also cause back pain and damage to your knees.

Many riders go for the classic road bike method of setting seat height by sitting on, then ensuring a straight leg when at the bottom of the pedal stroke. Although adequate there are some factors to consider. You'll spend far more time out of the saddle on a mountain bike ride and the trails can get pretty technical. To cope with this, running your seat fractionally lower, giving your knee a slight bend, will help you get above the saddle and move around. **Christoph Sauser** believes saddle height to be a *"very personal thing that should be the same on all of your bikes to keep you supported and injury free."*

Your saddle height can also reflect where and how you ride. Downhillers for example, run their seats low. In a sport where you don't tend to sit down for more than five seconds, maneuverability is paramount. Downhill World Cup winner, **Tracy Moseley** has this to say. *"Although you obviously need a low enough saddle to be able to get all over the bike without it getting in the way, I also think that a saddle can be of use for some steering, cornering and stability. I think that if it is too low, if you ever pedal sat down you'll not get the same power output and it takes more effort to get back up from a really low seat, which can be fatiguing. I don't have a particular height, but I think it's personal preference and should be experimented with."*

The pros often use their saddles as extra leverage on steep cambers or fast, flat out turns. Having the seat a little higher than rock bottom will help you to do this. However, running your seat way too low will also prove incredibly inefficient for pedalling.

If you're a trail rider who drops your seat for the downs - remember to put your seat up for the climbs. Find a height that's efficient and comfortable to help you get to the top as easily as possible. Stop on the summit and drop the seat right down again, but don't ram it all the way down - it's unlikely you'll find a descent that won't have a flat part of some kind. Having a saddle at a height you can pedal well with will keep you powering through.

2.POSITION

Seatposts have all sorts of adjustment possibilities that often get overlooked; adjustment fore and aft or altering the seat angle. Small changes can bring huge differences in comfort and performance. In terms of horizontal positioning, as a guide, set up your seat so that the front of your leading kneecap is directly above your pedal axle when your pedals are level. If you're taller, you may find that sliding the saddle back on its rails will be more comfortable.

The angle of your seat can also dramatically change the way you feel on your bike. Start with your seat as parallel to the ground as possible. From this level, you can experiment with dropping the nose or tilting the seat back slightly. Both will have an effect on performance, by either pushing you off the back or by forcing more weight to go through your arms.

Where and how you ride can influence your choice of saddle set-up. Dirt Jumpers and BMXers typically run their seats very nose high. A cross-country or endurance based rider will strive for the best comfort and efficiency when seated and a downhiller will combine maneuverability with performance.

It can take a bit of time to get right so expect to be jumping on and off the bike every few kilometers to tweak it a bit more.

PEDALS

In the world of pedals there's really only two choices and depending on what discipline you ride in, that can actually be narrowed down to one. For cross-country, the efficiency, power transfer and extra pedalling power a clipless pedal provides are undisputed. At competitive level, there's little chance you'll see anyone daring to compete on the humble flat pedal.

For downhill however this changes and the waters are somewhat muddied. Whether you choose clips or flats is a personal choice that can stem from riding style, confidence or for some, fashion.

Steve Peat has raced on clips for years and isn't likely to change anytime soon. Like many other pros, he feels the extra power and efficiency outstrips any benefit that could be garnered from flats. However, he's no pedal pedant and to help you choose, Peaty has this to say: *"I would recommend a new starter to ride flats. I think there are certain situations where clips work better and the same goes for flats, but I also believe that that you learn more about technique by getting used to flats first. I have been on clips for so long it would be hard for me to go back to flats now, clips work better for my style of riding."*

Just to show it's not a clear-cut decision, the 2008 Junior World Champion **Josh Bryceland** chooses flat pedals. *"I'll be honest and say that I never even realised clips existed until I started racing. Having seen some other guys running them, I still didn't fancy it. Using flat pedals mean that I can hang loose from time to time and get my feet back on with no dramas."*

Racing aside, as Peaty says, flat pedals will always teach a rider how to ride with more flow and develop a better understanding of how to work with the bike in different situations. The freedom a flat pedal provides, although intimidating for the less skilled rider, will force you into learning the proper techniques behind jumping, hopping and maneuvering the bike over rough terrain.

The freedom to move around makes flat pedals the first choice for dirt jumpers, freeriders and the majority of recreational downhillers.

GEARS

Gear selection is often overlooked. It generally comes down to whatever the bike came with. Long gone are the days when downhillers ran 54 tooth front chain rings. Like BMX, mountain bike has moved towards a more compact set-up. Some cross-country riders, influenced by the road, are opting for a double up front.

Downhillers too are simplifying things. 36-38 tooth single front rings are the norm, often run with a road bike cassette for the closest ratios. Chain devices are needed when losing a chain isn't an option. In fact, 2008 saw USA's Adam Craig ride numerous top international races using a single chain ring. In the Honda years Greg Minnaar also reduced his gears to eight.

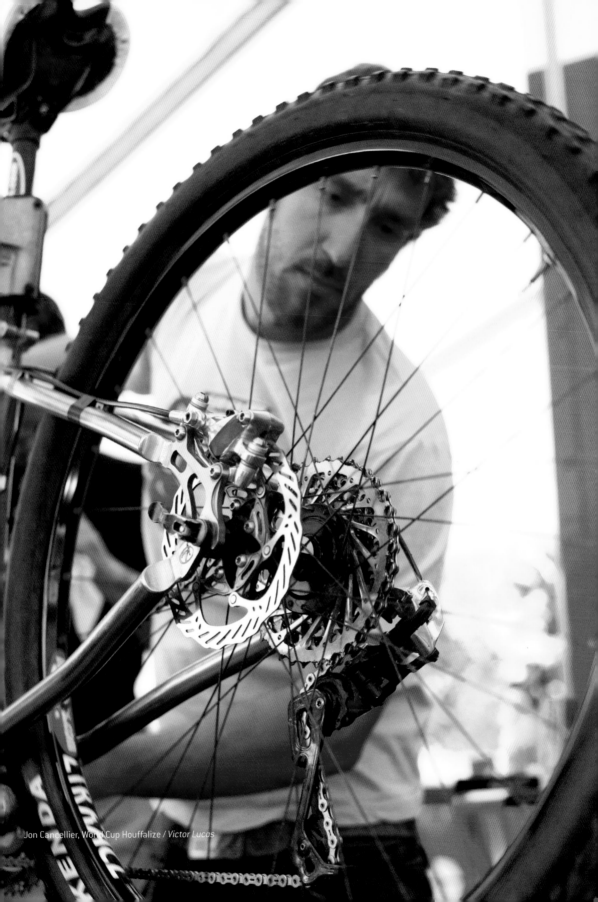

Jon Cancellier, World Cup Houffalize / *Victor Lucas*

Nathan Rennie's mechanic, World Cup 2008 Fort William, Scotland / *Victor Lucas*

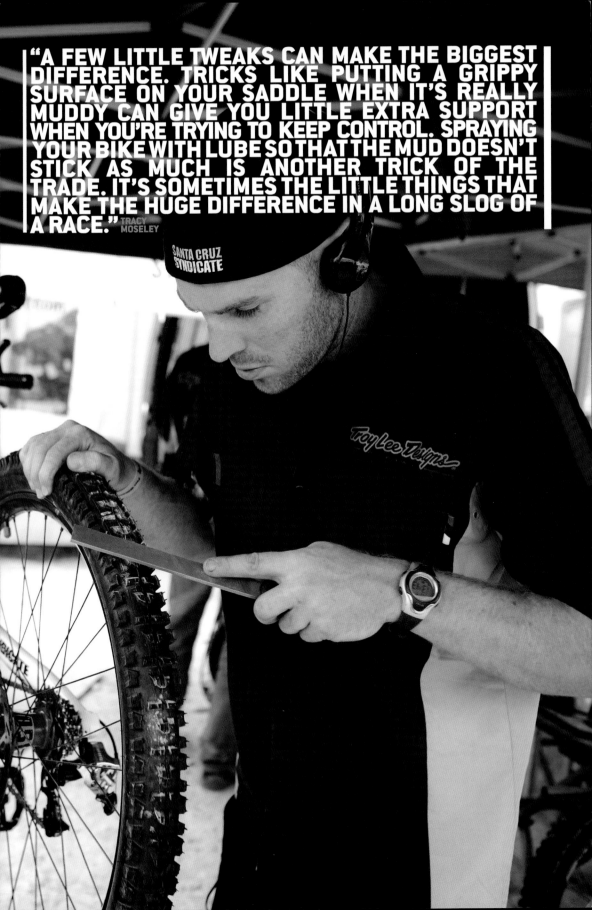

"A FEW LITTLE TWEAKS CAN MAKE THE BIGGEST DIFFERENCE. TRICKS LIKE PUTTING A GRIPPY SURFACE ON YOUR SADDLE WHEN IT'S REALLY MUDDY CAN GIVE YOU LITTLE EXTRA SUPPORT WHEN YOU'RE TRYING TO KEEP CONTROL. SPRAYING YOUR BIKE WITH LUBE SO THAT THE MUD DOESN'T STICK AS MUCH IS ANOTHER TRICK OF THE TRADE. IT'S SOMETIMES THE LITTLE THINGS THAT MAKE THE HUGE DIFFERENCE IN A LONG SLOG OF A RACE." TRACY MOSELEY

Victor Lucas

For trail centres and general use, a simple triple up front and an 11-32 cassette will do the trick. Although remember, like Adam Craig, if you're riding is a bit more demanding, there's no harm in reducing your choices and going the single ring set-up.

TYRES

Tyre choice is one thing you are guaranteed to hear radically different opinions about. Some riders have their favourite rubber that is irreplaceable - nothing else will do. Others will be on the constant search for that special tyre, the one that will provide grip in every situation and masks all their little handling mistakes. In reality, it's often simple issues with technique that cause the loss of grip for the average rider but it's still worth getting the tyres right for your trail.

1.TYRE PRESSURE

First off, think air not rubber. If it's wet, drop the pressure. Too soft and the tyre casing will roll around creating a lot of instability when you've got all your weight on it mid turn. Too hard and the tyre will deflect off the terrain, resisting the ground rather than softening the edges and keeping you glued to terra firma. An exact science it's not. You've got to factor in the weather, the surface type, how you ride, how much you weigh and often, how strong your tyre casing is.

If it's wet and you normally run a cross-country tyre at 35psi+ drop a few psi out of it. You'll find the tyre will roll slower and generate more drag, but will deform around the wet trail surfaces and give you lots more grip. A wet trail will also mean lower speeds and this in turn reduces the chance of picking up a pinch puncture, as you'll be hitting objects with less velocity.

A downside to softer tyres is that they can feel pretty unstable in hard corners: less pressure may allow the carcass to roll from side to side. If the trail is sun-baked hard, pump some more air in to give you more confidence in the fast turns and less rolling resistance on the straights.

2.TYRE PATTERNS

The tread on your tyres will have the biggest impact on how much grip you will have and how much rolling resistance you'll experience. As rolling resistance is less of an issue in the wet when grip is all that matters, you can get away with choosing a tyre with a far more pronounced tread pattern.

Downhill has seen a move towards wet weather tyres called spikes; tyres with a seriously aggressive tread that sticks into the ground, seeking out grip in super soft surfaces like deep mud, dust or loamy soil. Gee Atherton and Sam Hill are part of the new era, opting to run spikes on numerous tracks in conditions other than just wet mud. In fact, on the dusty slopes of Les Gets, France, Fabien Barel opted for spikes at the 2004 World Championships, even although he was competing under the blistering heat of the Alpine sun. His choice must've been spot on as he went on to win gold that day.

For cross-country, a heavy, strong and aggressive tyre isn't needed. Instead, riders opt for lightweight and fast rolling treads. The race can been tough enough without giving away valuable power to an overly grippy or soft tyre.

In the dry you should change your tyres out for a far less aggressive profile. As there's more grip on the ground, you can cut the amount of grip you have on the tyre itself. Lower tread profiles will help stability on hard ground and save you a lot of effort through the pedals.

SUSPENSION

Mountain bike suspension has come on leaps and bounds in the past decade. No longer are top riders tackling the Mont St Anne Downhill World Cup on 80mm elastomer sprung forks. You can now choose from air, coil sprung, oil damped, nitrogen charged, travel adjustable or remote lockout and carbon steerer tubes.

How you set up your forks or rear damper is one area where it seems that there's a lot of differing theories and ideals. Add to that technology that is constantly evolving and the complexity of different kit having different adjustment options and the whole thing becomes a minefield.

Underneath all of the hype and jargon, each suspension unit will be trying to reach the same goal: to provide a balanced ride that increases your grip, comfort, control and speed. A good suspension set-up should almost become a silent, unnoticed aid to your riding. Learn what your adjusters do and take time to understand the basics of spring rate, compression and rebound damping. As different manufacturers offer different adjustments, named different things with different settings, learning your own kit is the best place to start.

There is no holy grail of suspension set-up and although many riders look far and wide for a solution, the answer may be closer to home. Having worked in suspension for years, **Tim Williams** of Mojo Suspension offers a simple starting point. *"Take the time to have a thorough read through your suspension owners manual before riding. Most set-up queries can easily be answered with the comprehensive information companies compile to help you get the best out of your suspension."*

For the normal trail rider, changing suspension settings for specific conditions may not be too necessary. If you have spent some time getting your bike just the way you like it then chances are you'll ride it fastest in that setting.

However, if you're a pragmatist, looking for every performance gain or the handling just doesn't feel right then make adjustments one at a time and note the differences. If you get carried away and change a lot at once, you'll never know what is positively affecting your ride and what isn't.

PRO TIP: MARK FITZSIMMONS, *Fox Racing Shox*

The biggest mistake riders make is rebound set-up. 99% of the time riders think that fast rebound is the reason they get bounced or bucked in the back and this is far from the truth. Most of the time bucking comes from the bike being bottomed out and energy is being released that is undamped. The rider bottoms out from not having a firm enough spring rate or enough compression damping. When the wheel, tyre or swingarm energy releases, the shock rebound damping doesn't do anything.

Mike van Zyl rebuilding Boxxer fork / *Victor Lucas*

Chris Vasquez's tools / *Victor Lucas*

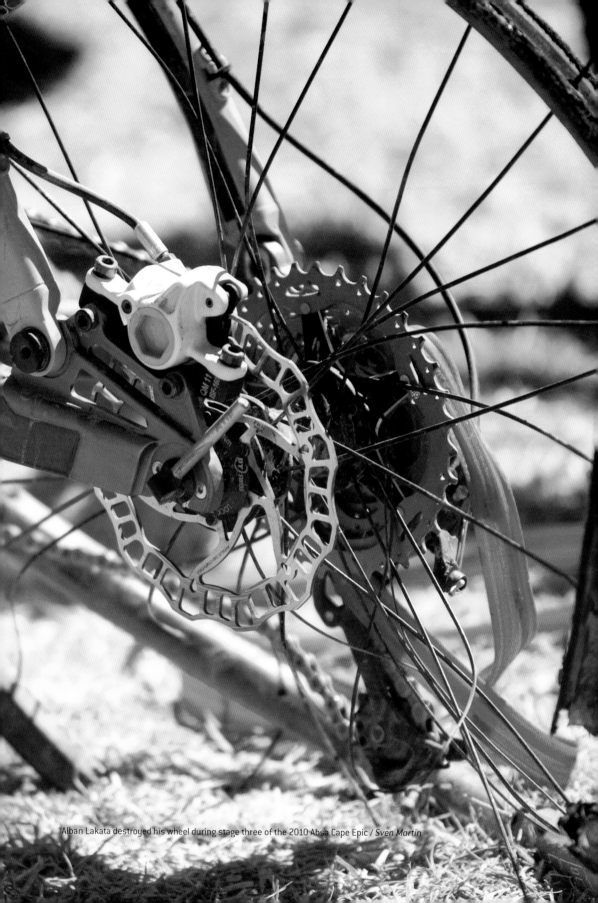

Alban Lakata destroyed his wheel during stage three of the 2010 Absa Cape Epic / Sven Martin

PACKING LIST

As you become more confident and seek more technical trails in remote areas, there's one thing you need to remember: the more epic your ride becomes, the more epic your walk home will be with your broken bike and sore feet. Bike shoes aren't designed to walk far in, and from bitter experience I can tell you that it's not something you want to do.

Packing right is an art. Too much and you'll be lugging more kit around than an overenthusiastic boy scout. Pack too little and there's a strong chance that although you may feel free and unrestricted for the first half of the ride the second will be replaced by a long walk out carrying your bike.

It is a fine balance to pack right but don't be tempted to leave the responsibility to your mates. I've ridden with some guys who've always relied on someone else carrying a tube. This relaxed approach can work, until the point where the punctures exceed the amount of tubes packed. I've heard of friends being left on a remote trailside after someone has demanded their tube back after an unfortunate second puncture. Sympathy can be in short supply and I would strongly recommend that when it comes to punctures, be prepared and make sure you can fix your own.

The same can be said for other spares. Avoid carrying a 30kg pack but taking essentials such as a chain tool, spare chain link, allen keys, tyre levers, pump and a small knife should become part of your routine. If you always ride with the same bunch, spread the load. There's no need for eight chain tools but I wouldn't suggest you rely on only one. Be clever and have a quick think before you set out. Thirty seconds of thought at this point can save you a whole manner of grief later on. I for one never want to have to run for an hour in SPD shoes, carrying my bike ever again. If it's avoidable, try hard to avoid it.

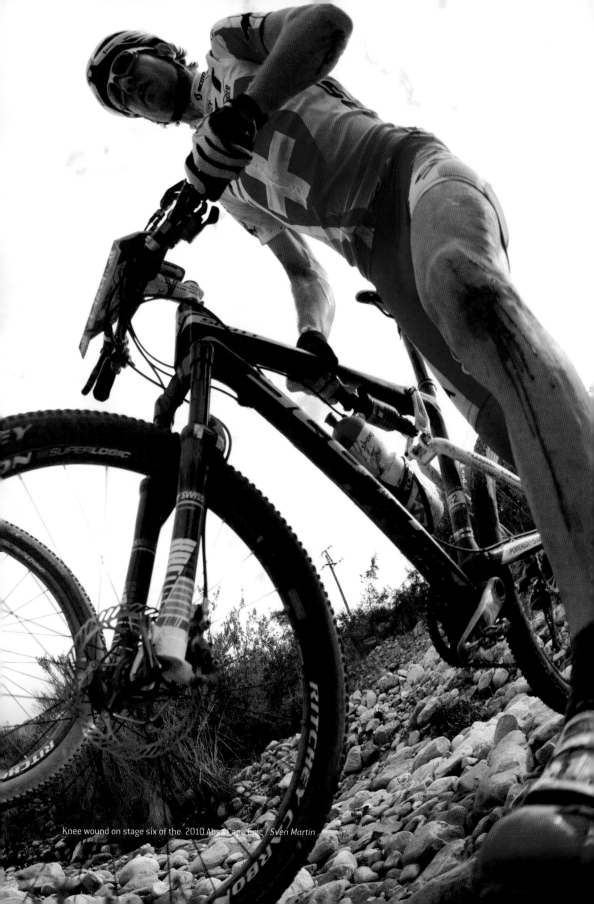

Knee wound on stage six of the 2010 Absa Cape Epic / Sven Martin

FIRST AID

The huge growth of the specific mountain bike trail, a way marked and signposted route around the hills and forests, has made the sport far more accessible and in many ways safer. However, it has also led people into a false sense of security. If something goes wrong, it can go very wrong, very quickly, and although you may not feel far from civilisation, it can often take a while to get rescued from a forest or hillside. The ambulance may be unable to drive up to you, there may be a locked gate in the way or the weather might not be on your side. For these very reasons it's worth packing intelligently. After all, a few well thought out and cheap items will go a long way to stopping a bad situation from getting much worse.

GET TRAINED

In mountaineering, your chances of surviving an avalanche are greatly improved if the people you are with know what to do. What happens in the first few minutes can determine whether you live or die. The same precautions should apply when you ride in the wilderness. Get yourself on an outdoor first aid course to keep safe out in the hills. However, if you're the only one first aid trained, who's going to help you if you wreck yourself? It makes sense to get a regular riding partner educated too to cover every eventuality.

YOUR KIT

A good outdoor first aid kit doesn't have to be bulky; you just need to include the essentials. Broken bones, cuts and grazes are the most likely injuries so get a decent supply of bandages. Stemming blood flow can be a lifesaver. If the squirting isn't serious, plugging it properly means you can continue your ride without too much drama. Likewise, a lightweight splint and sling is worth having so you can strap up your mate and get them comfortable for the long walk out. You don't have to be a paramedic. With the right knowledge, practice and a few essential supplies you can cope with a lot that a mishap in the mountains might throw at you. If you don't know what to take, find out before you go.

Don't forget warmth either. Foil blankets are light, cheap and easy to carry. Stick one in your bag and use it. Cold is a killer, especially after an injury. Take a spare beanie too. By sticking a hat and a foil blanket on, you'll greatly increase the casualty's comfort and chances of getting off the hill alive and well.

TREATING WOUNDS

General first aid is also a commonly overlooked area. Although some trail centre's provide ranger services who carry the essential alcohol wipes and plasters, it's worth being able to look after yourself quickly and efficiently. Cuts can easily become infected and at best this might stop you riding for a few weeks. At worst, infected cuts can be far more serious. Clean your cuts as quickly and thoroughly as possible. Give it a quick wipe with antiseptic and cover with something that'll protect it until you get home. After all, that little nick on your shin is the perfect breeding ground for bacteria thrown up by your front wheel. Once you're all showered and cleaned up properly, make sure you get every last little drop of muck out of the wound and keep it covered until it's healed. If it's a deep one, keep an eye on the wound for excess gunge, swelling or redness. If you're not sure, get yourself to the doctor's surgery to make sure you've not picked up an infection.

Dan Atherton's helmet / *Victor Lucas*

CLOTHING
What to wear or more importantly what not to wear.

Almost every year we hear of some lost climber or someone stuck in the great outdoors because they were unprepared. As mountain bikers it seems many of us don't think it applies to us. We can cover big distances in a relatively short space of time and get out of trouble. But that means that in a short space of time, we can also get ourselves into a lot of trouble. Accidents aside, bad clothing choices can lead to injury or illnesses or just plain discomfort.

IMPACT PROTECTION

It goes without saying that you should never ride without a helmet. Whether you're throwing yourself off an Alp in a carbon fibre full-face helmet or just riding your regular week-night loop in a well-vented skid lid, you should always keep your head protected.

With your head covered, there's a multitude of pads now available to suit most riders. It's fair to say that your knees and elbows are usually the first to hit terra firma so keeping them covered is a good idea. Alongside the essentials, shin pads can help against pedal slips and stray rocks, reinforced gloves may protect your knuckles if tight, wooded trails are the order of the day and neck braces are starting to become more common among downhillers looking for that little extra.

The modern day 5" trail bike can go very fast over very rough terrain so don't feel that padding up is unnecessary for your normal trail ride. In fact, wearing some lightweight pads if you're going flat out on skinny tyres and short travel forks makes sense. Just remember, pads aren't a get out clause. If you wouldn't do something without pads, you should re-evaluate whether you should be doing it with them. No protection offers invincibility.

WEATHER PROTECTION

If it's cold make sure you keep warm. It's probably more common to see mountain bikers wearing shorts over any other garment, but make sure that you cover up your knees if it's cold and wet outside. Leg warmers from a road cycling store can be a good addition to your stack of kit as they can be used on and off and don't cost the earth. Three quarter length lycra shorts will also keep your knees warm if the temperature gauge is a little on the low side.

Up top, the layering method is the best bet. A good base layer is worth its weight in gold. My Merino wool long sleeve has seen more use than any other piece of kit. Choose wisely and you won't need to own a wardrobe the size of Elton John's. A good breathable waterproof jacket that's light enough to stick in your pack, some long fingered gloves and

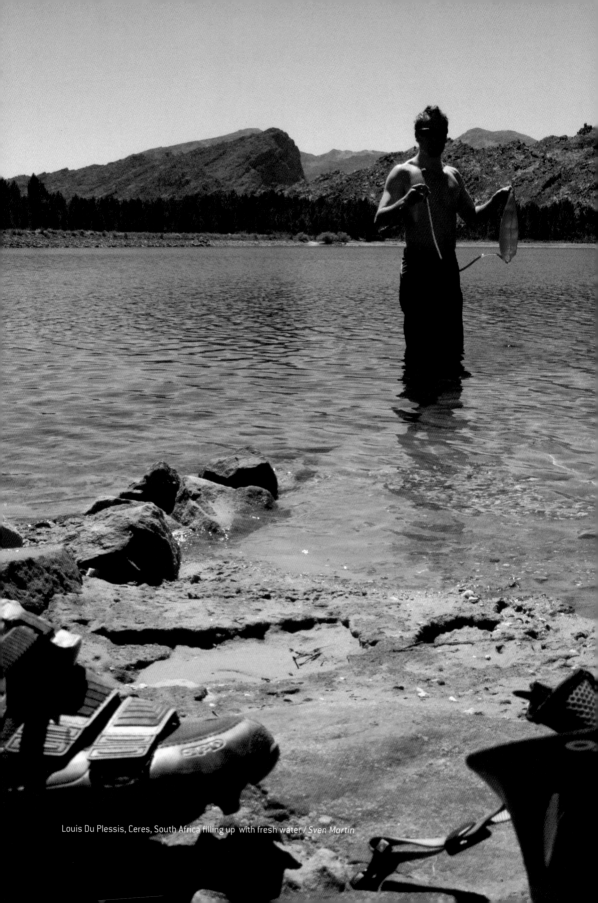

Louis Du Plessis, Ceres, South Africa filling up with fresh water / *Sven Martin*

that base layer will see you right on most autumn and winter rides. Add a summer jersey and a lightweight windproof and you're sorted for almost every condition.

Make sure you keep your kit clean and dry. Going out in dirty or damp clothes is a recipe for getting ill or injured. Pay particular attention to your shorts: the inside is warm and dark, a great place for cultivating bacteria. Put them in the washing machine after every ride. The same can be said for base layers. If you're packing for a weekend away, take enough stuff to make sure you have a dry change for each ride. Damp clothes against your chest will keep you chilled and can lead to infections that won't help your performance on the bike.

HYDRATION

We'll go over the details of what to drink in the Nutrition section page 79 but for now, just remember to carry some fluids. Sharing bottles is a sure fire way to transmit infection and before you know it, the little cold your mate had has got you by the neck. Hydration packs are a good way to go. Not only can you carry more to drink, but by having your drinking hose near your mouth, it promotes regular sips. By staying well hydrated you'll be able to ride faster for longer.

One final tip is clean your water bottle or hydration pack's bladder regularly. Don't leave energy drinks or water in there to go stale. Although penicillin is a useful drug for many people, try and refrain from growing your own in your water bottle. Those little black patches of fungi aren't always your friend so give your bottle a good wash and just as importantly, make sure it's well dried out and fresh for the next ride.

Bike washing / Victor Lucas

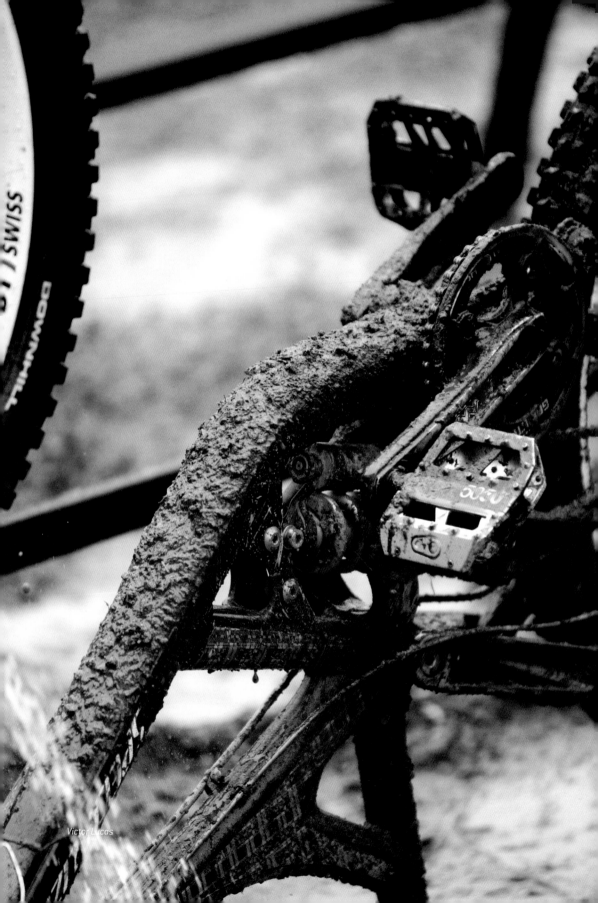

Victor Lucas

MAINTENANCE
Don't turn up with a dog.

Picture this. The sun is up, the light casting long shadows over your favourite section of single-track. It's the last descent and you only have three miles to go. The dirt is just damp enough to provide perfect grip without getting you muddy and your mates are all laughing and hooting. Then, Bang. There goes your mate's spokes, the ones he hadn't bothered to tighten. The ones you'd all told him about on the ride the week before. It's happened to all of us. And it never gets any less annoying.

LOOK AFTER YOUR BIKE

It sounds obvious but it's all too easy to conveniently forget about. I for one have been known to come in from a cold mid-winter ride, have a coffee, a long hot shower and then put off fettling the bike until another day. One of my good friends lives by the motto "Your bike should always be good enough that you'd be perfectly happy to race it the next day". He's certainly right. That is a great approach to have, one that I've always admired. Sure, a full service would be the perfect thing to do after every ride, but in reality, as long as you do the following few things, you'll at least ensure your bike won't fall apart on the next ride.

WASH

A good wash goes a long way. The sooner the better. Leaving mud, grit, snow sand and whatever else you've picked up off the trail to dry is a bad idea. Try and get all the muck off your bike as soon as possible. If you're using a power washer, avoid any seals. The last thing you want to do is force water into all the bearings and

scoot the grease out. Problems are a lot easier to spot on a clean bike and there's no point spraying oil onto the top of the mud.

LUBE

Just a quick squirt of a thin lube on the most important moving parts is all you need. Don't go overboard on the chain and avoid the braking surfaces. If you're riding in the dust, use a non-sticky oil. Conversely, if you're riding n the wet, use a lube that's sticky enough to stay on the chain after repeated water splashes. A drop of Teflon lube on the fork sliders and brake lever pivots will help to reduce friction on the next ride. A good lubricating method only takes a minute but will pay dividends on the long run. Dry bearings, chains and pivots will wear out in half the time and make your bike feel like a bag of spanners.

CHECK YOUR PARTS

Sometimes the most unlikely of bolts rattles loose. This will probably be just the sort of bolt that you never carry as a spare, but can end a ride if it disappears. Start at the back wheel, have a quick shake of the bits, a quick scan with your eyes. Follow that up to the seat, down to the bottom bracket and cranks, back up to the handlebars and then finish on the forks and front wheel. Just give everything a shake or a tap. If you get into a habit of doing this it'll take you no time at all. Another quick check is to pick the bike up a wheel at a time and gently drop it. You should be able to hear if there's anything loose. A quiet, solid thud is usually a good sign that all is well.

Sven Martin

PREPARATION

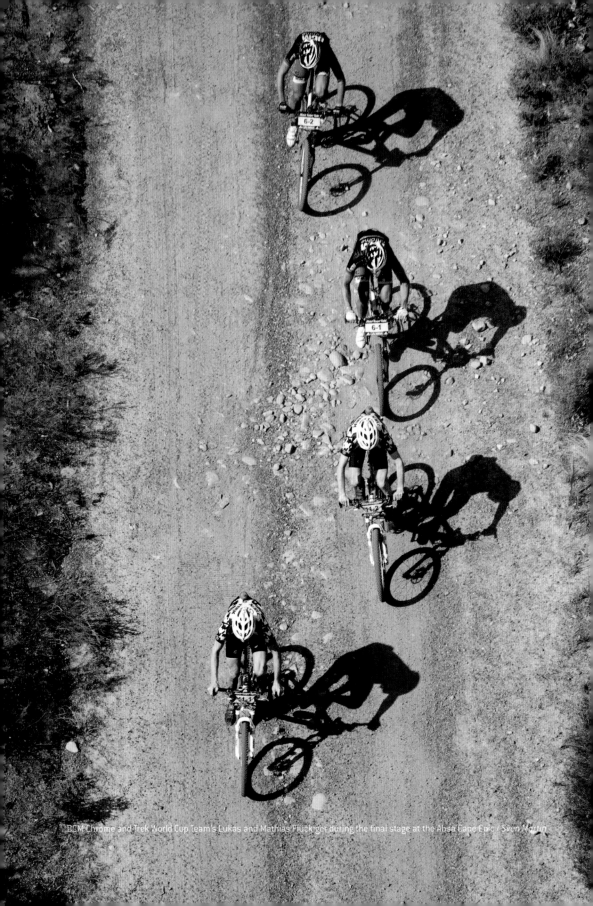

DCM Chrome and Trek World Cup Team's Lukas and Mathias Flückiger during the final stage at the Absa Cape Epic / Sven Martin

HOW TO TRAIN
Getting into shape is much easier if you learn how to properly.

Don't just go down the gym and lift metal in a random fashion. Preparation is key: if you are serious about getting fitter, plan your training schedule. It's not just a matter of working out which days in the week to train either, doing the right things at the right time of year is also crucial. But, most importantly, you need to fully understand the demands of your discipline. For an endurance rider, there's little point in squatting huge weights and trying to look like Arnie. A good power to weight ratio and aerobic endurance are what's really needed. Likewise, a downhiller should be looking to improve power, developing faster recovery times between repeated sprints and building a solid core.

Once you've thought through your needs, group your training time into blocks. Think of building from one training block to the next, with each phase reflecting on the previous one. However, even though this means that not all your training will be in the saddle, try and get out on your bike as often as you can, even if it is just for an easy spin. **Tracy Moseley** says that keeping that basic familiarity with riding is essential if you want to progress, *"Time on the bike is important. Whether it's downhill, cross-country or dirt jumping. You need to keep that feel and keep progressing your skills all of the time, otherwise you'll be left behind."*

GET TO KNOW YOURSELF

Before you even start to plan your training, let alone go out and work up a sweat, there's one crucial thing you need to understand: your own body. Learn to listen to it, find its balance, its homeostasis. What might work for others may not work for you. A good athlete is a clever, thoughtful athlete - one that knows when to push it and when to stop. Rest is as important as the training itself. Learn how you react to different forms of physical excursion; how quickly you become fatigued and how much sleep you need to recover. Realise also that your body won't always react in the same way. Simple stresses in day-to-day life can take more of a toll than you think. Work, family, study, insufficient sleep or a mild illness can all be physically and emotionally draining. Take these into account and don't push yourself when you may be vulnerable.

Cram too many hard sessions in without adequate rest and you are at risk of overtraining. **Joe Friel** a leading cycle coach uses this great motto *"if in doubt, leave it out"*. That perfectly summarises what you should be doing. In the long run, you'll benefit far more from slightly less training than living with the perpetual fatigue and illness that overtraining brings.

When I start coaching new people, I often spend the first season teaching them how to train, rather than focusing on the exact details of the sessions. It's this knowledge that will allow you to get it right in coming years. On a cold mountainside, no one can understand your body like you can.

PHASES

Even if elite competition isn't your goal, getting fitter to ride can make any level of riding more fun. There's no harm in taking inspiration from other sports - road cycling in particular has a strong training heritage that we can learn a lot from.

It can be easy to think that riding your bike all of the time is the best training for riding your bike. It's not. Planning your training in phases will bring the best results in the most efficient way. According to **Bobby Behan**, World Class Triathlete and Christoph Sauser's Manager at Specialized, *"periodisation is imperative at any level of international competition".*

the same fundamental training things each year when I am preparing for a World Cup season and I know what makes me feel good, but I also look for new things and try to lift my game to keep up with the fast young guys."

In some of the newer disciplines like downhill and enduro riding, there's been a hedonistic heritage and a perception that training shouldn't be taken too seriously. But this laid back attitude isn't popular with the top pros and **Behan** agrees. *"There is the illusion that the gravity athletes don't train, but party a lot! However, behind this image, the gravity athletes do train hard and prepare in a professional manner, like their cross-country counterparts."*

Steve Peat has seen all the changes in training mentality the sport has gone through over the past decade. *"I certainly learnt a long time ago to be more professional and realised I wouldn't get anywhere without hard work and hard training. Now it is an ongoing change, I do*

So you can do a lot more than just shuttle runs. Only doing your set discipline over and over means you'll never be able to isolate its component parts and develop each one. Anyway, the added danger element in downhill may mean that by doing more and more runs, you end up spending more time on the physio's table than you do on your bike.

Structure should be considered if you're just training for competition or to trim off the winter fat for a summer's worth of faster riding. The idea here is to divide your time into specific, planned periods, each with a specific, set purpose. The amount of time you dedicate to each phase will depend on how long you want to spend on getting fitter, but the same general

Pros including Sam Hill (left) and Shaun Palmer (above) turn to moto-cross, others to surfing / *Victor Lucas* / *Jim Michell* / *Victor Lucas*

theme can be followed. With a periodised plan, you don't always have to be flat out, lower intensity sessions will form a great platform, helping you to prepare for the heavier ones.

Different coaches, authors and books call each phase different things but the underpinning principles remain the same.

LAST SEASON'S HANG OVER

Give yourself some time off after a busy season. Long summer seasons take their toll on the body and mind - even if you're not at the sharp end of World Cup competition. A little down time does no harm. If you've been riding for months, allow yourself up to four weeks. Some riders opt to take up other sports. Cross training and dabbling in other sports can be a great way to press the reset button and rejuvenate your motivation. For downhillers, motocross is a favourite - Greg Minnaar, Steve Peat and numerous others turn to their motorised wheels for training.

Others choose skiing, running, snowboarding, wake boarding or surfing. Whatever you choose, remaining active is the key. A change of scenery will also help to clear the mind and allow you to reflect on the past season. Use this time to collect your thoughts and plan your year ahead. Set some goals and relax. It will all help your motivation and confidence.

PRO TIP: RENE WILDHABER

Multiple Mega Avalanche winner and endurance downhill specialist.

> *I always try to mix technique and endurance training so I get a little bit of everything. Downhill riding and climbing up high mountains on skis, cross country riding or even just working on the farm. Really, it's everything I like to do.*

Dan Atherton pedalling hard on the stationary in Schladming, Austria / Victor Lucas

In the gym / *Rutgerpauw.com* / *Red Bull*

BACK TO BASE

Your base phase is crucial but it's often overlooked. Think of it as building the foundations of fitness. The further you want to push your fitness levels, the larger your base stage needs to be. It'll help to get your body prepared and give your systems the kick-start they'll need. For someone training for a race season, a solid 9-14 weeks of base training will stand you in good stead to take on the next step. If you're pushed for time and are training for an event in the immediate future, you should still think of giving yourself a few weeks at this level.

Know your body and be honest with yourself. Plan sessions that you know you can keep to and don't be over ambitious. Also work out a realistic amount of time you can dedicate to training and don't overdo it. Remember, inadequate rest will only lead to set backs, so err on the side of caution to begin with and build from there. It's better to get a few solid, high quality rides in per week than to end up stressed, ill or injured by too much training.

During the base phase you need to train your body to become more economical so it uses less energy to achieve the same output. This is where your aerobic fitness comes into play. Think of the aerobic system as your energy supply. In any exercise over a couple of minutes, your aerobic system will take on a crucial supporting role, bringing oxygen to the parts that need it most. The longer you train your aerobic engine, the more oxygen carrying capacity it'll have and the more fat and carbohydrate your body can convert into energy for your muscles. The end result is you'll lose weight, feel stronger, use fuel more efficiently and you won't get fatigued so quickly.

To boost your aerobic system your base training should involve lower to mid intensity rides. Road bikes are great tools for this, but a steady pace and achievable distance is key; there's no need to sprint flat out yet. If you don't want to hit the road, indoor resistance trainers and rollers are good too.

BUILDING STRENGTH

Strength programmes should start to be introduced toward the last few weeks of your base phase and develop into more specific preparatory exercises as your programme develops.

Building strength is important for almost all mountain bikers, but how much emphasis you place on it depends on your discipline. Endurance based disciplines that require a lot of climbing or long hours in the saddle benefit from powerful, yet light riders. On the other hand, downhill and dirt jumping need a lot of strength to increase bike control and handle the heavy landings or big hits.

It could also be argued that a downhiller carrying more muscle bulk will be less prone to injury. Using their extra size and strength to keep everything together during a massive stack. Compared to other disciplines, downhill also places additional demands on the riders during seriously rough and fast sections. **Chris Kovarik**, one of the most powerful riders on the downhill World Cup thinks there are advantages of extra strength. *"If you are a smaller rider it might help to bulk up a little to help protect yourself if you crash. At the same time, extra bulk can help you be strong and pull out or save yourself from a crash"*.

World famous tracks like Fort William or Mont St Anne put riders through massive hits at flat out speeds.

These huge knocks can be hard to control without enough power in your shoulders, back and arms. A rider's strength is also called upon when everything starts to go wrong. Getting a bike back on track and avoiding a serious accident can take monumental effort.

Don't just rush straight for the heavy metal, developing and conditioning muscles to weight training is very important. Learn the correct techniques and build stability into your lifting before really pushing it. You'll need to develop a strong upper body to handle the big hits, so start by building your arms, abdomen, shoulders, back and chest. Use free weights over machines where possible to improve your core strength and to increase joint stability. As a cyclist, your legs are your power-house so keep the bias even and don't forget strengthening your lower body too.

Cross-country on the other hand doesn't place as many demands on a rider's upper body. Focus on developing strength in your quads, hamstrings and glutes - the major muscles associated with producing power at the pedals. An over-developed upper body might even act as a hindrance, increasing the amount of weight you need to pull up a steep climb and so making the whole ride more fatiguing and less efficient. However, a simple strength programme provided by a strength and conditioning coach may give you some additional increases in power and core stability that you may not gain from riding alone.

For recreational trail riders, some increases in strength can also be useful. It means you can put a bit of aggression into the descents or simply make carrying the water and tools in your pack for a whole day a little easier.

PRO TIP: GREG MINNAAR

Although I'd rather ride cross country any day, I try and get into the gym as often as I can. Getting aerobically fit is far easier than building power so you need to devote time to the gym.

In the gym / Carroux.com / Red Bull

If this is you, basic development of the legs through good use of a squat machine or leg press and calf raises will do the trick. Follow this with a simple upper body programme that focuses on the shoulders back and arms. Arm curls, shrugs, bench press and the bent-over row are all well documented exercises that will give you good results.

GET THE WEIGHT RIGHT

If you're a rookie in the weights room, start light. Work at getting your technique spot on. Accurate early lifting is invaluable as you'll build neural pathways that'll help you to lift more weight in the next phase. Lower weights and higher reps will also help to build muscular endurance. If you're looking to trim down but need some additional strength, don't increase the load too much. You should be aiming to make the muscle tissues more efficient and protected against repeated contractions rather than trying to increase muscle mass too much.

For the downhillers or riders seeking an increase in size, after your learning phase, reduce the reps and increase the load. Throughout the whole process, increase the load progressively. There is no overnight fix. Take your time to get it right.

This slow and patient approach will help to avoid injuries and provide you with the maximum return. Again, respond to what your body is telling you. Any pain or twinges should be taken seriously. Early attention with an ice pack and then rest is far better than ignoring the problem and having to endure a lengthy and often expensive rehab process.

CORE

Core stability should be central to your training regime. A solid trunk will hold you upright and stable even through the roughest of sections. Your lower back and abdominals, obliques and hip flexors all play a major part in stabilizing your trunk.

For downhillers or freeriders, a solid core will make you stick it out when things get out of shape. Taking a massive hit through the arms whilst resisting any loss of balance is near impossible with a weak core. The performance section will discuss in more detail how to use a stable upper body to its full advantage.

Chris Kovarik shows off his bike at the Megavalanche, Alpe d'Huez

/ *Victor Lucas*

Like any strength based exercises getting your technique right is vital. If you're new to it, learn the neutral position before doing any demanding moves. Lie on your back and press your lumbar spine against the floor. Tense your stomach and lower back to achieve this. Maintaining this position throughout all core exercises is fundamental to developing your core properly.

The dynamic nature of mountain biking needs to be reflected in your training. Exercise balls or wobble boards are the best tools to promote stability. Even simple press ups with your hands or feet on the ball will make you work your core far more than you would normally. Add static holds and resistance exercises that use your own body weight as the load. If you're in the gym, using free weights over machines will also develop your core strength far more than you might think. In fact, current research is starting to show that freeweight lifts like the squat work your core stabilisers more than floor-based exercises. This is just another reason to get off the machines and learn to lift bars and dumbbells. Balance boards used in surfing are also a great addition for some fun but effective sessions. More advanced moves might have you standing on an exercise ball and lifting a light weight.

Endurance riders also benefit from increased core strength as it can improve their power output. Wobbling around weakly on the saddle saps energy, but if you can remain solid and stable then all your effort can go into turning the pedals.

PRO TIP: CHRIS KOVARIK

I use a personal trainer that works specifically with cyclists. Although I'm powerful, it's a programme that's designed to help develop your core rather than bulk up. In between the gym I ride cross country hard once a week and then use light spins to flush out my legs in between sessions.

SPECIFIC PREPARATION

Once the base phase is complete you should start to introduce more specific workouts where more focused sessions and higher loads can be introduced. In an ideal world, at least six weeks should be devoted to this phase. Ramp up the intensities; add some sprint drills or some short explosive hill efforts.

REACHING YOUR PEAK

By now, you've been following a few months of structured training and this is when you start to benefit from all your hard work. Your goal might be a race season or a riding holiday with your mate, but with the target in sight, the number of hours you spend training should start to reduce. Instead, introduce more specific sessions that replicate what you're going to be doing. For a cross-country rider that may be simulated races or for a downhill it may be full runs at full tilt. Other than these specific sessions, cut back your other training to a level where you are simply maintaining what you've already built.

FLEXIBILITY

Flexibility is an important part of any training programme. Yoga and Pilates can be used to develop both control and posture whilst also helping to strengthen the core. Even a few basic stretches pre-ride and again post-ride especially if you're about to sit in a car for an hour or two will pay dividends to your overall wellbeing. This is especially important if you sit at a desk for the best part of the week.

A good way to think of flexibility and tension is to picture the whole body as a chain. All linked together. It's easy to give your quads or calves a quick stretch after your ride and still complain of lower back pain. In order to reduce muscle tension, stretch right from you ankle to your shoulders. It's the best way to avoid developing any tight spots half way up the chain that may start to cause some issues later on.

Gee at his best! / *Sven Martin*

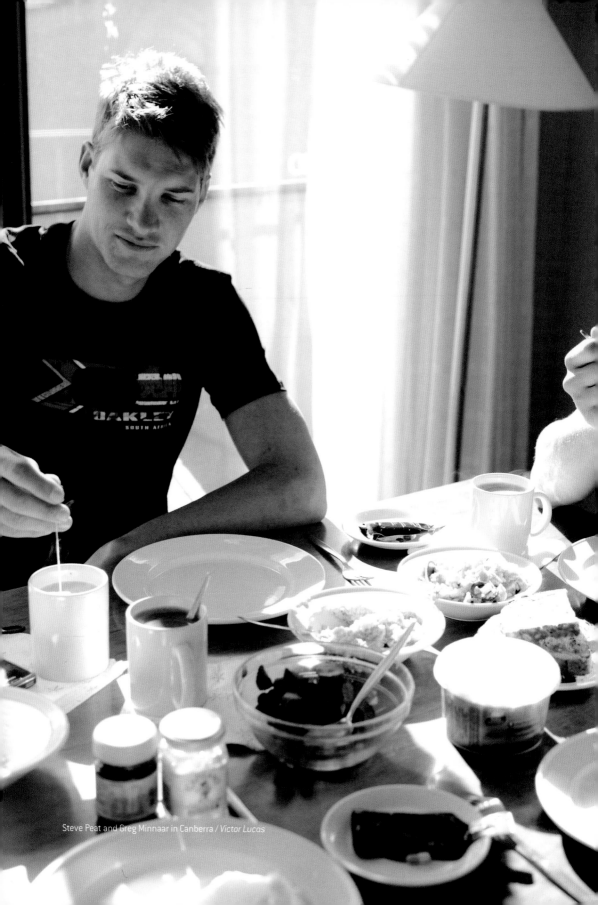

Steve Peat and Greg Minnaar in Canberra / *Victor Lucas*

THE BASICS

You will only get the best out of your body if you are careful about what you put in.

Food intake supports our entire lifestyle and a poor diet can lead to mood swings, poor concentration, fatigue and illness. If you pour dirty petrol into your fuel tank your Ferrari won't go far, so why fill up on the wrong foods?

Regardless of how much training has been logged in the previous months or how perfect their bike is set up for the race, a badly fuelled athlete just won't perform to their best. We need energy from food merely to stay alive. An active daily life requires yet more energy, or calories. Exercise, and your body will need to up its fuel intake even more to meet the increased energy demands.

The recommended daily intake of calories is around 2500 for men and 2000 for women. These figures have been calculated to fuel the needs of a general day-to-day life. Heavy training and competition could mean that an endurance rider will need to consume up to three times this amount. That's a lot to try and eat in one day, but choosing the right food and drinks can help tremendously.

Long, fast rides can use up to 300 calories an hour. To avoid a calorie deficit, your intake needs to match what's being burned. If weight loss is one of your aims, you need to slightly reduce your intake in comparison to what you're using but this should never amount to a difference of more than 500 calories a day. Sports nutritionist and mountain biker **Jaymie Mart** agrees. *"You need to balance your body weight. If your input exceeds output then you'll gain weight. Likewise, if you don't eat enough you'll experience weight loss".*

If you run out of carbohydrate and fat, your body will turn to protein (muscle fibres) for fuel. Unless you want to trim down on your bulk, getting adequate carbohydrate and fat will stop you losing muscle tissue. To keep track of how much energy you are expending, a good heart rate monitor will give you a run down of how much you've used and therefore, how much you need to eat to replenish your stores.

Food is divided into the three macronutrients - protein, fat, carbohydrate. If you understand how these will be used, it can help you to choose the right things to be eating.

Carbohydrate is the primary fuel source for any longer mountain bike rides. This means that on your regular trip, you'll mainly be using the carbohydrate you ate a few hours ago to turn the pedals.

After you've eaten your meal, you still have to transform it into something your body can use. Glycogen is the result of carbohydrate digestion and is stored in your muscle tissues and liver for use during exercise. This absorption can take a bit of time though. Unlike filling up your car with petrol and just driving off, if you're on empty, it may take a while to get going again. Take this into account and eat 2/3 hours before you ride.

PRO TIP: GEE ATHERTON

Food is super important when you are training hard. It can make the difference between surviving an intense racing/ training/travelling period or burning out. I don't stress about it to the point of following a strict diet, but I'm always keeping an eye on what I'm eating. For me, the main problem I have is keeping enough calories in me when I'm training so I don't get too lean. I try to eat what I call "real" foods, like I stay away from fast food, or processed food if I can but at the end of the day, if there is no choice I'm all good for smashing down a burger and chicken wings. Generally though I'm eating a lot of meat and carbs with chocolate on race day.

Running low on your body's carbohydrate stocks will lead to fatigue. To avoid this, take on carbs that are quickly transformed from food into glycogen. Heavy, dense foods can take some time to digest and fat can slow the process further whereas gels and fluids which contain carbohydrates are quickly absorbed. You should be taking on food during any rides over one-and-a-half hours. If you are racing then it's possible to store up to about one hours worth of fuel through a normal diet. This obviously throws up a few issues.

Firstly most disciplines race for over an hour, so you need to look at your fuelling before and during the event. Downhill on the other hand only lasts for a few minutes, which can create a false myth. Some riders feel that all of these theories don't apply to downhill-ers as you're only riding for a few minutes at a time

Mexican food... always a good choice / *Victor Lucas*

and in fact, a burger is all you need before your run. Take a step back and look at the whole event though. Downhillers will analyse the course and this practice can seriously diminish a rider's energy reserves, especially as they will often have to push their lead-heavy bike back up the hill each time. Fuelling regularly and properly throughout the race weekend will make a huge difference.

During rides longer than an hour you should be carrying quickly absorbed and easily digestible bars and gels. Bananas, jelly beans and jelly babies are also good snacks to take out. You can also prepare your fuelling and start to fill up your energy tanks before you go out. Maximise your body's carbohydrate stores; for ultra-endurance events a perfect diet in the run up to the event is crucial, but you can also loosely apply these strategies to a regular Saturday trail ride. Try and avoid sleeping in and grabbing a bit of toast on the way out of the door or even worse, not eating altogether. If you've had to wake up really early to drive to a spot or an event, stop on the road and get some food down you. But be careful what you load up with. If the ride has a café near the trail-head, try to resist a full cooked breakfast, or any fatty food, at least an hour before you get in the saddle.

Ensure your pre-exercise meal is predominantly carbohydrate based. Studies have shown that effective fuelling prior to exercise consists of 200g-300g carbohydrates like pasta, rice, potatoes and couscous. Once you're back from your ride, take advantage of an absorption window that occurs when your systems are suppressed. In this two-hour long period, your body can transform carbohydrate into glycogen at up to four times the normal rate. This means that your energy stores can be replenished faster, helping to negate the slump in the immune system that follows exercise. Do this and there's more chance you'll be fighting fit for a ride again the next day.

FLUIDS

Water is vital. It doesn't matter if you are a downhill rider who does runs lasting a few minutes or someone who goes out for cross-country endurance epics: adequate hydration is crucial. Even very low levels of dehydration can lead to losses in concentration and fatigue. In fact, it has been shown that as little as a 1% loss of fluid can reduce athletic performance and mental sharpness.

In downhill, where the times are millisecond-tight, the margin for error is miniscule, so any lack of focus could have a huge impact. In endurance events, fatigue or

Dan Atherton taking on some energy / *Victor Lucas*

A quick and easy way to assess your hydration state is to check the colour of your urine. Clear or pale straw coloured is perfect, whereas dark yellow indicates dehydration. If you're racing, needing a quick pee just before the start is a good sign that you're fully hydrated and ready to go.

When to drink is also important. Just like food, you should be aiming to take on sufficient amounts before your ride. If you know you're going to be exercising in high temperatures, you should start hydrating a couple of days before. In the two hours before your ride aim to consume 400-600ml of a well-balanced isotonic sports drink. The extra calories and carbo-hydrates in the fluid will help you to stock up your glycogen stores quickly and reduce the chances of you feeling bloated on the trail.

Even although you may have taken on loads of fluid both before and during your ride, you should also continue to drink after your ride has finished. Drinking water post-ride will also help to flush out the toxins and waste products produced during exercise.

poor technique caused by a lack of concentration can spell disaster for a competitive rider.

You need to drink little and often, whether you feel like you need a drink or not. By the time you're thirsty, it's too late and dehydration has already set in. In hot conditions, fluid loss through sweating will be greater so you need to carry more fluids with you and drink much more than you would on the same ride in different conditions. Cold weather can also stop people from drinking enough. The cold can act as a diuretic, causing you to go to the toilet more often, and losing more fluids. Waterproof clothing and thermal layers can also cause you to sweat excessively. Bear in mind that regardless of the outside temperature, the more you sweat you more you need to drink.

What you drink should reflect what type of riding you are doing. When you sweat you lose electrolytes and water. Therefore, to replenish these lost minerals quickly try an electrolyte or hypotonic sports drink. As these fluids contain less particles than the blood they'll be absorbed easily. This is great if you need to hydrate quickly (for example racing in high humidity) but these drinks don't contain much energy. Adding carbohydrate will provide a good fuel source but the higher the con-centration of carbohydrate in the drink, the slower your stomach will be able to process the fluid. An isotonic drink, one that contains the same number of particles as the blood is best for both fuelling and hydration.

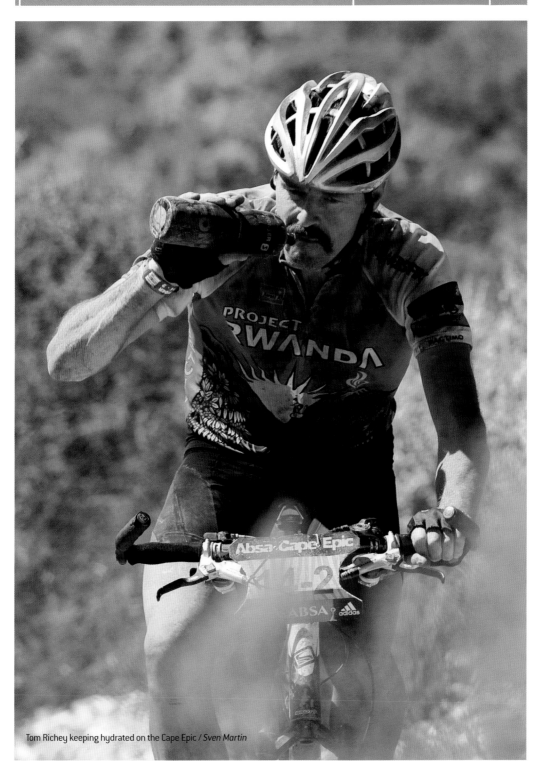

Tom Richey keeping hydrated on the Cape Epic / *Sven Martin*

CARBOHYDRATES

Carbohydrates are your main energy source for longer rides and should make up the best part of 50/60% of your total food intake. You need to choose what type of carbohydrate you're consuming and understand how the timing of the meal might affect your riding later on.

The two main types of carbohydrate you need to think about are complex and simple. To get the maximum out of your fuel, you need to balance the intake of these two carbohydrates and know when to use each type to gain the most from them.

Eat a complex carbohydrate rich meal about 2/3 hours before you go for a moderate to long ride to fuel up. Unlike complex carbohydrates, simple sugars are digested very easily and provide a quick energy source. If you are already out on a ride but you feel completely blown and you need to get home, a sugary sweet will give you that quick kick you need for the final push. This can also work well for downhillers towards the end of their training day when they only have one run to go and need to be sharp.

There is a downside to consuming only simple carbohydrates. The blood sugar spike caused by the sudden influx will be swiftly met with an insulin response that causes a slump in energy as your body desperately tries to control its blood sugar levels. These peaks and troughs will do nothing for either your energy output or your concentration. Particularly in downhill, where I've seen many riders struggling with fatigue following a day of consuming sugary snacks in between training runs.

For longer endurance riders and those looking to lose weight, make sure you don't just focus on carbohydrate. Teaching your body to burn fat as a fuel is equally as important.

FAT

Fat isn't always the evil ingredient it's made out to be. Sure, some fats, including Trans-fats (the man made ones) and the saturated fat found in some foods aren't good for you. The list of negative effects that these fats have on you is pretty long and includes heart disease and obesity. However, there's a growing amount of research to suggest that monounsaturated fats and Omega-3 fatty acids found in lean meats, nuts and oily fish are beneficial.

Carbohydrate alone is unlikely to provide adequate amounts of energy for longer rides, so you can use fat to supplement the fuel supply. Per gram, fat provides the most energy of any macronutrient and we can all store more than enough fat for hours of low intensity exercise.

Getting the benefits of fat for energy lies in the quantities in which you consume it. Think about including more free range meats in your meals, missing out on the

Eat well before you go out on a ride (left) and take a few snacks to keep you going (above) / *Victor Lucas*

fried bacon sandwich for breakfast, cutting back on pre-packaged foods and using more spreads and olive oils in your day-to-day diet.

PROTEIN

Protein has a multitude of uses for mountain bikers. From rebuilding damaged muscle tissues, to supporting your immune system.

Your diet should include about 20% protein from lean animal meats and dairy products. Vegetables will provide some protein too but vegetarians beware, it can be very difficult to get all of the amino acids you need from vegetable based proteins alone.

Some riders take protein supplements. Drunk along with carbohydrate, protein can be very advantageous to recovery rates, particularly following a weights session or a very tough, damaging ride. Adding muscle

bulk isn't always ideal though and riders should think about their power-to-weight before beefing up their lean mass.

Jaymie Mart has seen the effects of correct protein intake before. *"Throughout the season, it is common for riders who are travelling or increasing their energy expenditure to experience a loss of muscle tissue. This can lead to decreased power and bad results. Most cyclists will require between 1.2g and 1.4g per kg of body weight per day. 1.2g/kg/d is recommended for endurance athletes to maintain mass and up to 1.6g/kg/d for power athletes who aim to build mass".*

One word of advice though - as your body can't absorb much protein in one go, spread out your protein intake over the day. Try breaking down your total volume into 20g chunks and leave around two hours between each feed.

HEAD GAME

A strong mental attitude is just as important as technical ability and physical fitness. Just like your body, your mind can also be trained.

Your state of mind will have a major impact on what you can achieve and the enjoyment you gain from doing it. Confronted with a difficult section or faced with a sudden crash-crisis, a confident, motivated and focused rider may see a way through the problem, calmly spot an escape route and ride-out the tough part. Faced with the same situation, someone lacking in confidence may tense up, exacerbating the problem and increasing the chances of a crash ten-fold. Or just bottle it.

Some riders think that sports psychology is only a last resort for losers. This attitude is naïve and just plain wrong.

IT'S EMOTIONAL

No matter how honed your skills or fit your body, you need a strong mind too. Once you've learnt to adopt it, the correct mental attitude becomes self-reinforcing: confidence boosts performance, which enhances confidence and increases your motivation to try even harder.

Remember, if you're a competitor, when all other things are equal, it tends to be the more confident athlete that takes the win.

Josh Bryceland, in the zone before tackling the DH course at Mont St Anne / *Victor Lucas*

MOTIVATE ME

Motivation can be the push to get you to the top of the climb first or provide the extra confidence you need to try and nail that trick, even though every other time you tried, you crashed hard. Motivation to get out of bed early if it is cold or wet or you're tired from the previous days antics. Motivation to drag yourself back from injury and persevere with mundane rehab exercises when all you want to do is get out and ride.

Hailing from the UK, **Tracy Moseley** knows as much as anyone how tough it can be getting motivated to go out in the cold and wet. *"Yeah, there can definitely be some low times and moments when you wonder why you put yourself through it, but for me it's the belief that I can do better and the moments of victory. Those emotions you get from winning are what can drive you to keep going and doing better. It's a challenge and if it was easy everyone would be successful so you have to accept that you will have to take the good with the bad to be successful."*

The first step is to understand what motivates you; whether it's completing an event you haven't done before, winning, or landing a trick because none of your buddies can do it.

Next, aim to set up an environment that'll inspire you as much as possible. Try riding with a more competitive bunch or look to find something to aim for. You may have more than one motive, this can be advantageous in many respects, so don't feel like you only need one reason to do something.

Be positively motivated. Rather then doing something to avoid failure, find something that you can excel at. A positive frame of mind will really help to build confidence.

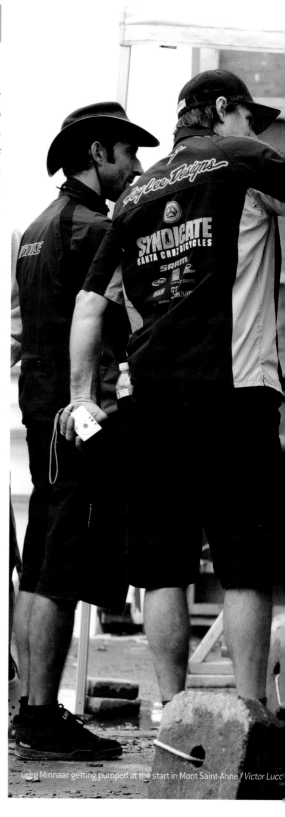

Greg Minnaar getting pumped at the start in Mont Saint-Anne / *Victor Lucc*

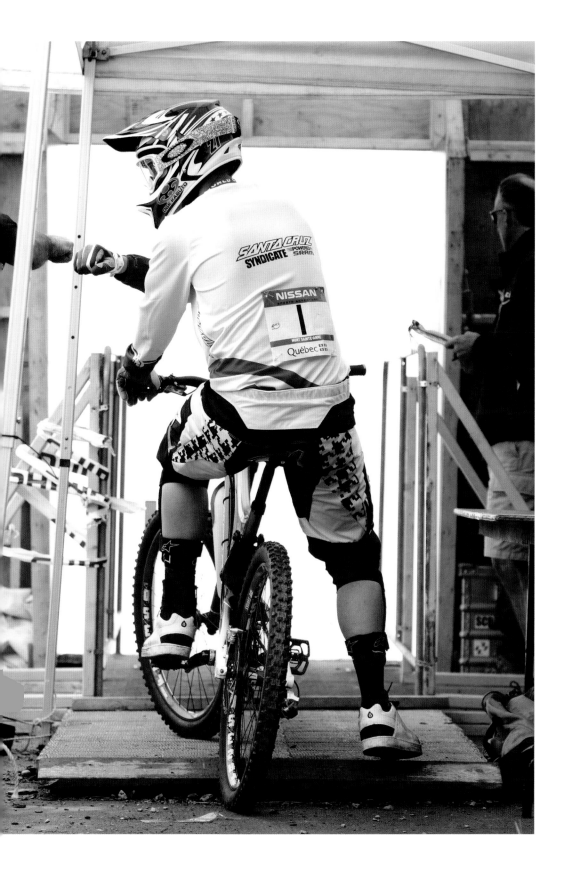

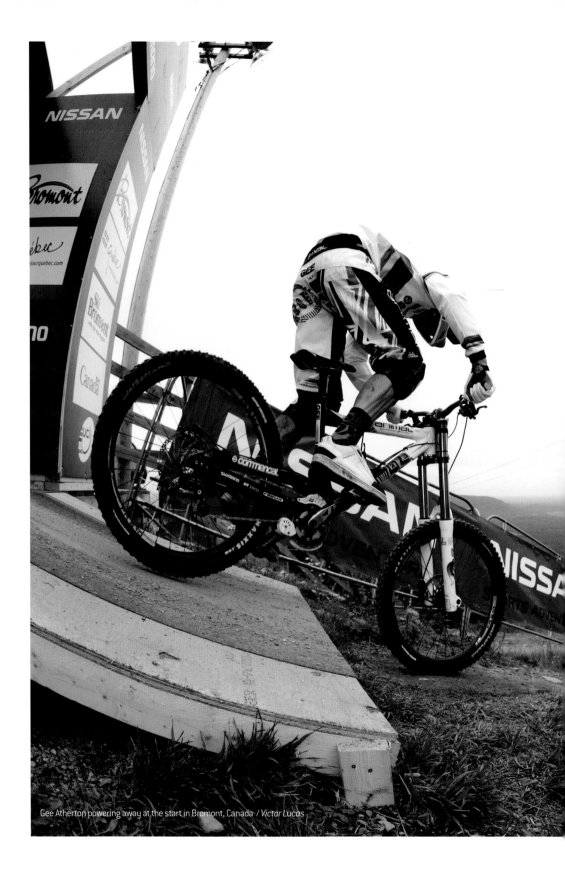

Gee Atherton powering away at the start in Bromont, Canada / *Victor Lucas*

If for you, mountain biking is pure pleasure, or simply a means to get some exercise, motivation can be used in other ways. It can help you ride a few miles further, clear a difficult section of trail that's been defeating you or clear a bigger jump than you have attempted before.

Riders who are passionate about the sport and their competition programme usually have a work ethic strong enough to see them through the rigorous training schedules and everyday commitments that may mean missing out on something that friends or relatives may be doing.

GOING FOR GOALS

Goals are one of the fundamental aspects of sport psychology. The first thing any psychologist will ask you is, "What are your goals?" If you know what you want to achieve you have a chance of getting there. Whether it's World Championship gold or to get fit enough for a 20-mile ride, if you don't know exactly what you want, how will you ever achieve it?

Be careful to set realistic goals though. Even Olympians have said that aiming for something four years away can seem unachievable. Knowing the individual steps to achieving your main ambition makes it seem plausible on a day-to-day basis, so break down your ultimate ambition into bite-sized chunks.

Even if you just ride with the Sunday morning bunch, give yourself a goal a ride. By breaking it down this way, you'll suddenly find that with little effort, you've started to overtake your mates, or you're pushing them to try and ride a trail that you all deemed too difficult before.

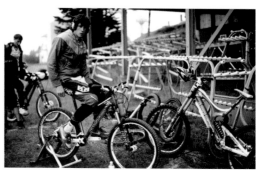

IT'S NOT JUST THE OUTCOME

The main types of goal that riders tend to set themselves are outcome goals. You may want to get gold at the Master's World Championships, win a local race or just for once, to be the first out of your mates to reach the top of a steep hill climb. Outcome goals are good because long-term plans can be used to motivate you in the short term. For example, remembering how it felt to win a race may inspire you to train hard in the off-season to experience that success again.

On the downside, if you only look to the future and set a specific target for yourself you may start to lose focus if you encounter setbacks. You may have the ride of your life, yet be beaten on the day by someone who just went faster. There's no advantage in worrying about things you can't control - as you can only control your own performance make that your primary focus.

PERFORMANCE TUNING

Set yourself goals that allow comparison as you progress towards them so you can compare yourself against your own previous achievements. You can then find additional motivation by bettering your personal best. It will help you build a positive mindset that drives your riding development, no matter what level you're at.

PROCESS THE THOUGHTS

Think only about the task in hand. Let's say you want to win a race and your cornering always lets you down. Start to analyse each corner as it comes up. Identify your weaknesses: if it's braking too much, then a positive thought like *"Look for grip in the turn"* will help you improve. Concentrating on individual aspects like this is identifying "process goals".

A cross-country coach once said to me that it seems as though downhillers see things happen in slow motion. Having thought about this comment, it seems as though downhillers don't see less, they just know what to look for and what trail obstacles aren't worth worrying about. Consciously or subconsciously, they have set themselves a series of process goals that get them from top to bottom as fast as possible. For any technical and fast mountain biking, controlling and simplifying your thoughts will add clarity when there are hundreds of things trying to distract you. Set yourself process goals and don't get distracted.

Above left to right:

Steve Peat in the start gate / *Victor Lucas*

Josh Bryceland pre-race prep in Mont St Anne / *Victor Lucas*

Josh Bryceland / *Sven Martin*

Steve Peat and Greg Minnaar warming up in Bromont / *Victor Lucas*

CONFIDENCE, CONFIDENCE, CONFIDENCE

Confidence is key, and how you build it is something all riders should understand. Don't think that confidence is something you either have or not, you can work to get your mindset right. Learn the fundamentals and over time you should be able to put yourself in a better mindset. Then you can reap the rewards out on the trail.

Once you start reading the technique sections of this book, it'll become apparent that you'll need to be relaxed and focused to perform most of the riding skills. Add competition and you jack up the pressure. The amount of self-confidence you have will directly affect your focus, how relaxed you are, how anxious you are and ultimately, how successful you are.

START SMALL

If your target is to nail a 360° flip-whip off a fun box, to drop a steep, loose, rocky chute or to nail the slippery root section in your local woods, start easy. If you go big too early you might crash and this might dent your confidence. Choosing goals that are tough but achievable will help you to push yourself, yet with a positive frame of mind. Collect a few successful attempts at something within your current abilities, then start to progress.

SEEING AND HEARING

Watching someone else is an excellent way to learn. If you ride with someone who has already mastered the skills you seek, don't be afraid to ask them to show you how they do it. The more aware you are of how a skill should look, the easier it'll be to learn.

Once you know what you're meant to be doing, imagine yourself doing it successfully. Creating a mental picture is a powerful tool often advocated by sports psychologists. Not only will visualisation help you to learn the skill, it should make you more confident about actually attempting to nail it out on the trail.

Intense team plans for the World Cup in Schladming / *Victor Lucas*

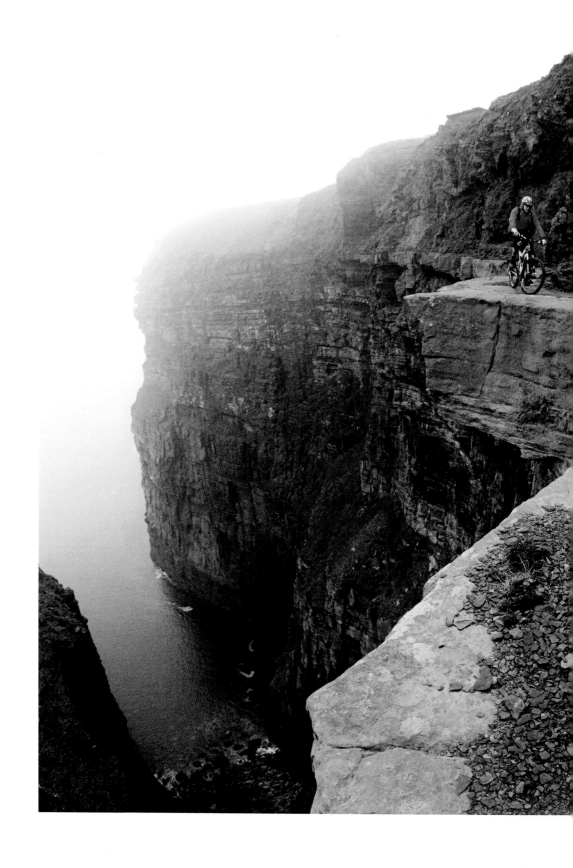

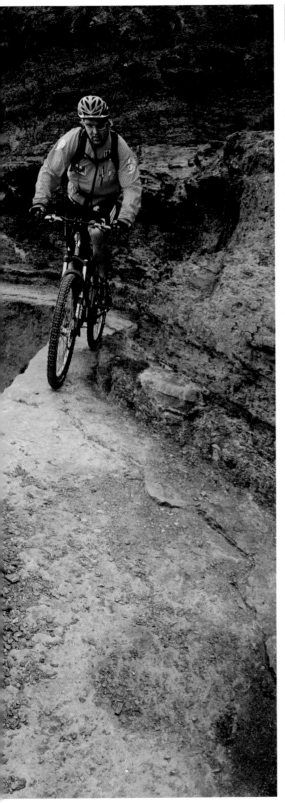

DON'T DOUBT IT

Staring at a slippery root section and telling yourself you're not going to clear it is usually a self-fulfilling prophecy. Self-doubt and anxiety creates physiological changes like muscle tension. If you are stiff and tense you are more likely to crash. It's a vicious circle. You didn't think you were going to make it, you didn't make it and now you'll probably be even less confident the next time you see that stump or root or jump again.

How you talk to yourself can speak volumes. Keep every thought positive and encouraging. For example, rather than telling yourself "don't brake" think "find grip" or "let it roll". It sounds so simple but it really does work. Self-talk used correctly can work wonders for your motivation, confidence, enjoyment and will have a real impact on your success as a rider.

If you are having difficulty with a challenge and self-doubt creeps in, think back to something that used to catch you out, but you now breeze through. If you could do that, what's stopping you doing this? Well most of what's stopping you is in your own head. With positive self-talk and an ability to visualise yourself clearing the section; situations like this will become easier. Stay positive and your self-doubt should diminish. As your ability increases, your confidence should too.

Steve Peat and Hans Rey showing no fear in Ireland / *Victor Lucas*

PERFORMANCE

Victor Lucas

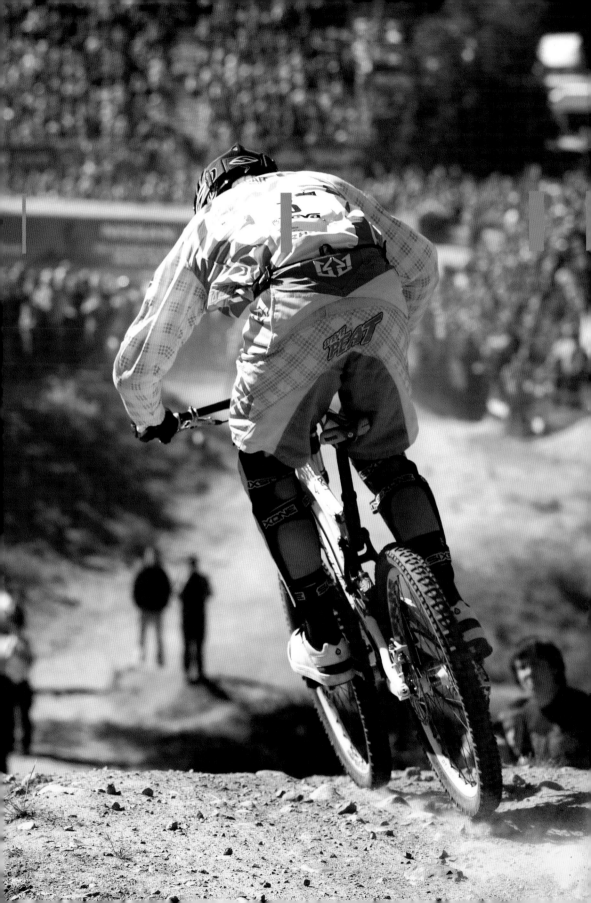

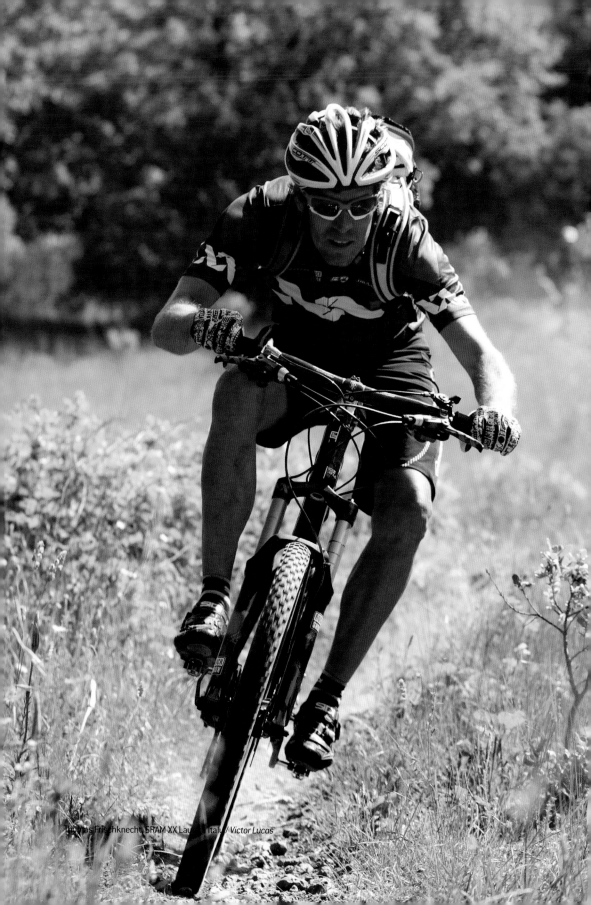

Thomas Frischknecht, SRAM XX Launch, Italy // Victor Lucas

FLOW
Flow is where it all begins.

If you watch any of the greats, their bikes and bodies work seamlessly with the terrain. For these men and women, riding never looks like a fight. Well, not usually anyway. There are a few key techniques to developing a flow and carrying your speed through a section or along a trail. Once you've mastered each one, riding at 80/90% should start to feel effortless, as you learn to use the trail to your advantage.

Harmony isn't often a word associated with mountain biking, but that's what you should be looking out for. Next time you're watching the World Cup or your favourite riding film, check out how the top athletes seamlessly blend each section into the next. Their speed never seems to diminish; with each turn, crest or jump they find more momentum from somewhere and flow on.

For a lucky few, transferring what's happening underneath the tyres into smooth forward movement comes relatively naturally. For the majority of riders though, it's not so simple. It's far more common to see people heaving their bikes over the jumps or struggling to accelerate after a tight switchback has killed any chances of carrying speed into the next section of trail.

IT'S ABOUT TIME

To flow, you need timing and for timing you need to anticipate. Keep your head up - think about what is coming next and how the section you are on links to the next. Practice trying to maintain flow from one section to another. Take it one step at a time but as your riding progresses, try linking different stuff together, from a berm to a drop-off or a jump into a switchback. A lot of the techniques of keeping your flow are the same no matter what sections you are moving between.

FIND THE RHYTHM

I've yet to see a mountain biker that makes a good dancer, but you've got to have rhythm if you want to dance down the trail. Rhythm and timing are inextricably linked – it's not just enough to know when to act, one movement should smoothly lead to the next. The dirt jumpers amongst us will already be fully aware of rhythm and how important it is to making it over the next gap. It's not by chance that lines of doubles are called rhythm sections. Find the beat on the first couple of lips and you're laughing all the way to the last transition. If you miss-time one, by coming in too hot or even too slow, you'll never regain that flow until you go back to the start and try again.

You may not be aiming to clear the huge jumps in Whistler or even the local dirt jumps, but any section of trail, regardless of how flat it is will demand some rhythm. And the faster the trail is, the faster the tempo you'll have to work at.

The Specialized rider, Olympian and 2008 Cross Country World Champion **Christoph Sauser** says finding and maintaining a rhythm is very important and to do it means combining several things. *"You need to carry as much speed out of corners as possible by having the right gear in place, looking ahead, keeping your arms and legs relaxed and by pedalling as long and smooth as possible. Riding like this you can preserve a lot of energy for free."*

BENEFIT IN KIND

For cross-country or enduro racers, being able to keep your speed through good, well-honed timing will save you vital calories. **Sauser** relies on the flow to catch his breath: *"If I'm stuck on somebody's wheel during a race, I'll relax and save energy on descents."*

Any energy saved can be burnt later, in the next big climb or a sprint to the finish line. *"If I'm trying to catch a rider, I'll keep my flow and push hard. Sometimes, I'm so full-on, I risk quite a bit."*

For downhillers, keeping your flow and therefore your speed through sections that are too rough to pedal, will gain you the tenths of seconds that'll get you one step closer to the podium.

Even if racing isn't your game, rides will be far more enjoyable if you can stay relaxed and not feel like you're fighting your way through each section. Instead, you will be working in unison with the trail: going with the flow.

World Champion Nino Schurter flowing around a corner with ease at the XC World Champs in Canberra, Australia

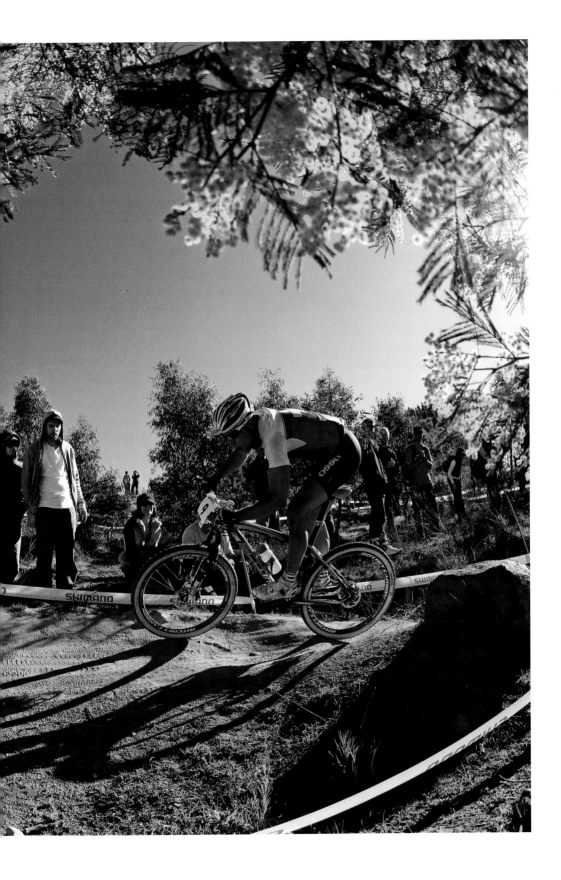

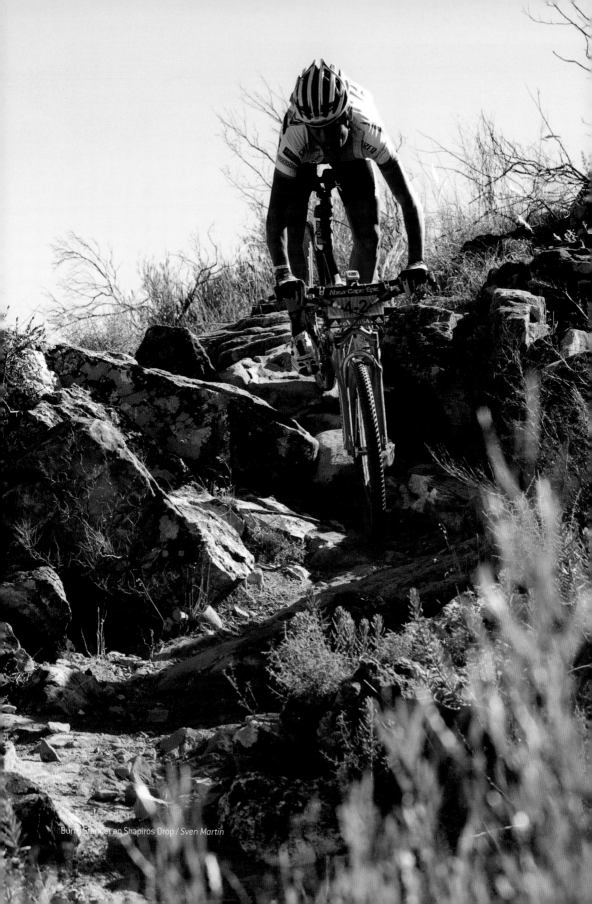

Burry Stander on Shapiros Drop / Sven Martin

BODY POSITION
It's not how you sit on your bike that counts, but how you stand on it.

Whenever you need to gain any control over the bike you need to be standing up. From this position, you can move pretty far in any direction - out to the side, over the front or off the back - and because standing is the foundation for all other movements, it's best to start off right.

You need to get your neutral position dialled in. This will become second nature after a lot of practice and it's well worth it. I remember someone once saying that this position looked a little like *"a hawk, poised for attack."* In many ways it is just that; finely balanced but ready for action or reaction.

Getting the solid standing position right really boosts your confidence. From this stable base, you'll be able to perform whatever technique is needed at the flick of a switch.

So, on a 70kmph downhill run, you can react like lightning to a rear wheel drift, or in a cross-country race you may have to snap-react to avoid a rock that the rider in front of you just threw onto the trail.

Whatever the scenario, being ready for anything all of the time will make your riding far slicker and safer. It can also be the difference between being at the back of the pack and leading from the front. Well known for his distinguishable riding style, the Multiple World Champion and World Cup winner **Sam Hill** agrees, *"I think everyone has their own style and different things work for different people but a neutral position is best to be able to make quick decisions on the bike to change direction quickly if needed".*

The more you learn to move from your standing base, the sooner you'll start to realise just how much space there is available to you. But let's just pull it back a step. Here's how to achieve that all-important stance.

CENTRAL PARK

On flat ground, park yourself so that your torso is over the middle of the bike. Don't be scared to put a bit of weight through your arms and hands. In fact, the more weight you can load onto you hands, the more aggressive you can be when riding. It'll give you stability and plenty of front wheel grip. Your hips should be hovering above

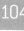
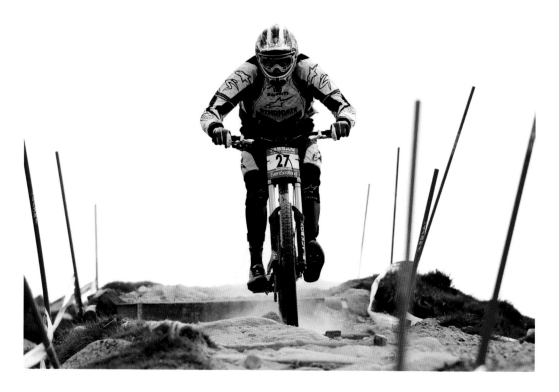

your saddle, supported from the pedals with supple yet strong legs. Keep your knees slightly bent so that you can both flex and extend with the changes in the trail.

HEAD UP

Throughout your entire ride you need to keep looking ahead - maybe even as much as five metres beyond your front wheel. For more technical sections that involve line choice and direction changes, looking where you're going is important to get your line right. For pumping and flow, keeping your head up will make it much easier for you to get your timing right. You might also find that keeping your chin up will have a good effect on your dynamic balance and how much stability you have when reacting and moving.

ELBOWS OUT

Have a look at most of the top downhillers and you'll see their elbows sticking out to the side. This position allows the rider to have much more movement in their arms before their upper body gets knocked off balance. Think of it as preloading the handlebars. The more poised you are, the more adept you'll be at taking on rough sections and taking control of the situation. Whilst highlighting the importance of your elbow position, **Sam Hill** thanks his motorbike. *"I used to race motocross when I was a lot younger and my dad would always tell me to keep my elbows up so I might owe him for that one."*

Your elbows should remain in the outward position whenever you're descending, although there may be some points when you want to change your position. On flat, long and open sections of trail, pulling your

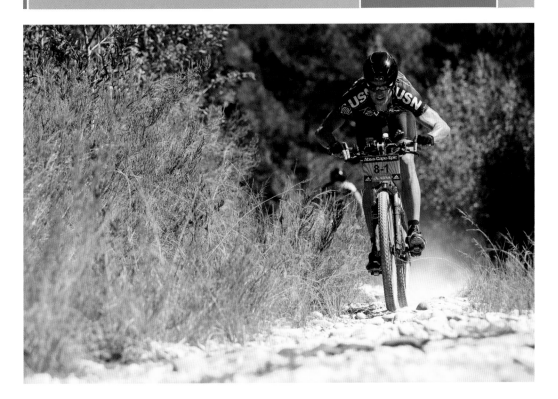

elbows in a bit will reduce your frontal area and help decrease wind drag. This may not seem that important but any energy saved can be used to make you faster elsewhere, so give it a go. For climbing, pulling your elbows in towards your sides will also help you to pull on the bars and move your upper body over the front end, keeping it down when the trails get steep.

FLAT FOOT, FLAT OUT

Your head is up, your knees are bent and your elbows are out. Now you have to make sure your feet are in the right place. Everyone has a favourite lead foot; it's natural. Whether it's your left or right, it doesn't really matter. What is important though is recognising which is your natural lead and making this part of your neutral position.

When the trail is flat, your feet should be too. Keep your pedals level so that they can dip left or right if need be to avoid any trail hazards or bank into turns. Dropping your heels slightly will increase your stability too; it is one of the simplest, yet least used techniques. Your centre of gravity will lower and even at high speeds on rough ground, you'll feel pretty steady. Dropping your heels will also give your knees a bit of extra flexion, helping you to move around the bike more and, if you ride flat pedals, the increased load on the pins will decrease the chances of your feet getting blown off in rough sections of trail.

Left: Head up and elbows out coming down on Ft Bill / *Sven Martin*

Above: Brandon Stewart during the prologue of the 2008 Cape Epic / *Sven Martin*

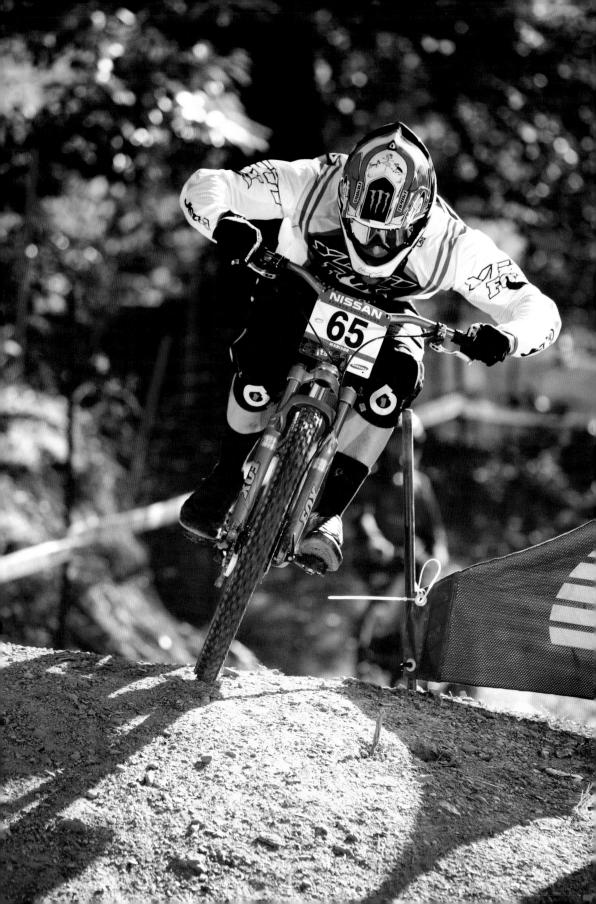

PUMPING THE TRAIL
A term that describes itself pretty well.

'Pumping' is an exaggeration of your movements, a method of driving speed from otherwise speed-sapping sections. Imagine you've snapped your chain and need to get moving, the thrusting and pushing you'd need to do is exactly what you need to introduce into your normal riding, snapped chain or not.

It's amazing how much speed can be garnered from simple, well-timed body movements. If you want to see it exaggerated to its full, watch some top level BMX or 4X racing. There are no better riders out there for dialling in this technique than the women and men who need to eek every little bit of acceleration out of the track. Watch their arms compress into the crests and aggressively push down their backsides. You'll also see their legs mimicking their arms. All in one perfectly timed, rhythmic sequence that mirrors the ups and downs of the track beneath their wheels.

Jared Graves, World Cup Maribor 2009 / *Victor Lucas*

DON'T PEDAL FOR PEDAL'S SAKE

As bikes are pedal-powered, it's hard-wired into your brain that to go forwards you have to push the pedals. Yet this isn't totally true - gravity can also be harnessed to fuel you forward. One downhill series in Wales had a chainless run as part of the programme and more often than not, the competitors were surprised by how close the times were to the runs when they could pedal. In fact, it wasn't uncommon for riders to go faster without a chain. Why? If you remove your chain, you're forced to pump the trail whereas, if you stick your chain back on, you regress back to the 'moving means pedalling' mentality.

If the terrain is rough and you're not getting much drive because it's difficult to time your pedal strokes, it's likely that you'd go faster if you stopped pedalling and started to pump the trail instead. Try a chainless downhill run. It's a good method of learning to pump. Pumping will in turn help your flow.

WELCOME TO THE GUN SHOW

Mountain bikers don't think about their arms enough. On a road bike, once you're in the saddle there's little left to do other than stay neat and tidy and turn your pedals. There's not much your arms have to do really. Mountain biking, on the other hand, (no pun intended) requires far more from your arms. The trail is rarely as smooth as the road and it requires more input from you. This means getting out of the saddle and supporting yourself on your arms. As the bike follows the undulations of the trail your elbows will need to extend and flex - those arms of yours are going to have to start working. They will need to work the whole ride.

When you come up to a steep bump that you want to pump, you'll need to lift the front wheel off the ground so that the front wheel is just above the lip of it. At low speeds try using a manual but some extra speed may need some extra effort so don't be scared to assist the lift with a slight pull. If the transition is a bit mellower, you might only need to un-weight the front end by lightly pulling on the bars. In either case, the key here is to use your arms to get the front wheel over the steepened gradient without letting it send you skyward.

As the front wheel comes up, you're going to want your head and shoulders over the front so you can start pushing through your arms at a split seconds notice.

As soon as the front wheel clears the lip, you need to start your push. The faster you're going or the steeper the transition, the more aggressive this will have to be. Let the movement be led by your elbows. Once they've bent, they then need to straighten out.

The more you can absorb the force, the faster you'll be able to hit it and still keep your wheels on the ground. Think of it as second-guessing the trail. It wants to send you into the air - you want to stay on the ground and gain some speed. Remember to maintain your aggressive body position throughout.

Get smart and think about every section of the trail ahead. There are more of these types of quick gradient changes out on the trail than you think.

A LOT OF LEGS

With your arms controlling the handlebars and the front end, your legs need to take command of the pedals and the rear wheel. The synchrony of the movement is important so practice timing your upper body and lower limb movements to work together. Just like you've done using your arms, you need to absorb the bump and force the rear wheel to track the ground. Match the force of your leg extension with the level of effort you made with your arms only hundredths' of a second earlier. It's your quadriceps that'll do most of the work here. A good way to think of it is by focusing on forcing your knees backwards and pushing your heels downwards as if trying to get them into the dirt. The acceleration you gain from this move will be mainly down to how well you control the back wheel. The more force you can transmit, the faster you'll go.

Jill Kintner showing perfect body position at the Sea Otter Classic / Sven Martin

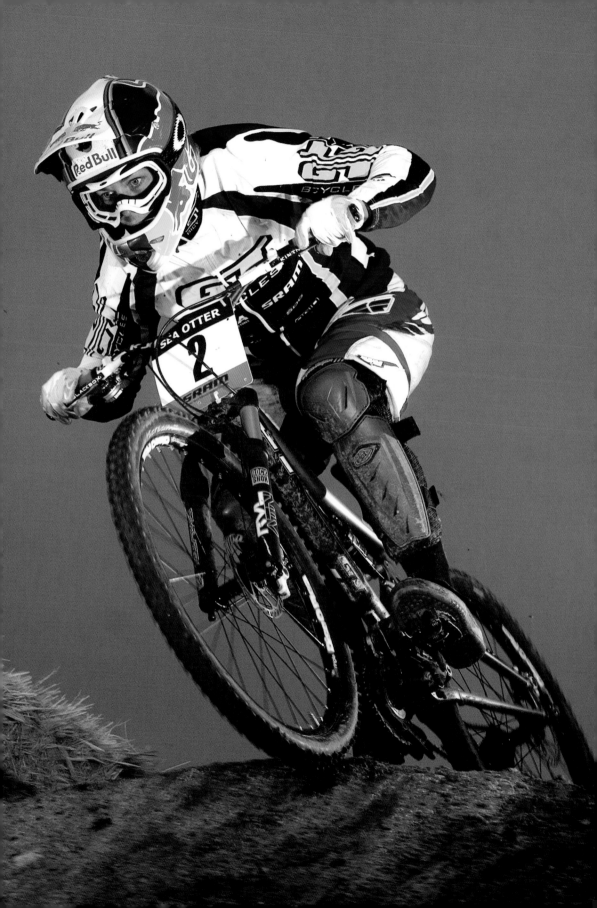

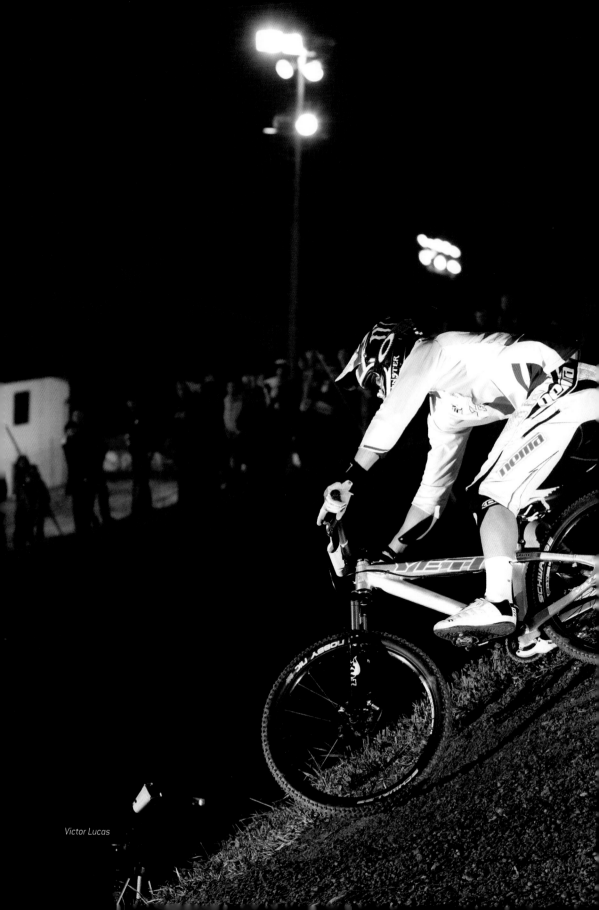

Victor Lucas

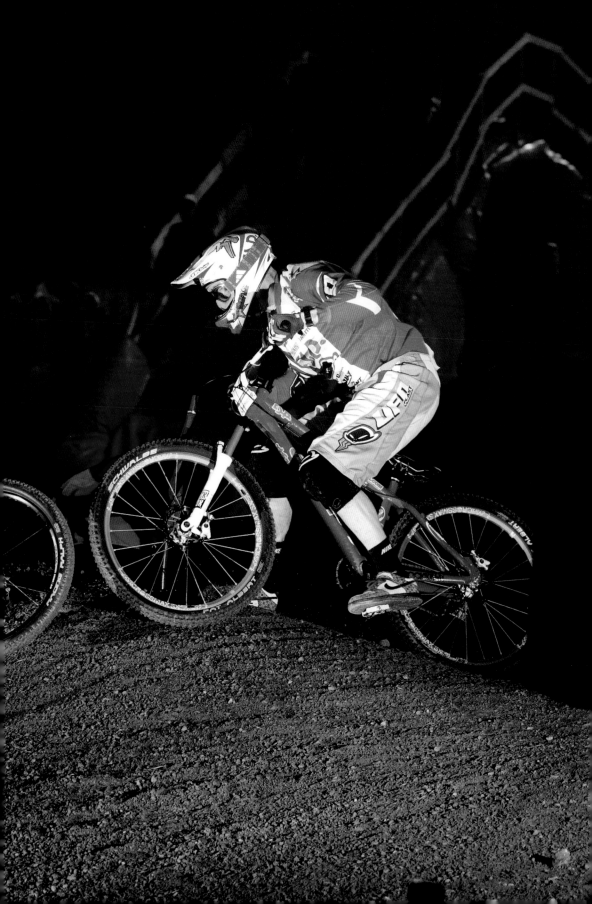

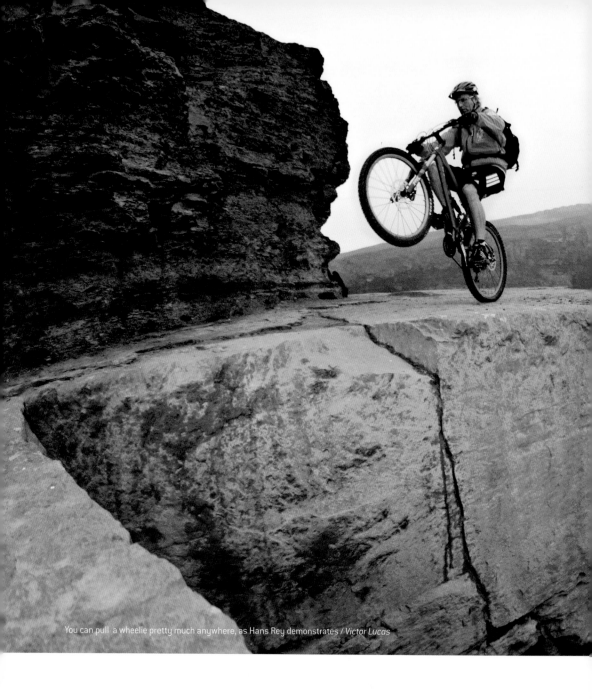

You can pull a wheelie pretty much anywhere, as Hans Rey demonstrates / *Victor Lucas*

THE WHEELIE
"Can you do a wheelie mister?"

Probably the most likely question you'll be asked by a bunch of kids at the side of the trail. Simply put, this golden oldie is the art of staying in your seat and using the torque of the pedals to lift your front wheel off the ground. It has developed some new names over the years, including my personal favourite, the 'power assisted lift'. But this move isn't likely to help your Gran get up the stairs.

Out on the mountain, techniques like the wheelie are rarely used on their own, but toned down, there are certainly some fundamentals that can be used to your advantage. From slow drop-offs to climbing rock steps - the more adept you get at these basics, the easier you'll find it when you need to pull something special out the bag in a tricky situation.

UPPER BODY

The position of your upper body is the most important aspect to get right if you want to pull a successful wheelie. To begin with, get totally balanced and central on the bike. With your bum in the saddle you need to form a square with your shoulders, handlebars and two almost-straight arms: a relaxed bend at the elbow is what you're after to keep you supple and loose.

Use this square as a reference point throughout the whole move. If you notice that one arm is squint, straighten it up. If your shoulders fall out of line with the handlebars, you'll never maintain your balance. Aim to get all of this sorted whilst you're still on the ground. The slightest mistake will be totally exaggerated once you lift the wheel, so don't lift until you're set and solid.

The wheelie is a little special: it's one of the only techniques that predominantly uses your shoulders (and the power from your pedals), but not your arms. Your arms are only needed to hold your body in position. It may sound strange that you can lift the front wheel without using them but it's something you'll have to get your head around.

Remain seated, lean backwards, keep your head up and those arms straight - and stay totally relaxed.

If you notice your forearms are tense and you're only keeping the front wheel up by pulling on the bars, start all over again.

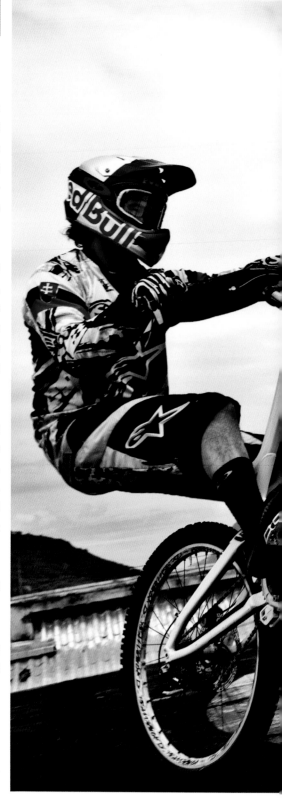

Filip Polc pulling a wheelie in Rio / *Balazsgardi.com / Red Bull*

TORQUE

The wheelie is a weight shift that uses the power produced at the pedals to provide the lift you need. This'll be where the name 'power assisted lift' came from.

Timing is of the essence: as you lean back, apply pressure to your lead pedal. Choose a gear that's easy to turn without too much grunt yet gives you enough resistance to produce some power. As the wheelie tends to be a low-speed move, it's likely your gear will be middle or small ring and near to the top at the back.

RESCUE BRAKE

Your rear brake is your escape route, your Get Out Of Jail Free card. The moment your front wheel rises too high, a quick but gentle pull on the rear brake lever will bring the front wheel back down to earth. If you are going for the wheelie world distance record, modulating the rear brake will help you to control the speed of the manual and keep it going for longer. Remember not to grab a handful. Just a gentle feathering of the brake should be enough to help you out.

WHERE TO DISH IT OUT

With wheelies mastered, you can now use them out on the trail. On a technical climb, if you're faced with a ledge or a lip, use this method of lifting the front wheel to get you up and over the step without losing balance or grip. You can also use it to get the front wheel over a steep-sided rut or ditch, or to come off a drop-off at a really slow pace by lofting the front wheel using some of the power from your pedals.

Whatever the situation, if you spend a little bit of time getting your balance on a flat surface, you'll be able to adapt the technique to suit the situation.

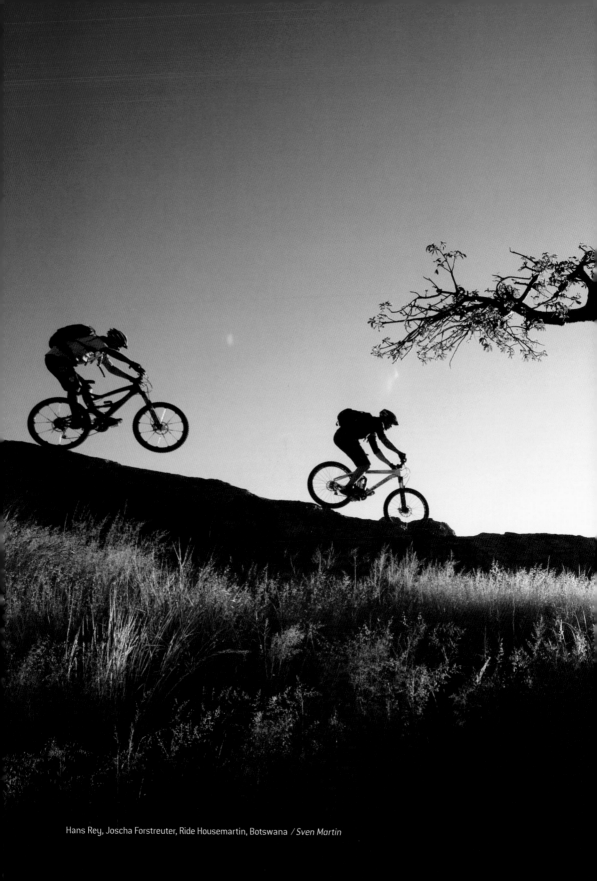

Hans Rey, Joscha Forstreuter, Ride Housemartin, Botswana / *Sven Martin*

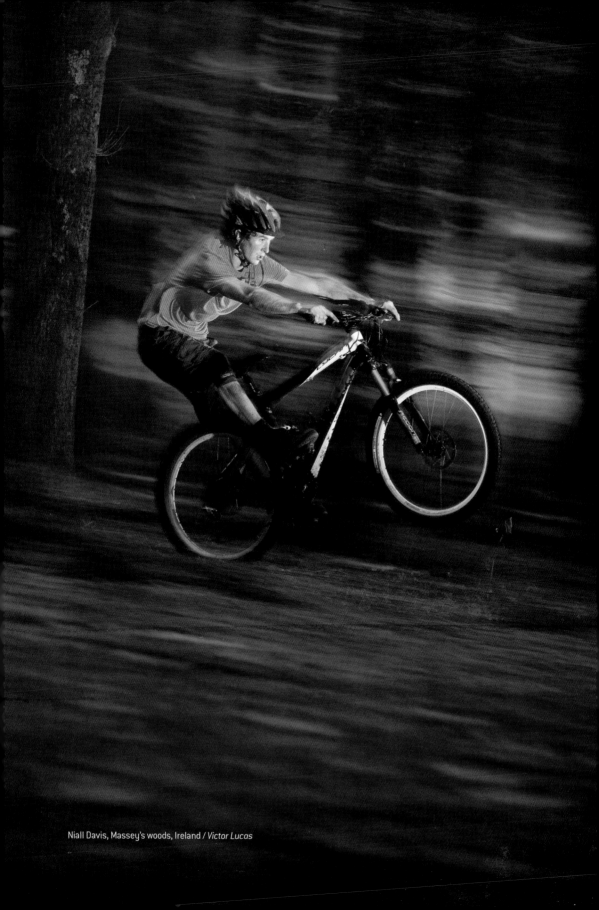

Niall Davis, Massey's woods, Ireland / *Victor Lucas*

THE MANUAL
So important we named the book after it.

The manual is one of those things that you don't think you need until you learn it. Once you have, you'll suddenly realise you're using it all the time and you won't know how you rode without it. If you can wheelie, the chances are that you'll pick this one up quickly. The trick is in realising that you don't need to be strong to do it; brute force can be left at the door. Instead, you need to use a body weight shift to lift the front wheel effortlessly with only momentum and impeccable timing.

The key is your body position: in a wheelie you sit and pedal, but the manual demands that you stand up and don't use any pedalling to hoist the front wheel into the air. It all sounds very simple really and to a certain extent it is. There are a few important ground rules you need to follow. If you can get these dialled, with a bit of practice there's no reason you won't be able to manual like Dan Atherton does down the first straight of a 4X.

CLEAN AND JERK

Make sure you are in complete control before you go trying anything. As the manual needs a quick shift of weight, stability is central to your success. To stay stable during the lift, get into your poised position - out of the saddle with elbows bent and ready. From this point you might want to start off with a quick movement forwards. Think of this part like pre-loading a spring. The more you compress the spring the more energy it'll bounce back with. Never stop moving throughout this process; any hesitation will kill all the momentum you have built up.

Like a pendulum, start to straighten out your arms as you move back, leading from your hips. Keep moving back with your arms straightening, and with a bit of work from your legs, the front wheel will have no choice but to lift off the ground. It's that simple. If

PRO TIP: JOSH BRYCELAND

Once you've got a feel for things and found where your balance point is, start using your legs for balance instead of the back brake. This is the key bit to maintain balance while you're cruising along on your back wheel. It's much more efficient when your bike is rolling at its own pace with no rear brake drag slowing you down.

that sounds a bit difficult to co-ordinate at first, just concentrate on moving your hips back and your hips only, then start thinking about the rest of the movements. It will start to make sense.

If your hips have moved so far that they're hanging over the rear axle, that's perfect. Now that you're there, keep your arms relaxed and think about hanging back off the bars. There's no need to be tense at all.

However, if the front wheel has dropped with a bang straight away, you may still be trying to lift it using your arms: an impossible task whilst your upper body weight is still over it. You'll struggle to manual for more than a bike length using this style, so relax, think about it, and try again.

THIGH MASTER

The momentum created by moving your hips backwards and extending your arms will take all the weight off your front wheel. But this weight shift alone won't get it to leave the dirt. You now need to recruit the lower half of your body into doing some work. Drop your heels and push forwards, and by contracting your quads you should start to almost push the back wheel under the front. It's this push that lifts your front wheel. The timing is tough to get right but once you find that synchronicity between your top-half moving back and your legs extending, you've got it made.

KEEP IT UP

Once the front end is airborne, your legs take sole responsibility of keeping it there. Use a pumping motion to generate speed if you need it. For example, if your front wheel starts to drop, straighten your knees and push it back up. Likewise, if you're heading off the back, bend your knees and bring your hips back in towards the

saddle. This will pull your centre of gravity towards the middle and start to bring the front wheel back down. With all this pushing and pulling, you might find you need to add a touch of back brake into the mix to keep your speed in check. By keeping one finger covering the back brake at all times, you can gently apply a bit of brake to slow you down or, if you've been over exuberant with the lift, drop the front wheel.

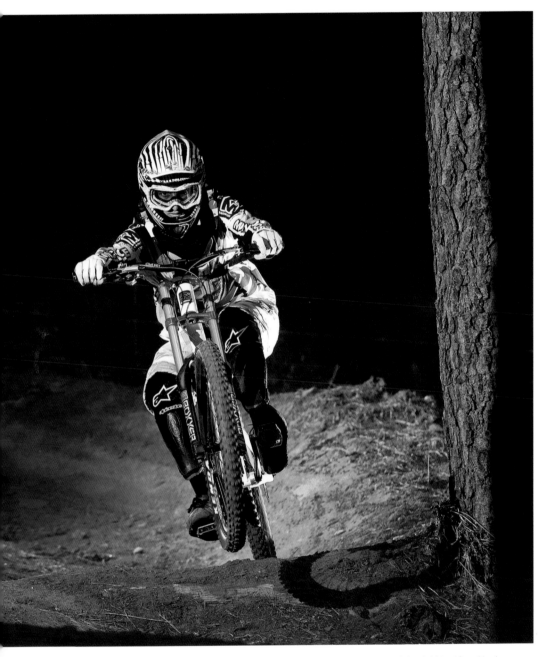

Andrew Neethling, Stellenbosch South Africa / *Sven Martin*

COMPRESSION RATE

Every time you come across a compression in the trail that's too tight to pump through, think of manualling it. Be clever and second-guess the drop by pushing with your legs. The aim here is to keep the back wheel pinned to the floor for maximum speed and control. This works through everything from World Cup 4X whoop sections to river splashes out in the wilds of Canada or a steep dip in your local trail. Remember, try and keep your upper body in the same position throughout. If you move forward, your wheel will drop, so to perfect the manual, practice til you can isolate all the movement to your legs only.

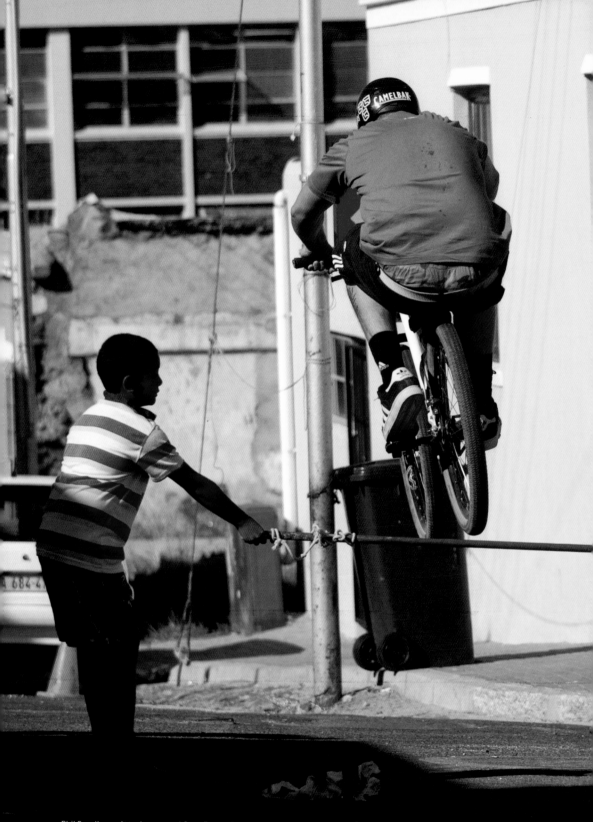

Phil Sundbaum hopping around Cape Town / *Sven Martin*

THE BUNNY-HOP
Everyone has heard of the bunny-hop.

It is often disregarded as a playground trick, but in various guises, it can be really useful. You don't have to be trying to clear the high-jump. From getting over a huge area of roots or skipping over a gnarly piece of trail on a descent, the simple bunny-hop truly does deserve its place within the core of mountain biking techniques.

Getting both of your wheels off the ground without the lip of a jump to assist you requires the same techniques that all World-Class downhillers use to 'go light' over rough sections.

Many people masquerade as bunny-hop kings when all they are doing is yanking on the SPD pedals. Of course it's easy - when your feet are stuck to the bike. But to really get it right, you need to use a unique combination of body weight movements, plus a bit of arm and leg activity thrown in for good measure. If you can't get the bike airborne using flat pedals, you can't bunny-hop.

PRO TIP: GREG MINNAAR

Practice makes perfect as timing is very important to getting it right.

FIRST STEP

If by now you can manual like a pro you'll understand this section easily. If you can't manual, go and read the Manual section page 119 and then come back to us. As we've said previously, you should be able to lift your front wheel without needing the strength of a bear. The bunny-hop adds a second stage to your manual. To begin, get your front wheel up in the air. Your hips should be off the back of the saddle and your arms should be straightening out. Imagine now that your weight has been completely removed from the front wheel and is entirely over the rear axle.

Your quick movement backwards will have generated some momentum that can now be transferred into getting the back wheel off the ground. It's crucial that you don't stop moving at any point. Whether you're going forward or backwards, as long as the energy you're creating is being maintained, you're onto a winner.

PLAYBOY BUNNY

Getting the back wheel off the ground is often the part riders struggle with the most. Imagine you're a bull scraping your hoof on the ground, awaiting the cue to chase your matador. That *"toes down, scoop backwards"* movement is exactly what you need to replicate in order to kick the back wheel up off the ground. The next problem is keeping the front wheel in the air while you're doing it.

You'll need to get the weight off the front end. To do it, your upper body needs to lunge upwards and forwards whilst your toes dip and scoop up the back wheel. It might help to think of the weight transfer as a manual in reverse.

To begin with this will probably feel pretty clunky. It's a lot to cram into such a small amount of time. Keep it going though because after a while it'll become second nature - your toes will hardly have to dip and you'll be able to clear ditches, roots or any other trail nasty with only the subtlest of movements.

PRO TIP: GREG MINNAAR

There are three ways to get out of trouble; your brakes will help you stop before you hit "it", you can lean back and wheelie through "it" or you can bunny-hop over "it". So it's an essential skill to have.

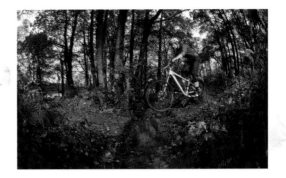

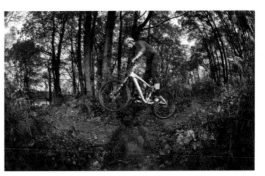

APPLICATION

We've mentioned that the bunny-hop can be used quite a lot. The more delicately and refined your technique, the more places you'll be able to use it. Try using a root to give you some extra loft, allowing you to gap the rest of the slippery section. The same could be said for short rocky sections that would need you to slow down if you were coming in too hot to roll through. **Greg Minnaar** suggests you also use the bunny-hop to *"get over logs and ditches or when you're tearing down a downhill and there's a sharp edged rock in the way - whatever lies in your path, you can probably hop over it"*.

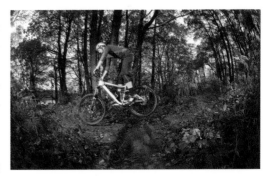

When you're on top of your game you should be adding some turning of the bars on the front wheel lift and some sideways hip movement on the rear wheel hop to get the bike moving sideways through the air. This can be used to set up for corners, especially if there's a steep crest or tight turn beforehand. You can also get the bike to move onto your chosen line super-fast and aggressively by adding this dynamic move into your riding. As **Cam McCaul** says *"If you need to boost a bit more height off a lip you can get the pop by using a bunny-hop."*

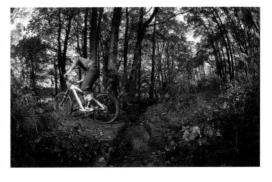

The author, Chris Ball, showing how to hop over a ditch / *Andy McCandlish*

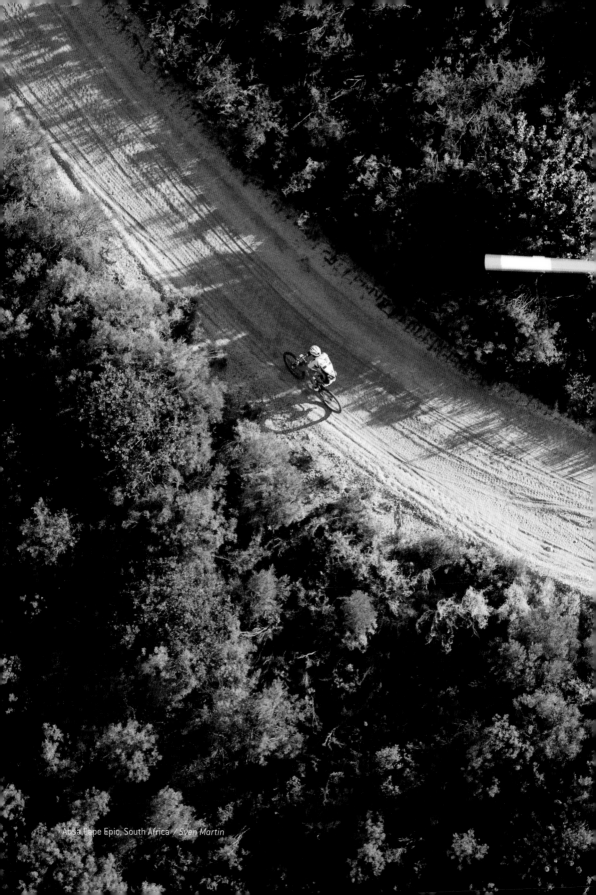
Absa Cape Epic, South Africa / Sven Martin

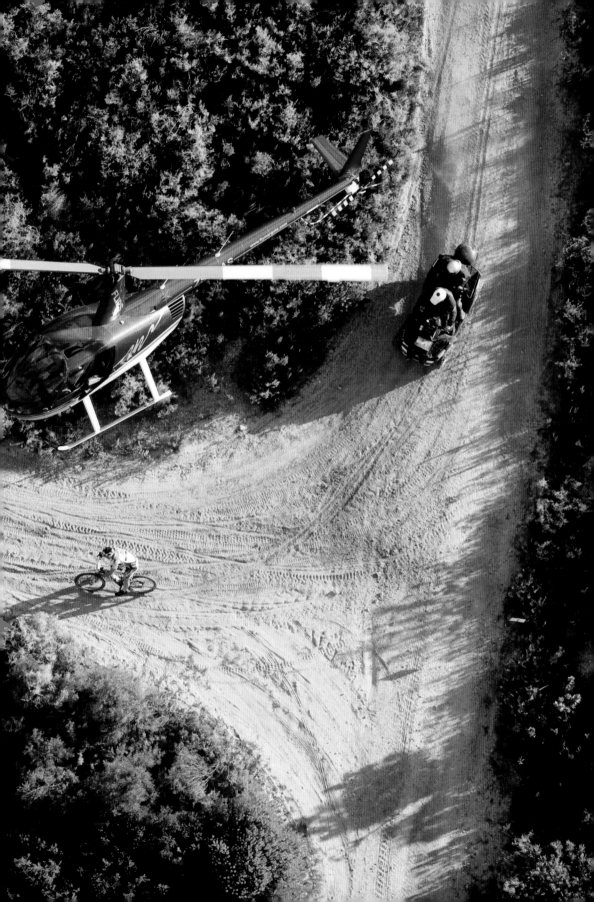

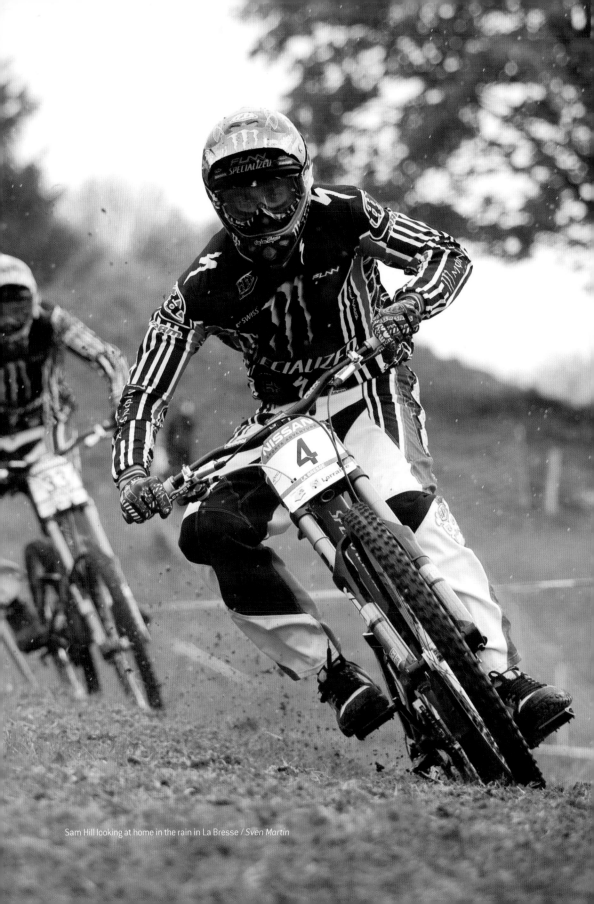

Sam Hill looking at home in the rain in La Bresse / *Sven Martin*

FLAT CORNERS
Flow is where it all begins.

Modern trails are becoming increasingly over-built and the good old flat corner is being replaced with berms, banked up at nearly every turn. This has had a knock on effect - riders rarely get the chance to ride flat corners and so are missing the key aspects to all cornering. Before anyone picks up a spade and builds a berm. learn how to hit flat turns right and you'll have all the right ingredients for taking on almost everything else.

The UCI World Cup in Schladming has a famous final approach to the finish that links huge, flat and steep grassy corners together. The skill and blistering speed of the final runners down this section is phenomenal. With two wheels drifting in perfect synchrony the sheer brutality of the whole thing is almost gladiatorial. Luckily, there are some core techniques you can do to get a bit of that world-class flair into your regular riding.

Ruaridh Cunningham is one of the fastest riders ever witnessed around those Austrian corners. *"As a 15 year old, I'd always watch DVDs and be amazed how fast the top guys were hitting corners. On the long summer nights I'd ride for hours just hitting a series of corners over and over again, getting faster every time. Each time I'd brake a little later or try and carve a little tighter. I would come back the next night and push it even further. At World Cups I'll do the same thing, so in Schladming, I pushed hard on those bottom turns in practice, even hard enough to crash. By race time though, I knew my limits and rode as close to them as I felt comfortable. I think the phrase 'practice makes perfect' pretty much sums this one up."*

HANGING BY A LINE

If you've ever watched Formula One you'll know all about the racing line and the concept of apexing a corner. Wet races are always the best to watch, as you see the track drying out, leaving a thin light strip that goes from the outside on the entry to a turn, right into the inside (apex) and then lazily back to the outside curb on the exit.

Take this apex idea as your textbook line. Obviously, mountain biking has a huge range of surfaces, corners and terrain, all of which will have an effect on your line. But this concept applies to the vast majority of flat corners so use it as much as you can.

Chris Kovarik follows this principle too. *"Entering the corner I would spot the apex and once I'm there I'll start making small adjustments to line up the exit and come out as fast as possible."* A big corner is a fast corner and the tighter you make it for yourself the slower it'll be. Stand next to the tapes at any World Cup race and you'll see the riders pushing out for as much space as possible on the entry to wide, fast turns. It makes perfect sense really: the less you have to steer, the less you have to brake.

Ruaridh Cunningham puts entry high on the list of essentials. *"Your set-up into the corner is key. For a start you need to know what line you're taking in the corner, what rock you're going inside or what rut you're going to hit. You should be able to come into the corner knowing where you want to go."*

PRO TIP: **CHRIS KOVARIK**

First off, I'll read the terrain either beforehand on foot or scan ahead as I'm riding and see if there are any sniper rocks or holes that might push me off-line in the corner, then I find the start, apex and end of the turn and plan my attack.

The Holy Grail of cornering is exit speed. More speed out of a corner will mean you'll enter the next section faster. This has a knock-on effect the whole way down a trail, reducing fatigue and decreasing times.

IT'S IN THE BODY

Once you're confident with your line and you're going in the right direction, your body position is next on the list. If you've ever watched a downhill skier, think about how they shift their weight from their hips side-to-side, to get bite at the ski's edge. Your riding should reflect this.

Try and keep your upper body as stable as possible. Keeping solid up top will make you far less likely to get bucked off by a big hit or deep compression. If you're a racer, a solid core will help and some strength training should be included into your regime. If you're just wanting to carry speed around a corner on your normal trail ride, think about keeping your chest upright and stable. The less movement the better - try and use your chest as a stable platform from which your arms and legs work. The more floppy you are, the harder you'll find it to control.

As one of the stronger riders on the circuit, **Kovarik** thinks there's time to be made here. *"Hold a strong line because the more wobbly and twitchy you are the more time and speed you're going to lose."*

Your elbows should be pointing out and absorbing all the braking bumps, allowing you to remain totally focused on the exit. Keep your head up and try and look as far round the corner as possible.

It's your legs that should be doing most of the work. Like a skier, pile as much weight and power onto your outside leg as is needed. Twist from the hips to shift more weight onto your outside foot if needs be. It's likely that your outside pedal will drop with that much weight on it. In fact, that's a good thing, dropping your outside pedal will give you more ground clearance and will promote a good body position.

BRAKES AHOY

Slowing down isn't always a good thing. If you've come into a turn way too hot, the first thing you might want to do is come to a stop, get off and vow never to ride again. However, try and make stopping your last option.

Braking creates a whole world of problems including loss of grip, tension and probably forcing you off line. It may feel like riding a runaway train but try and scrub your speed in a straight line on the approach. In the corner, braking will only upset your grip and position so start slow and build confidence. Once you realise how much grip there is when your tyres are left free to roll you'll never look back.

If you do need to kill a bit of speed, brake gently and feel for the grip. Once the tyres start to slide, ease off and let the bike search for grip again. Modulation like this will keep you on the trail, rubber side down.

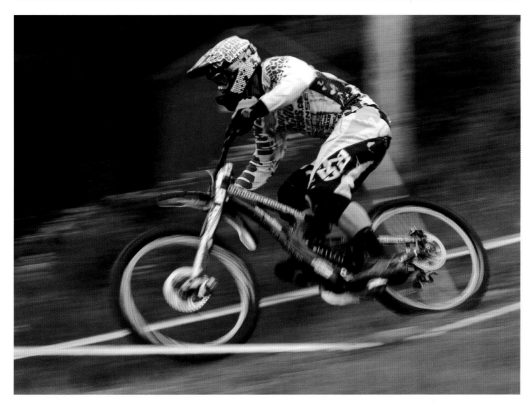

Chris Kovarik / *Sven Martin*

GRIPPING STUFF

Grip is the trick. Most riders get put off by the lack of the good stuff and don't ever build up enough courage to find the true boundaries of their grip. Equipment-wise, a softer suspension setting and lower tyre pressures will help you out if the amount of grip available is low. Remember, when you need grip, you need to stop braking. This will seem weird at first but if you see the light you're onto a winner. For flat corners, if everything's in order and you're still about to slide, hang your inside leg out. You might look like a motorbike speedway racer but it should give you that little bit of stability you need before you resort to pulling those brakes again.

As well as being team-mates, Kovarik and Cunningham ride quite similarly; it's the grip these guys find mid-turn that blow the others away. **Cunningham** says *"If you've*

done it right to this point the actual "carve" of the turn should be the easy part. From here on, it's just pushing your limits. Keep pushing harder until your bike starts to slide." **Kovarik** is quick to add: *"Don't be scared to drift as this is part of the fun on flat corners. Once you've learned the basics, there's nothing better than a fast, flat out controlled drift."*

PRO TIP: RUARIDH CUNNINGHAM

Come into the corner balanced right, braking or leaning into the corner. When you're off balance it's never going to turn out good. Braking before you enter the turn is key, think about entering slower and exiting quicker, it works for me.

BERMS
Berms are everywhere.

From the manicured perfection of the Beijing Olympic BMX track to the upper slopes of the Fort William UCI World Cup course, the abundance of berms now means that nailing them is an essential skill.

Think of a berm as an old friend. Rarely do they cause you grief; in fact their very presence should mellow you out. Hit them right, and they can add a whole new dimension of flow to your riding. A well-sculpted berm will allow you to change direction effortlessly and give you a bit of speed too.

The flip side is that if you're unsure of how to ride the steep sided bank, a berm can look pretty intimidating, as it rears out of the trail ahead.

Kyle Strait hitting a berm just right / *Sven Martin*

GO WITH THE FLOW

The best thing to do with a long shallow berm is to let it do the work for you. If the shape is right, the line should feel natural as the gradient holds you in place the full way around the turn.

If the berm is big and open enough for you to be able to choose where to go, try and follow the idea that the steeper it is the faster you can go. So, as berms tend to steepen as they rise, a slow pace may mean that you stick to the bottom whereas, flat out, you should be looking to stick to the steeper lip near the top. Even as you hit tighter and steeper berms, you should feel like the dirt is doing all the work.

Aim to make the corner as smooth as possible. If the berm tightens towards the end, adjust your line with it. Likewise if the corner opens up, you should be easing your line out to reflect that. The more consistent your line, the more stability you'll get and it'll be easier to start introducing more speed.

BRAKELESS

Brakes and berms don't really go together. In fact, the very presence of a berm should relax you and make you feel like you can keep your speed rather than having to slow down. To help with your confidence think of a berm as something positive rather than another trail obstruction. This mindset should stand you in good stead to railing the turn with prowess and skill. The first thing that'll happen if you pull on the brakes mid-berm is a sudden change of line. As you're trying to get your tyres perpendicular with the dirt, any braking force will start to pull you upright making the corner a struggle to get around. Like a flat corner, if you do need to scrub some speed, do it on the way in, while everything is still upright and there's plenty of grip available.

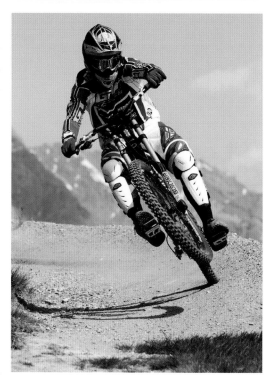

When you get into the berm, look for the exit. There's not much else you need to be thinking about. The further you can look around the berm, the more you will carry your speed. Once you are comfortable with the idea that the berm is your friend it will all become easier and you'll be able to relax and think of what to do next. Thinking a few steps ahead of yourself is the way to ride if you want to get really fast.

FRONT LOADER

With the bank there to support you, it's possible to put more weight on the front wheel than you could on less stable terrain. As you come into the berm, start putting more force through your arms, as if you're trying to push the front tyre into the dirt. The steeper the bank you're pushing against, the more weight you should be able to trust the front tyre with. It should all happen nice and slowly.

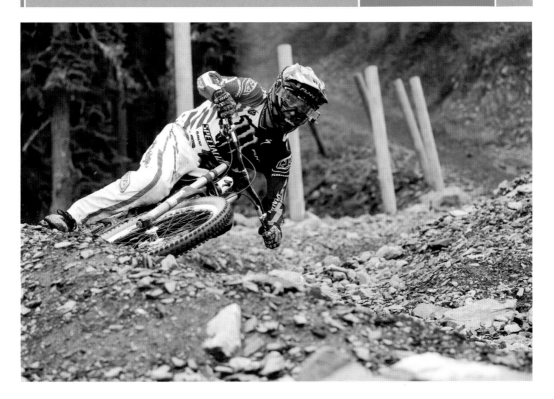

Remember that flow we spoke about. Riding your bike is a combination of lots of different moves happening together so always let the trail, the grip and your feeling dictate how much you're going to move. Load the front gently and progressively rather than all at once. It's only once you start riding like this will you truly be able to notice the difference between suspension settings and contrasting tyre treads.

ATTACK, ATTACK, ATTACK

As you get more confident with hitting berms without hitting the brakes, you can start pumping them for speed. It's incredible how much speed you can get from a berm and just how aggressively you can hit them. Ever seen the images of riders doing a power-wheelie out of a tight berm after hitting them so hard the end of their bar is almost scraping the dirt? Impressive.

To begin with, shift your weight forward just like you normally would. However, this time you're trying to coil a spring and generate inertia that can be unleashed on the exit. To do this push into the berm harder than before and as you reach the mid-point or where the berm starts to leave you, push the bike away, like you're trying to do a strange manual whilst in the turn. If you get the timing right, this quick shift in weight will give you a burst of acceleration that you will have never had before. It's one of these things that you'll know when you get it right.

Left: Power wheelie off a berm in Livigno, Italy / *Sven Martin*

Above: Sam Hill in full flow at Crankworx, Whistler / *Sven Martin*

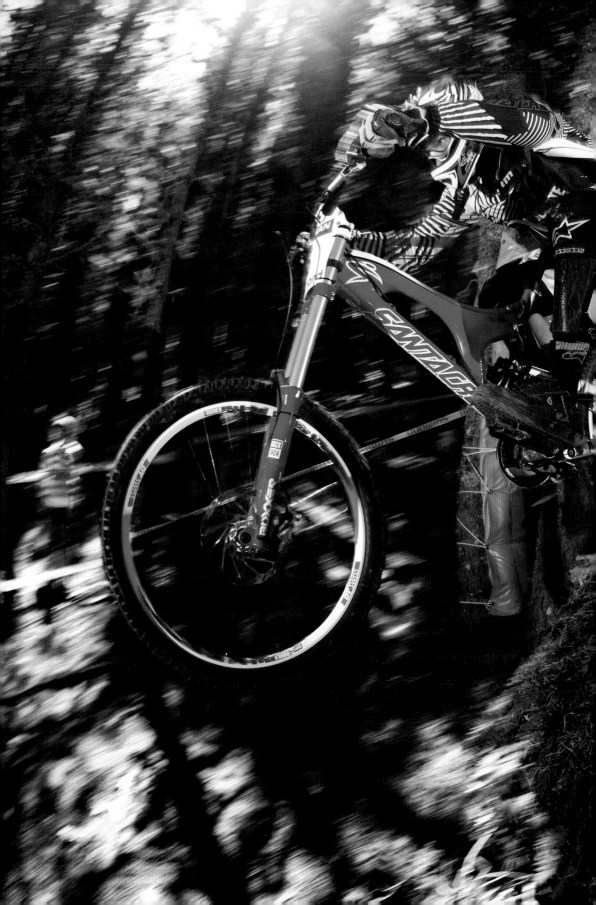

DROP-OFFS
Drop-offs come in all shapes and sizes.

To some riders, the only vertical drops to register on the scare-scale are those of biblical proportions seen in the Red Bull Rampage. To most mortals however, the little 1m step in our regular ride poses enough problems.

Here's the secret to drop-offs: there's actually very little difference in technique between your 1m step and those 10m monsters in the magazines. Technically, if you can nail the little ones, there's nothing to stop you dropping in from the top of your local quarry face. I did say technically. In reality, confidence and experience are the biggest issues when it comes to getting your bike off the ledge and onto the transition of a big drop safely and smoothly.

Although drops can seem very intimidating, there's less to them than you probably think. If you're new to the game, start small. Find something flat or with a mellow down-slope and a drop that's still small enough to roll without snagging your chain rings on. If it's sufficiently small, you'll have much more leeway if you bottle it at the last minute. It will also be more forgiving if you misjudge your entrance speed and come in too slow.

Greg Minnaar, World Cup Andorra 2009 / *Victor Lucas*

And bear in mind that the better you get on the small stuff, the more adept you'll be when it comes to handling the nasty surprises that some trails hide. Not every drop-off will have a nice, friendly run-out. You might find one at the top of a steep chute or midway through a super-slow section littered with roots or rocks.

By building your confidence gradually through progressive riding, it'll be far easier and more comfortable when you put yourself in the line up for a 10m behemoth.

As one of the world's top all-round riders, **Gee Atherton** has ridden his fair share of drops, from the small rocky ledges of Val Di Sole in 2008 where he earned his rainbow stripes - the mark of a cycling World Champion, to the red dusty cliffs of Utah where he stamped out his big-mountain credentials during the Red Bull Rampage. *"Drops are all the same basic technique and need to be broken down into smaller parts. For example, you need to consider the approach, making the drop, and the landing. Drops only really go wrong when your judgment is out, so if you come in too quick, it's all bad news, or if you nose in too much to a flat landing, you're going to have an equally bad time."*

THERE IS NO COMING BACK

The run-in is where it's often won or lost. If it's a new drop for you, take a walk and check out your line. This is especially important if you can't see your landing and need to know where to go. It can be worthwhile finding a reference point that you can see on your way in - the tip of a tree or something on the horizon that'll get you in the right direction before you drop. It's also worth checking out the size and whether or not you'll have to clear a small gap. Even **Cam McCaul** doesn't take things for granted and will check out unfamiliar drops. *"I'll do runs in four or five times to memorise where the landing is."*

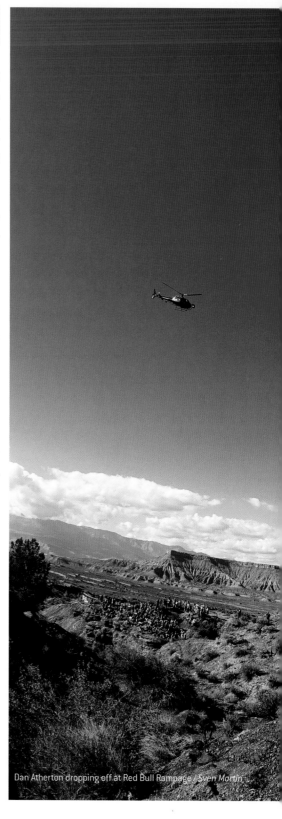

Dan Atherton dropping off at Red Bull Rampage / Sven Martin

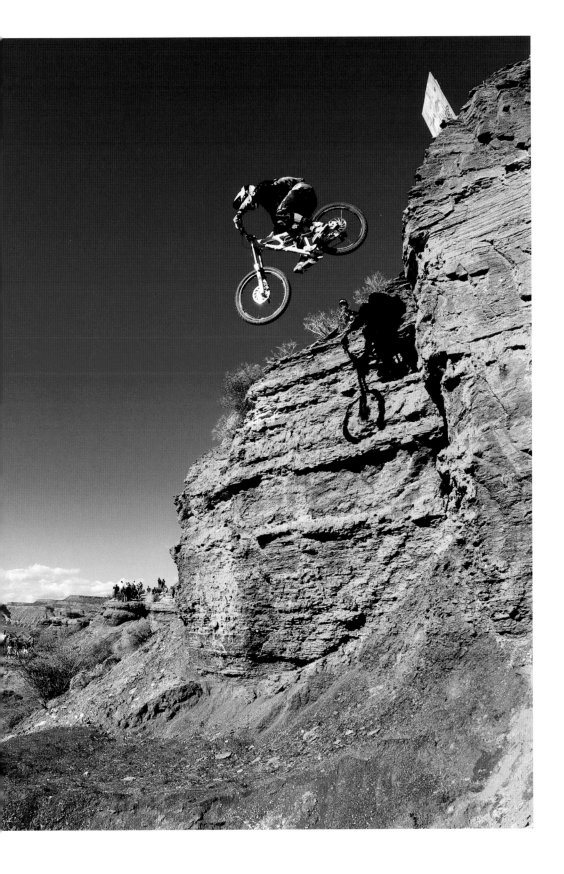

Knowledge is power and forewarned is forearmed. All this information will be needed to gauge your entrance speed correctly. Too fast and there's little you'll be able to do but brace for a head-banger on landing. Too slow and there's the risk of going into a nose-dive or coming up short on the gap - if there is one.

With a good idea of what you need to clear and where you're going, you should now be able to estimate the right speed needed for the drop. The worst thing you can do late into the run up is try and brake. Get your balance set and your speed just right a few bike lengths back from the lip. You're better accelerating off the drop than trying to slow up. With a few metres to go before you take off, get your pedals level and your upper body square. By now you should be able to manual so try and replicate the same set-up position - standing up, weight central, elbows out and bars parallel with your shoulders.

Look at the lip from as far back as you can to get your timing and position spot on. By this point you need to be 100% set on going for it. If you're unsure, stop in plenty of time and go back to the start. The last few metres of the approach are crucial to your success at landing the drop so keep it focused and relaxed. Think positive, look for any reference points and make sure you're in balance.

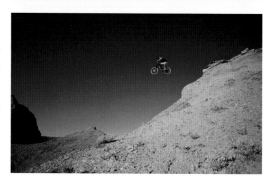

Sven Martin

WE HAVE LIFT OFF

With your approach mastered you should be reaching the lip with stability and balance. Being confident at the manual will save you a lot of grief at this point as the movement is practically identical. Watching any pro, it's obvious that they never really gain much height off a drop. Instead the bike heads outwards on the same trajectory as the take-off and heads for land as the rider moves their hips forwards again. Avoid any temptation to yank on the bars – you should never really go up unless there's a lip sending you that way. Leave the nasty, off-balance, straight-backed hucks to the other guy in the park.

Your front wheel should be lifting off the ground at the exact point the ground drops away at the lip. For slow, technical drops, it may be necessary to be far more dynamic and actually haul the front wheel up using a pretty big weight shift from the hips. Try to avoid moving upwards and instead replicate your manual by sliding off the back of the saddle and moving on a horizontal plane only. The lower you can move from, the more balance you'll have and keeping those heels down will add loads of stability. Keeping a low centre of gravity will be rewarded with a smooth and confidence inspiring performance.

PRO TIP: GEE ATHERTON

Always make sure you know what you're dealing with. Make sure you know exactly where the landing is and exactly what angle you want to hit it. Once you have all this dialled, make it your bitch.

TIMING

The timing of the whole sequence should be reflected by the size and location of the drop whilst taking into account the speed you're approaching it at. If it's a fast drop, the movement will have to be compressed into a fraction of second. The slower the approach, the longer there'll be to spot the lip and move backwards. Remember, the move comes from the hips and don't rush yourself into doing everything too late.

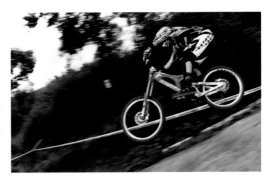

Greg Minnaar touching down in Pietermaritzburg / *Victor Lucas*

SPEED

The speed a drop can be hit at is down to the height and distance you can travel before landing. A low drop with a long mellow landing can be hit flat out, whereas the same drop with a steep landing and short gap needs to be approached slowly to avoid over-shooting the transition. Experience will prevail when it comes to adjusting your speed, that's why it's best to start small. The experience you gain from riding more and more drops will give you the knowledge you need to get it just right first time on the bigger stuff.

It's hard to judge your speed on blind drops. **McCaul** has this piece of advice: *"Always aim to shoot it a bit longer the first time and suck it up. Once you get it dialled in, you can then slow up and pop it to add tricks if it's that kind of drop."*

You'll find that the faster you start hitting drops, the less you have to do. Use the speed to carry you off the lip with only the slightest of weight shifts to keep the front wheel up. Momentum and flow should be your principle thoughts.

The flatter the landing, the less forward momentum you'll have and the more bike parts you'll break. Keep it clean and smooth by aiming for the down-slope where possible.

TOUCH DOWN

With both your wheels in the air it's time to start moving forwards again. As you moved your hips backwards on take-off, reverse the movement and bring them forwards again so you're starting to get a bit more weight over the middle of the bike. By landing with your weight off the back, there's more chance of losing it. A bit of weight through your arms will give you control and confidence when you touch back down on the dirt. The danger here is to get over-zealous and move forwards too quickly. You want to try and move slowly to avoid any unwanted nose-dives or front-heavy landings. In an ideal world, you should be landing as centrally on the bike as possible.

The more of the shock you can absorb through your arms and legs the better. It'll mean less stress on the bike, a smoother landing and it's likely you'll carry a lot more speed away from the drop.

Aim to land with both wheels at the same time to keep your speed and increase your ability to stay in total control after you've landed. If the landing is really flat, getting your back wheel to land slightly before the front will take the sting out of the thump. The emphasis should be on getting the back wheel down only slightly first though - a big nose-high landing can be both hard to control and feel seriously rough.

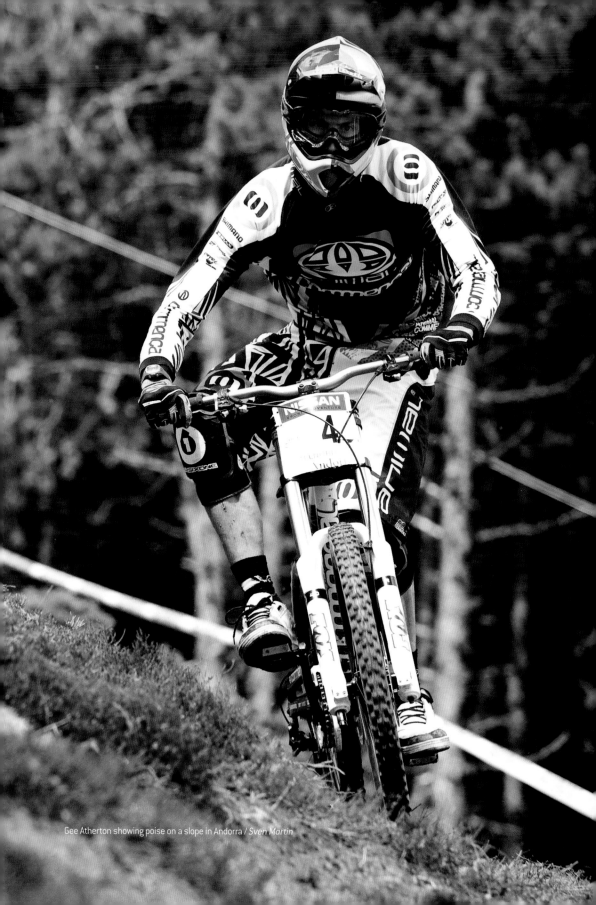

Gee Atherton showing poise on a slope in Andorra / *Sven Martin*

OFF-CAMBERS

The edge of control and sheer speed that the top guys are operating at is seldom shown more than on an off-camber section. The 2003 World Cup finals in Kaprun, Austria went ahead on a track littered with huge grassy alpine meadows during a week of torrential rain and storms. The wide off-camber pastures were like ice rinks, with just one foot wrong taking the riders right to the bottom of the slope and out of the running. Throughout practice, the sheer commitment, speed and measured aggression of David Vasquez, Steve Peat and Nathan Rennie was seminal. Where others couldn't let go of the brakes, these guys were cutting across fields like they were flat trails.

There was no way these guys were going to be slowed down by the awful conditions that weekend. For the riders pulling themselves out of the catch netting on every run, that race was an eye opener of how much grip there is and how fast you can truly hit off-cambers.

It was no surprise that Vasquez went on to win that day and Rennie took the overall World Cup title after a great season. Peat's precise, smooth and clinical style continues to dominate on the fast cambers of today's World Cup circuit.

Kaprun aside, the groundbreaker was to happen some four years later on the near vertical slopes of the 2007 World Cup in Champery, Switzerland. As a mid-afternoon storm decimated the super steep Alpine course, leaving only slick mud and exposed rooty off-cambers in its wake, one rider gave the rest of the world's top riders a lesson in how to hit this terrain. That day, the young Australian Sam Hill rode as though it was dry. His attack mode found grip where there shouldn't have been any and he placed a time that beat most of the guys who'd come down in the dry. That moment changed many people's perspectives on what can actually be done with a modern mountain bike. A lot of the younger guys, riding similar set-ups to Hill, suddenly found out just how far it can be pushed and that they would need to up their game to stay with the pack in the coming years.

Getting onto the fast lines that link the roots to the corners or the switchbacks to the jumps often involve riding off-camber. As the trail tries its hardest to push you aside, off the edge of the trail and off-line, being able to demand grip and carry your speed across a camber is a weapon that every top rider needs to have in their arsenal.

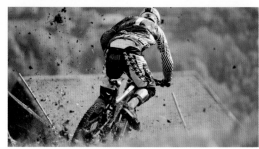

LINE

Your line is crucial when getting across an off-camber. It's always far easier to get up a camber than along one so choose a line that will fire you upwards. In other words, start low to finish high. If you come in too high, you'll be fighting for grip and balance the whole way and nine times out of ten you'll end up at the bottom wondering how the others are sticking to the slope above you.

The worst thing you can do is turn sharply on the camber. Instead, try to do all your turning beforehand, while grip is still on your side. On some trails, especially man-made ones, there may be a bank lurking on the opposite side of the trail to the camber that you can use to turn against, generating a pop that'll drive you to the top of the camber with speed and control.

As you start to lose speed, it's time to start looking for a way off. Your line should continue to rise up the gradient until you feel it's time to come off. An upcoming corner will either dictate this or a sufficient loss of speed will force you to start your descent. Either way, keep your line as simple as possible.

PRO TIP: STEVE PEAT

❛❛ Make sure you have the line set before entering the camber and stick to it. Look far ahead and go for it. ❜❜

SPEED

It was the sheer speed and commitment that let that a handful of elite pros do what they did that weekend in Kaprun. The pace Vasquez had through the most technical part of the course - a tight, tree-lined off-camber covered in slick, runny mud - allowed him to make it through unscathed. Other riders, approaching with less speed and way more apprehension were coming unstuck, unable to keep the tyres from sliding off the edge and into the nets. To a certain extent, speed is on your side here. Rather than trying to scrub momentum, try and use it to your advantage. The faster you can go, the longer you'll stay up high. **Steve Peat** agrees: *"Speed will help you get through an off-camber section more than anything else. You don't want to have to be putting a pedal stroke in while you're traversing. If your pedal clips the ground, you'll be flung off in a nice high side."*

BRAKES

With only marginal grip available, get intelligent with your braking. Try and keep your eyes on the end of the section and don't worry too much about picking up a bit of speed.

Use your brakes in two areas only. The first time, as you approach the slope, where you'll need to find something substantial enough to brake on. Whether it's a flat part of the trail or an opposing bank, look around

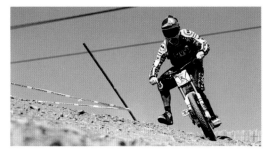

WEIGHT PLACEMENT

How you stand on the bike will have a massive effect on how much you can push the limits of your grip and speed. Watching tall riders like Peat, Atherton and Minnaar tackle off-cambers, it's clear that they're all legs and hips. The faster and more aggressive it gets, the more they'll use body language to keep the bike on course.

quickly and use whatever you can. As soon as the tyres start to head up the camber, the brakes are off-limits. **Peat** has this advice: *"Don't use your brakes, this will set you upright and drag you down the camber."*

So, any slight dragging or pulling of the levers will have you back at the bottom in no time. Listen to Steve, keep off the brakes on the camber and you'll find amazing amounts of grip out there.

Once you've reached cruising altitude and it's time to come down you can gently scrub the brakes a second time. This can help to initiate the turn and get you off the camber at the right time. A little tip though: try using the natural deceleration caused by the upslope of the camber to slow yourself down.

LITTLE CAMBERS AND TIGHT CORNERS

Sometimes just getting your front wheel wide for a corner will mean that you need to run the tyre up a tiny off-camber. If you're pushing hard and braking late, try and have more bias on the back brake to keep the front wheel biting in. If it's only a few feet, as long as the front wheel leads, the back wheel will follow, even if it's locked up and sliding in the opposite direction. As it became known in Rally, you can bring a little of their Scandinavian Flick technique into your riding.

Your head leads the way, so it should always be fixated on where you want to end up. A mate of mine has a saying: "don't look at the trees or you'll end up kissing them". In other words, if you don't want to go somewhere, don't look at it. With your head up and looking forwards, try and keep you upper body stable with your shoulders hardly moving an inch. Stability up here will result in a low centre of gravity and more stability at ground level. Drop your outside foot to match the severity of the camber and the speed you're hitting it at. For example, if you're clinging to the edge of a cliff-like slope your outside foot should be right at the bottom of its stroke with your heel pressed down for yet more balance. A mellower slope may only need your foot to drop by 20°. The most important aspect of the weight shift is making sure you have a bias over your outside pedal.

To add stability, control and style into your technique recruit your hips into taking on some of the workload. With your head and shoulders looking at the end point and your outside foot down, try and shift your hips outboard to allow you to get more force into the tyre edges and ultimately, increase the speed you can ride at. Get this dialled and you're well on your way to replicating Hill's annihilation of the cambers in Champery.

From left to right: Greg Minnaar (left) and Gee Atherton (right) showing their speed and commitment / *Sven Martin*

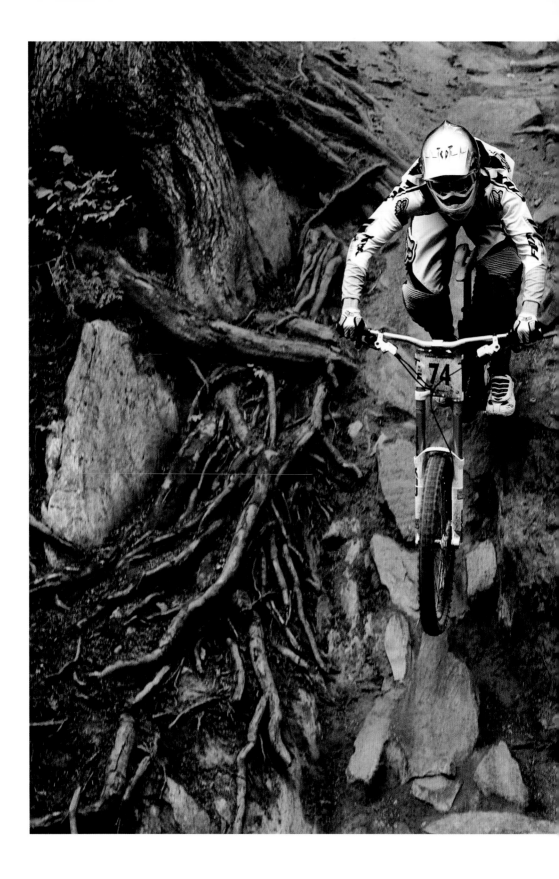

ROOTS

It's been seen at World Cups and World Championships time and time again and goes something like this: a rider's having an issue with a slippery root. Under the cover of darkness, an anonymous worker bee is sent to deal with the issue on the course. Next morning arrives and there's a gap where the offending root once was and the course is easier to ride.

So why do roots cause so much of an issue, even at the highest level? Due to the very subterranean nature of the root, they always get more pronounced as a trail gets worn in. On steep sections, heavy braking sweeps the topsoil aside exposing the slippery surfaces of the roots below.

Venues such as Schladming in Austria, Val Di Sole in Italy and Mont St Anne in Canada have gained their tough as nails reputations from the technicality and severity of the roots sticking out of their steep mountainous slopes.

Dealing with slippery roots at Crankworx, Whistler / *Sven Martin*

They are so synonymous with a challenge that, at a bad spot, riders will be seen entering into deep conversations about line choice and how they'll negotiate the root fest. Because they cause a bottleneck, action-hungry photographers and knowing spectators will often gather around a gnarly root.

From his years of riding experience, **Steve Peat** has to be one of today's fastest and smoothest riders across any rooty section. Although his clinical style works well for him, he thinks that there are basic underlying techniques we all need to master. *"I always say different riders have different styles and different ways of attacking sections of a track. Things I do won't always suit another rider but you will find the basics are very similar for each individual."*

ANGLE

Where you hit a root is important. Always aim to hit roots as square on as possible. The closer you are to 90°, the more chance you'll have of rolling over it. Keeping your head up on the approach should help you to spot any sneaky roots crossing the trail at an awkward angle. If the root snakes off down the track in a similar direction to where you are heading, it's likely that your tyres will slide along it, taking you wherever the root goes. There's virtually no grip on a wet root, so try and spend as little time as possible on the wood to reduce your chance of sliding.

To hit a root at the right angle you might have to change your direction into it by a fraction. Try doing a little set-up turn beforehand to line yourself up correctly. That may mean turning up the hill to let you hit the root nearer the tree or a slight deviation from the main line to get you away from the worst areas. Regardless of your ability, **Peat** says that *"picking your lines well"* is crucial to riding roots well. It's a precise art.

BRAKES

If there's one underlying technique to everything you do on a mountain bike, it's learning where and when to brake. Just like with off-cambers, berms or flat corners, braking through the roots can determine your success.

When the rubber hits the root it needs to be free to roll over it or deform around it. To do this you have to let go of those brake levers and stay relaxed. If your speed is right, you can dab the brakes going into the roots or straight afterwards, as long as for that little window of time, you don't brake on them.

There will always be deviations from the rules. That's one of the things about mountain biking. Unlike a golf swing, which you would unleash the same, time and time again, riding techniques need to be adapted to the conditions and the environment around you. This is the true skill. Don't take everything as gospel. For example, if you're hitting a very steep shoot with roots on it, you may have no choice but to brake. However, as long as you are aware that the brakes will lose you grip, you can prepare for the inevitable slide. It's this knowledge that will make you a better rider and more able to handle the situations that different trails might throw at you.

GO LIGHT

The art of 'going light' is a tough one to explain but one of the key techniques that separates a good rider from a novice.

PRO TIP: STEVE PEAT

You have to be light when riding roots and try not to stick the tyre into them too hard.

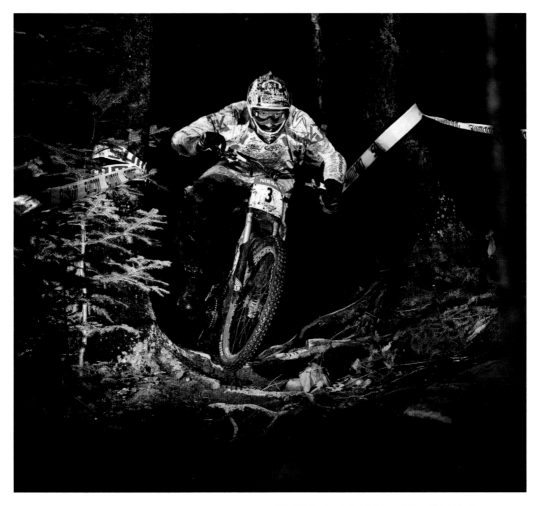

Steve Peat going light over a root section / *Sven Martin*

By taking your weight off the tyres, it will allow the bike to rise up and over the section without too much resistance from you. The less you are pushing down, the less chance there is of bashing into the root hard, something that would cause you to slide regardless of your speed or whether you are braking or not.

Imagine that for a split second you are hovering above your bike. Try and subtly lift your feet up on the pedals and gently pull on the bars. You're trying to float for a very short time yet keep the bike on the ground.

Speed helps as the faster you go, the further you'll travel in the same space of time. This might sound weird but it works.

Your line should also reflect this technique. As **Peat** says, "*Pick points where you can un-weight your bike and get a little pump to keep you propelling forward.*" By doing this, you'll find you can skip through sections like a pro and not crash your way through the roots with no style or finesse.

SWITCHBACKS

Switchbacks are those tight turns that make a trail double back on itself as it drops a step gradient, creating a zig-zag line that cuts across the fall line.

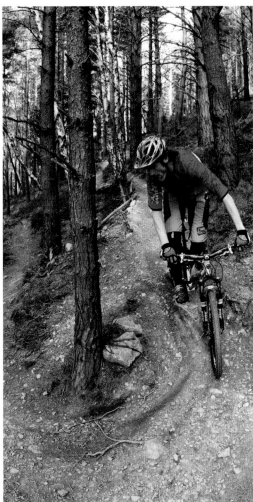

How you negotiate switchbacks can change an awkward, slow descent into a flowing, enjoyable series of linked turns.

Epic alpine events like the Mega Avalanche are all about switchbacks. As it steeply drops thousands of metres from bare rock-strewn mountaintops through woodland and meadows to the valley floor, switchbacks litter the course.

Gordon Lucas approaching a switchback in Djouce Woods / *Victor Lucas*

The storms that hit the 2008 Mega Avalanche made the track seem like a battlefield. By the bottom third of the course, the weather, fatigue and nightmare conditions had reduced many riders to crawling and sliding around the mud-covered hairpin corners that flow through the alpine forests. The leaders opened a large gap between themselves and the mud struggling pack simply because they kept riding the switchbacks and riding them well. Switchbacks aren't as hard as they may appear and those back markers could've used a few simple tricks to reel in the riders ahead.

EQUIP YOURSELF

Nailing a switchback requires a whole range of techniques: understanding speed and how to control it, knowing how to ride off-cambers, the art of flat cornering and potentially some berm techniques too. In reality, the terrain you're riding will determine the combination of techniques you use. That sounds like a lot to take in but it's not that bad. Break it down and approach it step-by-step.

APPROACH

Getting your approach right is really important. If the switchback is a man-made effort at a UK trail centre, it's likely that you can use the built up edges of the trail to your advantage. You're trying to make the tight corner as big as possible by getting your front wheel as far wide as you can. If it's wide and fast, you may be able to get both wheels wide - in which case you're in luck as you'll be able to carry even more speed out of the corner.

Look for banks or edges to turn against. Almost like mini-berms, a bit of a positive camber will give you some extra support as you turn. Don't just think of the sharp corner itself; as soon as you spot the switchback ahead, you need to start scanning the trail for anything that can assist your turn. The best spot is perhaps a few metres up the trail, where there may be a little berm or rut that you can fire into to slingshot you up and wide, readying you for turning into the apex of the main corner.

PRO TIP: GREG MINNAAR

By looking ahead you will see the switchback with enough time to set up for the corner. You want to set up wide, look through to where you want to be and get off your brakes.

If the corner is tight and narrow, see if you can get your front wheel to roll up the bank on the entry. That extra few centimetres will make all the difference when it comes to exit speed.

FOCUS

Once you are as wide as the corner will allow, shift your focus to the exit. Remember that you go where you look. There may be a drop to one side or the trail may suddenly narrow or steepen as you exit the apex, but try and be confident – you'll stay on course if you look at where you need to be going.

Your head shift should now lead the rest of your body into a change of position. As your head turns, let your body follow it and relax as the bike swings around underneath you. If the trail is really steep you should get a notable acceleration about now but run with it. Don't panic and haul on the anchors; it'll only undo all your good work.

WEIGHT SHIFT

Think of your weight shift as a chain of linked movements. You need to switch your weight quickly and smoothly from one foot to the other. Imagine a skier swinging from one slalom turn to the next. How much you move will depend on how exaggerated your cornering is but regardless of whether you're swinging from one berm to the next or just rolling your front wheel up a bank, how fluidly you move will decide how much speed and grip you'll carry through the switchback.

That sounds incredibly confusing but link it all back to how you rail berms or hit flat turns and it makes sense. Really you're just putting two corners together quickly and if you think of each one individually everything should slow down and be easier to process.

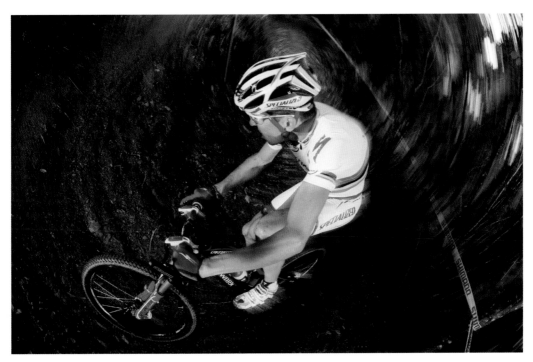

Christoph Sauser in Schladming, Austria / *Sven Martin*

BRAKES

In the battleground that was the '08 Mega Avalanche, it was the braking that separated the men from the boys. Don't back down from a switchback and get tense, instead use it to slingshot you down the next straight. The key to speed is how and where you're braking.

There are a couple of ways around this. For huge sweeping corners you will probably be able to let off the brakes early on and push into the last third of the bend for grip – just like those flat corners. However, if you're riding down a goat track, high up in the mountains, it's likely that the switchback will be way too tight and narrow for brakeless effort. Instead, kill as much speed as you can coming into the bend using both brakes. If you can, swing your front wheel wide, let off the front brake to give yourself more front wheel grip as it climbs the camber. While your front tyre is off on its own line,

you can still use the back brake to keep you in control. After all, your back wheel was never going to need grip as it's simply following whatever you've got the front doing. Just before the apex of the turn should be the latest you'll ever brake. Do it after this point, and you'll be losing exit speed, making it difficult to stay on the trail.

Whether you are blasting through a Welsh forest or dropping the gruelling slopes of the Alps, those simple tips for looking, weighting and braking should see you around any switchback you come across.

PRO TIP: GREG MINNAAR

The line you choose will determine how much speed you'll carry through the corner.

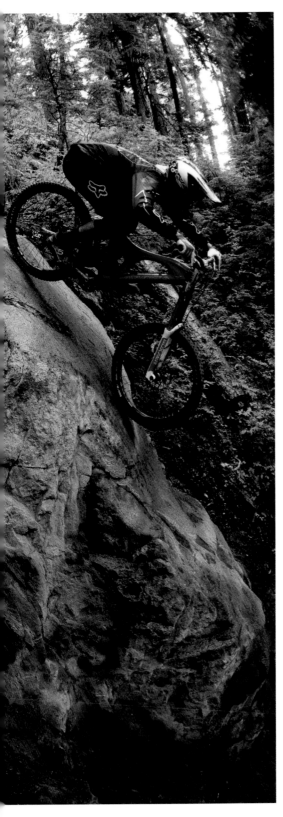

ROCKS

Whether it's the barren, wind blasted moraines of the high Alps, the huge glacial formations of Canada or the boulder strewn trails at British trail centres, handling rock sections well is essential for success.

From sliding down loose scree slopes with fist sized rocks moving underneath your tyres to traversing off-camber granite rocks the size of a house, a certain mentality is required. It takes confidence and calm determination to conquer the section rather than becoming its victim. The rocks will always win in a contest of hardness, so absorption is the way to go. Keep yourself focused on the end goal and let your ego have a small knock once in a while. Better that your mind takes the hits than your head.

The 2002 UCI Downhill World Cup in Fort William was a moment in time where sheer rider strength and brutality conquered all that lay before them. Chris Kovarik won by 14.02 seconds, one of the biggest margins in modern pro men's finals history, yet it wasn't just the gap he won by that was impressive. To go that fast, Kovarik had to take on a course that had been torn apart by the wind and rain all week. He came across mud covered hard Scottish rock on almost every section of the track yet pushed on, took each hit and destroyed the field.

Amado Stechenfield negotiating a steep rock at Crankworx / *Sven Martin*

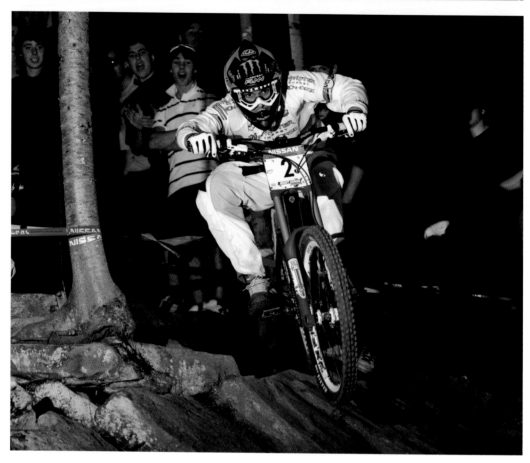

Sam Hill hitting a rocky section at Mont St Anne / *Sven Martin*

STRENGTH

As one of the more powerful riders, **Kovarik** puts his strength at the top of the list. *"I can make the bike stay on line by holding on and keeping it straight through the rocks"*. By staying solid and not getting knocked off his line, Chris can keep it between the tapes and take hit after hit. Although gruelling, it's this ability to take the rocks on at their own game that gives him the edge he needs to win.

Not only do you need to make your upper body strong enough to keep the bike on track, you also need the endurance to take the endless hits that a rocky run will throw at you. In **Kovarik**'s opinion, *"You need to make your muscles more efficient to hold on well. Get down the gym and develop your core. You don't just need bulk, you need the efficiency and stability that comes with it"*.

BRAKES

How you brake will depend on what the surface is like. If it's wet and the rocks are slippy, you need to go steady and approach the braking just like you would on a rooty section. As grip only comes when your braking is either light or completely non-existent, go easy on the anchors. No panic braking, and be prepared for a bit of movement under the wheels.

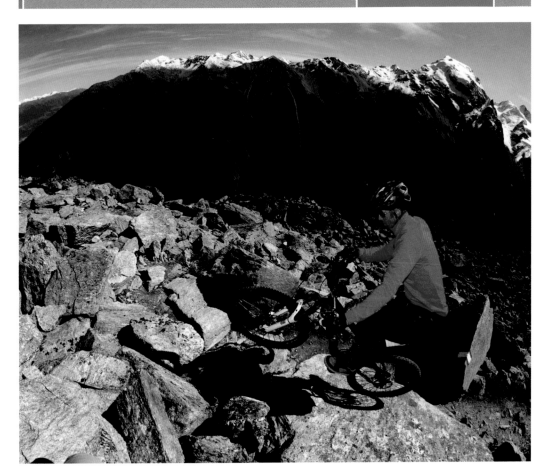

Gareth Rogers heading up a rocky section in Switzerland / *Victor Lucas*

If the slope is steep and rocks are loose you'll need more bias on the back brake to stop the front end from pushing off the trail. A bit of a rear wheel skid here or there is no problem, in fact sometimes it can really help to control the bike and keep everything on the straight and narrow.

Plan your braking for what lies ahead. If you're cresting at mach 9 into a rock garden you should be thinking of taking some speed off early. Once you hit the rocks, forward momentum and letting the wheels roll will be a huge help.

SET-UP

For a rocky ride, do a few things to set yourself up properly. To prepare for his ride at Fort William **Chris Kovarik** had this to say. *"Suspension set up is super importan. If your bike is set-up too soft you will be falling into all the holes and hanging up on every rock. If it's too hard you will be bouncing off line and getting beaten up. You don't want to be pinch flatting every run in those rocks so pay attention to tyre pressure and experiment with it. With your brake levers, try to adjust them as far in as possible without them crushing your fingers on the bars. Don't have your braking finger struggling way off by itself. Grip it closer to the bars with the others like a fist. This should give you way better strength to hold on with"*.

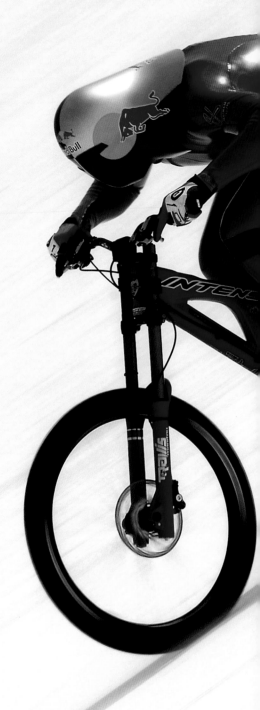

FLAT
OUT
FAST

Markus Stöckl setting a new world record at 130.7mph (210.4km/h) / *Alfredo Escobar/Red Bull*

Wide-open, featureless descents are less common, not just in trail centres where the drops make the most out of every contour line, but on the pro scene too. Gone are the days when World Cup events had riders race head long down open slopes. Yet, although they're less common, being able to ride trials like these at high speeds can still come in handy. Sometimes there's nothing better than the sound of the tyres reaching top speed during a flat out blast down a straight trail. Here are five things that you should keep in mind when letting it all hang out.

1.**THE FASTER YOU ARE GOING, THE FURTHER DOWN THE TRAIL YOU NEED TO LOOK.** The faster you go, the longer it's going to take to change direction or slow down so look really far ahead.

2.**KEEP IT SIMPLE, KEEP IT STRAIGHT.** Not only will you be able to go even faster but you'll stay way more stable and in control.

3.**MAKE YOUR CORNERS MASSIVE BY STARTING THEM REALLY REALLY EARLY.** The bigger the corner the faster you can go, so make your entrances as wide as you can. Push the boundaries of the trail and consider leaving the worn in line to find fresh space out wide.

4.**TUCK, TUCK, TUCK.** No point pedalling if your legs are only going to be spinning in the wind. Get low and crouched. Keep your pedals level on the straights and if the trail is smooth, bring your elbows in. You'll keep your speed without any effort and stay nice and stable.

5.**BRAKE EASY AND TRUST YOUR FRONT BRAKE.** From high speeds you'll need the power of the front brake. Brace your arms and progressively pull on that lever. Never lock any wheels unless you're fully ready for the slide and possibly the crash.

David Kinjah Njau during stage five of the 2008 Cape Epic / *Sven Martin*

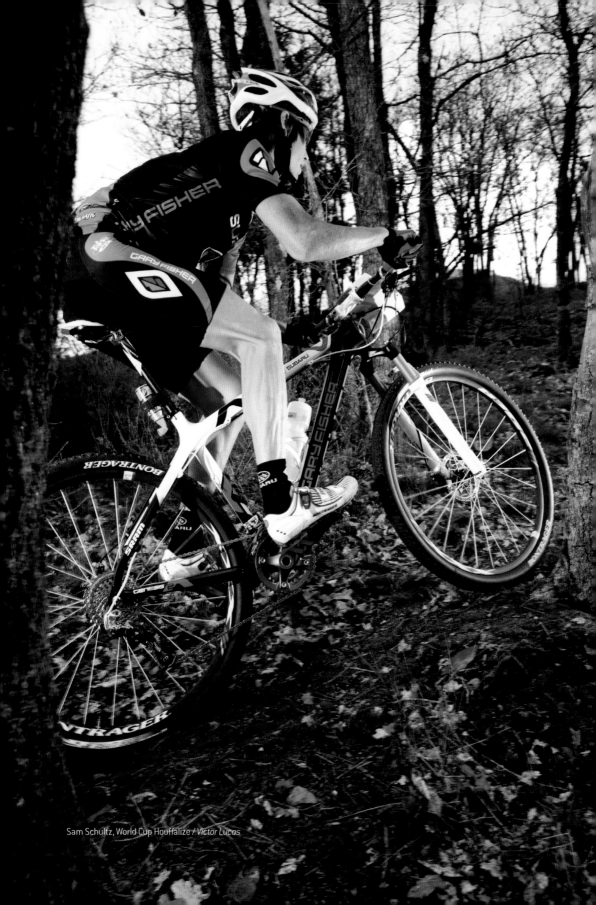

Sam Schultz, World Cup Houffalize / *Victor Lucas*

CLIMBING

If you're a pure downhiller, climbing probably means pushing your lead-heavy bike up a trail, loading it onto a truck or hanging it from a chairlift. If you are really lucky it is strapping it to the outside of a helicopter. For everyone else though, climbing is part of the ride. It doesn't have to be all pain. Real enjoyment and achievement can come from getting to the start of the descent under your own steam - even if you aren't a masochist. As Sir Walter Scott once said, "He that climbs the tall tree has won right to the fruit". Sometimes in fact, the rush of the descent feels that bit more intense, knowing that it's gravity's way of rewarding you for its earlier defeat.

To be able to climb like a mountain goat, here's what you need to do....

PACE SETTING

On longer, gradual and sustained climbs your aerobic engine is powering your body almost entirely, so hours in the saddle will only be of benefit. Remember to build your base through lower intensity rides before upping the tempo and raising your heart rate.

Finding a pace that works for you and sticking to it is often the best solution. Getting up and out the saddle and putting in short efforts will only make it harder so work within yourself and concentrate on your breathing. Keep the oxygen going to your legs by focusing on controlled breaths that fill your lungs. A good friend of mine strongly advocates learning a sound breathing technique and claims it allows him to maintain his pace on dragging climbs. He'd even tell you the breathing techniques learnt through yoga have attributed a lot to his elite performances and race wins.

For the racers pushing at the front of the pack, sometimes it's not always going to be that relaxed and controllable. Olympian and Cross-Country World Champion **Christoph Sauser** knows just what's it like to be at the sharp end. *"Lots of times other competitors set the pace and I just hold on so I don't get dropped. If I'm in control I make sure that I am in a comfort zone that lets me keep my pedalling smooth. Normally though, if you ride like this it's hard to drop the very good riders so I just get myself out of my comfort zone and think about pedalling as hard as I can."*

Christoph Sauser getting his weight over the front / *Victor Lucas*

CADENCE

How fast you pedal will have a direct effect on your efficiency and therefore your fatigue. Although some riders prefer to push higher gears than others, trying to maintain a faster cadence will always help keep the tempo up on longer climbs.

Pedalling with a higher cadence at a lower resistance will force you to correct any poor technique and imbalances in power delivery, instead, focusing you on maintaining a stable and efficient stroke. You'll also be far less likely to pick up injuries that are associated with the repetitive strain that pushing a big gear can cause.

Although the efficiency of high cadences have caused Lance Armstrong to champion such a technique in the mountains, off road, the more delicate power delivery can really help you find traction on steep technical climbs.

If the ground is wet or loose, steep or slippy, laying a lot of power down in one go will almost always result in a wheel-spinning end to your ascent.

PRO TIP: CHRISTOPH SAUSER

Keeping the momentum of riding at a high cadence is important. I try and pedal fast, at about 90rpm, when I'm climbing uphill over bumpy terrain. It helps me keep my speed and stops the bumps interfering with my pedalling too much.

WEIGHT SETTING

Getting your weight in the right place is crucial to climbing quickly and efficiently and if the terrain is particularly technical, your body position can mean the difference between a successful summit bid and a failed one.

The move towards longer travel forks has only increased the importance of body position on the bike. If you run a high front end it's likely that your weight will sit over the back wheel and allow the front wheel to lift on the steeper sections. To stop this from happening, you'll have to concentrate on positioning yourself over the handlebars.

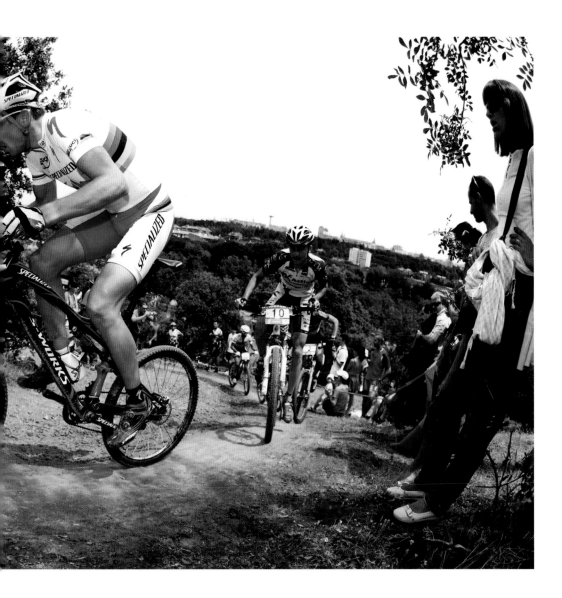

On steep climbs, often getting enough weight on the front to keep the front tyre on the ground is enough, but when things get loose, too much forwards bias will create insufficient weight on the back wheel to give the tyre bite, causing it to spin. It can be infuriating and time consuming if you're constantly slipping, spinning and putting a foot down so practicing steep technical climbs is a worthwhile use of your time.

Try sitting on the nose of your saddle to spread the weight between front and back wheels. Keep your elbows in and down to help you lower your torso over the bars and utilise some of your upper body muscle groups. If you have enough grip, you can get out of the saddle, helping you to pile loads of weight on the front and get extra power from your shoulders and back.

However, if it starts to slip, you're going to have to return to the saddle and apply pressure as evenly and delicately as you can. If you're fatigued and finding it hard to regain your balance and stay upright, try focusing on maintaining your composure and controlling your breathing. If you let things get too sloppy, it's unlikely you'll make it to the top without having to get off and push.

THE NORTH SHORE

It's Maui and J-Bay for the surfers, Chamonix or the BC backcountry for snowboarders and skiers. It's the Himalayas for climbers and the rivers pouring out of the Andes for hardcore paddlers. For mountain bikers it's a place amid the temperate rainforests on the west coast of Canada, a small part of the huge wooded wilderness around Mount Seymour, Mount Fromme and Cypress Mountain: North Shore.

It is just outside Vancouver and this is a city where mountain biking has a phenomenal participation rate. The trees are tight and the slopes steep, but thousands of riders have quickly graduated from simply steaming down the trails to riding an intricate circus of raised wooden ladders, ramps, snaking elevated paths, see-saws and helter-skelters. These crazy constructions have been hand-built by the riders themselves from the logs of the forest. Originally, these structures sprung from necessity as bridges to span impossible sections of trial, but if you've never seen what North Shore has developed into, just type it into YouTube, sit back and let your jaw drop. If you are good enough to ride the harder stuff you see, you probably don't need to be reading this book.

What started in British Columbia has spread around the world. Wooden structures now feature everywhere from international slope-style comps to local trail centres. They are used to construct technical sections, transitions, landings and drops. Even the World Championship down-hill track in Fort William, Scotland uses wooden bridges to cross heather-clad Highland peat bogs.

STAND TO ATTENTION

The first thing you need to check is that you are standing up. If your butt is firmly in the saddle, you and your bike will move as one unit, making it incredibly difficult to balance. By standing up you'll be able to constantly adjust your centre of gravity by moving your shoulders or handlebars side-to-side. You'll also be able to take evasive action quickly should it all go wrong: if you are standing on the pedals, it's far easier to put a foot down or throw the bike away and bail out if it gets really sketchy.

SPEED

Speed is key. Once you're on the wood, slowing down will be difficult to get right, so gauge your speed and brake early. There's no harm in setting your approach speed really low, then slowly accelerating along the wood if necessary. Remember, It's always easier to pick up speed than lose it. If it's a longer section of woodwork, a few gentle pedal strokes may help you along it.

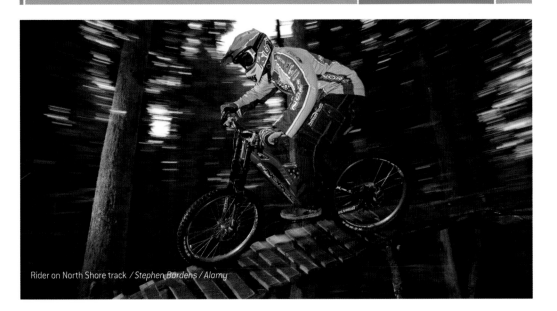
Rider on North Shore track / *Stephen Bardens / Alamy*

LOOK UP

Riding along a painted line on the road is easy. Take the tarmac away, elevate by a metre or more and things start to change, radically, even though they shouldn't. **Danny MacAskill** is used to riding on impossibly high ledges and tries to forget the drop on each side, *"just imagine your riding along a white line on the road. It shouldn't matter that you're up in the air".*

Don't worry how narrow the wood is, that's a recipe for disaster. Another common mistake is to become fixated with your front tyre. Think positive. Look towards the end of the wooden section. Draw a line to that point and forget about how high you are or how narrow it is. Guaranteed, you'll have an exponentially greater chance of making it to the end.

END POINT

At the end of the wood there might be a drop-off, a tight corner or a steep roll-in to another section. This will probably be the hardest part. Make sure any skills you need are dialled before you attempt this by practicing somewhere easier first. Trust me, you don't want to find yourself out of your depth when you are a few metres up on a ladder bridge.

If you are starting to increase the technicality of your North Shore style riding, keeping speeds down and focusing on control is the only way forward. Be smooth on the brakes, make all of your body movements controlled and plan what you're going to do before you get to it – even if that's only a few seconds early.

For slow drops, you might have to use a wheelie type lift to get your front wheel up. For ledges that you're rolling into, a manual will do the trick. Likewise, for corners and cambers, think of your braking just as you would on the dirt, although an increased delicacy in your riding wouldn't go amiss.

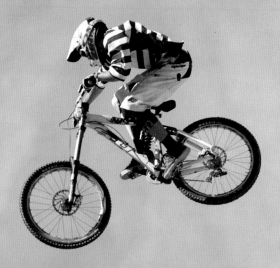

Cameron Zink off the ramp at Red Bull Rampage / *John Gibson* / *Red Bull*

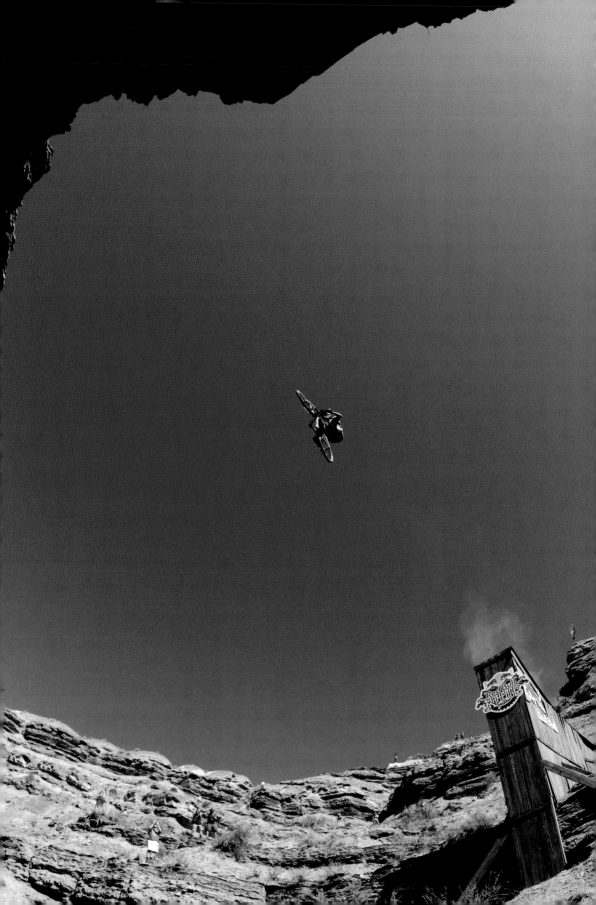

IN THE AIR

2005 saw the launch of New World Disorder's Ride the Lightning movie. On its release, the trailer showed Darren Berrecloth attempting a 360° drop, and immediately the perceptions of the scope and scale of what was possible on a bike swelled exponentially.

Riders had been hitting huge jumps and dropping frightening heights long before this movie was released, but the combinations, flow and style on display had reached a new level.

Fast forward a few years and mountain biking is up there with snowboarding and skiing for spectacular big mountain riding. It's no longer enough to land a 10m drop. Now riders are adding perfected corked flips, tail whips and 360s on their way down. At the 2008 Red Bull Rampage, nearly every drop, lip or gap needed to be tricked for any chance of a serious result.

The sport has taken from BMX, motocross and snowboarding but it has also developed its own identity and it's hard to keep up with the constant evolution at the sharp end.

Emulating the riders in films who can hit a lip effortlessly and float through air is probably one of the skills that sits highest on most mountain bikers' wish lists. Watching the top guys silhouetted, mid air, against a backdrop of bright blue skies and snowy peaks only fuels the desire to get out and try it for yourself.

Out on the trails, attempting to do what you've seen often just seems impossible. Where do you start when all you want to do is nail a corked flip? Start small. Don't try and run before you can walk. Dial the essentials of clearing gaps and pumping landings first. If you can hit any lip in control, you're well on your way to that 360° out of a quarter-pipe.

Cam McCaul getting some air / *John Gibson / Red Bull*

HITTING THE LIP

This is the most essential part by miles.

Getting it right while you're still on the ground will make the airtime part easy. Although you may be thinking about the jump as the take-off and landing, add the few metres before the transition into your thoughts. You need to be planning and setting up a few bike lengths before the lip so that when you get there, everything is done already.

One of the hardest things to master is learning the concept that, the less you do, the easier it'll become. Stick on your favourite film and watch any top rider; you'll see that they rarely yank on the bars and spring

Sven Martin

off the lip like a gazelle having a seizure. Instead, the transition from dirt to air is seamless. The line and arc should begin on the take-off and carry on through the air and onto the downslope.

On the run-in, spot your take-off point. That should usually be the highest part of the jump. You need to try and make sure both tyres reach this point of the jump before they lift off. Hopping off the transition too early will only cut short your airtime and bring you down heavily with no flow. By keeping an eye on this point, it should be easier for you to gauge your speed and get the timing of all your movements' right.

THE PUMP

Hand over as much work as you can to the trail. The more you can get from the dirt, the less you need to do yourself. Pump the compression before the jump starts to rise. If you're coming in fast, you might not have to do too much, but if you're rolling in slow, exaggerating the pump with your arms and legs will add height and distance to your jump.

The pump can also add stability to your riding. The more planted you are on the ground, the more confidence and balance you'll have so don't let yourself get all light and off-kilter before you even get to the lip. As with most general trail riding, the bike is better stuck to the ground than it is skipping over the top.

SPEED

The pace you hit the jump at can be tough to gauge to begin with. Start slow and build up on tabletops, where the consequences of coming up short aren't as severe as a double. The more jumps you hit, the more you'll understand what's going to be needed to get you the distance. Technique can also play a part. The more proficiently you pump, the slower you'll be able to go and still clear the gap. If you can only reach the downslope of a small jump by frantically pedalling at the take-off then something's amiss. Go back to the basics and refine your flow, balance and pump.

LIFT OFF

Now that you're approaching with the right speed and you're solid and in balance, you can start to work more on the take-off. Pumping should have moved you slightly down and forwards to load the bike - like coiling a spring. Now you need to release that pent-up energy by following it up with a gradual move backwards. The lower you move from, the more balance you'll have so recruit your hips into doing most of the work. Keep in mind that unlike a manual, where you do all the work, most of the effort will come from the physics of that spring, so keep all body movements very subtle.

If you were to roll your bike at the lip without you on it, it would take off on its own so all you have to do is make sure you're not loading the front wheel. All it's wanting to do is take off — so just let it. As the 19th century proverb says, less is more.

BACK UP

The rear end needs to mirror what the front has done only hundredths of a second earlier. As the lip is the take-off point, keep your weight off the front until your back wheel has rolled up the transition and is now at the same spot. This can seem difficult, but in actual fact it's pretty simple. Just like you took your weight off the front by moving backwards, you should now take your mass off the back end by moving forwards again. Too much and you'll either start a front flip or nose dive into the landing, too little and your rear tyre will stay planted on terra firma. It's a fine balance, influenced more by your timing than by how much you're moving. Subtlety is key, so keep the movements minute.

AIRTIME

If you've done all your jumping using the lip and the trail that precedes it then this part will be effortless - just like in those movies. It's the hang-time you're now experiencing where you can spot your landing or start trying tricks. If you feel like you're holding the bike in the air, chances are you've gone for the old faithful yank on the bars and need to re-think your take-off. The pedals you're using shouldn't make a difference at this point. With the weight shift back and forwards, the bike wants to take off underneath you and will be following the path you set it on at the start. If the bike is dropping away from you, it's back to the drawing board and time to re-master your take-off. Don't take the easy option and fit a set of clipless pedals, they'll only restrict you later on.

POP

We're not talking Britney Spears here. The pop you get from the lip is the result of a number of things. As **McCaul** says, *"You might have to bunny-hop more off the lip if you need more height than it's going to give you."* In this sense, exaggerating the boost you're going to get from the jump will require you to do a bit more work. It's not worth trying this until you've got mellow, relaxed jumping dialled as the timings and techniques are a little more complex.

Initiate the entire movement from the pump and use this compression as the trigger for all your other techniques to follow on from. On the approach get stable and central with your pedals level, push hard into the compression with your whole body weight and as you take off carry out the same moves as before but with extra effort and power. The bunny-hop can be introduced nearer the lip to squeeze that little extra from the height but make sure you're still using as much of the transition as possible. Try and let your moves be dictated by the shape of the ground rather than just pulling a monster bunny-hop off the top. It won't get you that far and will win you zero style points at the same time.

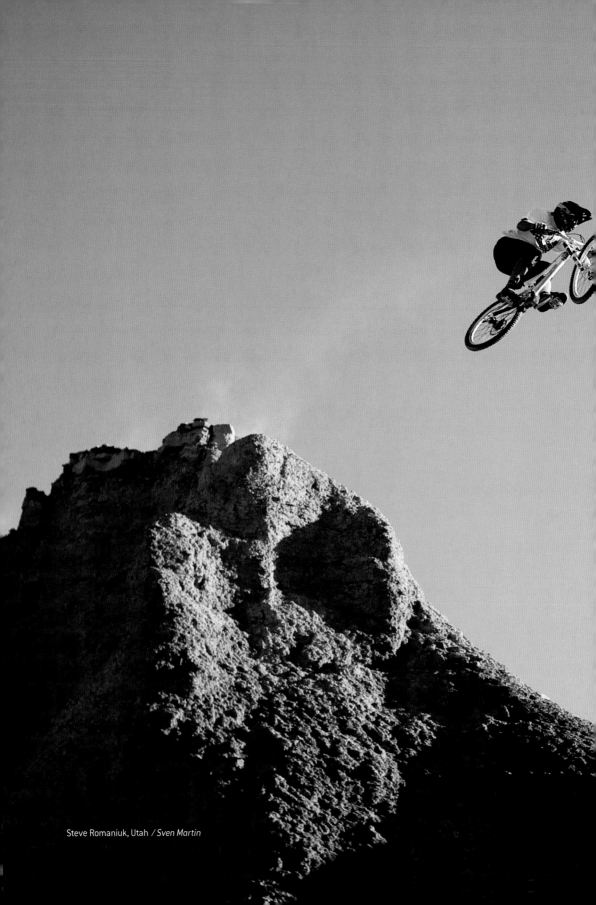

Steve Romaniuk, Utah / *Sven Martin*

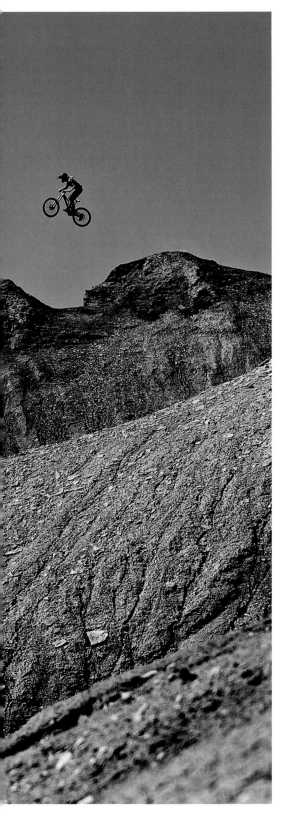

BIG GAPS

We've all seen the photos. Maybe it's a shot from behind and the trail of dust, backlit by the sun, is still lingering in the air on the foreground, marking the take-off spot for the rider that's now merely a silhouette in the distance. The gaps that riders are now clearing are huge, easily comparable to any air caught by pro snowboarders and skiers, but without the fresh powder snow cushion, the risks at stake are far higher for the bike guys clearing rocky canyons.

How is it possible to put yourself in these situations? Surely it's not just a progression from clearing the little tabletop on your local trail? Surely there is a huge secret, a special skill? No. It is just progression. Oh, and bravery. Or stupidity. Either way, if you really want to do it, read on.

Lorraine Blancher crossing a gap in Utah / *Sven Martin*

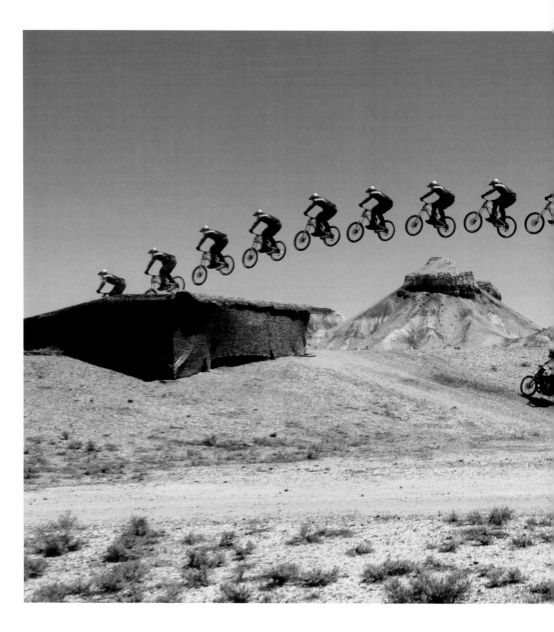

Cam McCaul sees gauging speed as the biggest challenge when jumping huge gaps. *"You should start on a 10ft gap and once you get the feeling of it you'll start to understand what is needed to make a 15ft gap and so on. Once you've jumped a number of gaps you can just look at the landing coming towards you and be able to feel if you're going fast enough to make it come all the way to you."* Cam's perspective is an interesting combination of experience and technique. There's no substitute for riding and experiencing progressively larger jumps. The inherent intuition you develop can take you all the way. In fact, **Cam** says, *"You could have 25 run-ins to a large gap but on that last run-in, when you get the speed just right, you just know you're going to make it."*

THINK OF THE BIKE

The set-up you're running can have a major influence how you'll perform on the big stuff. Take time to tweak your bike's set-up to the point that it feels right for

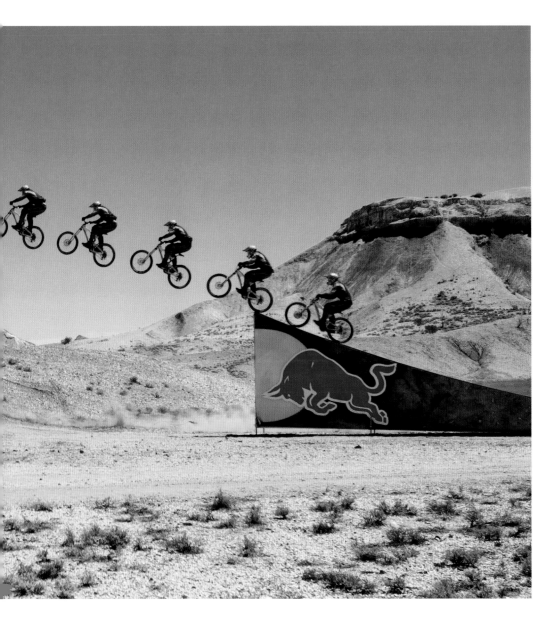

you and get used to feeling how it reacts in different situations. In general though, it's unlikely you'll need loads of grip so don't run your tyres so soft that they squirm around under you or your suspension so soft that it blows through all of it's travel without absorbing the impact.

Cam McCaul has had some experiences with changing set-up too quickly: *"Most of the biggest gaps I've done are on my 4" travel Slope Style bike and I have a real good understanding of judging distances and what I need to do on that set-up. One of the biggest gaps I jumped was the 50-footer at the Rampage and I thought I had the perfect run in with speed judgment dialled perfectly. Even with the right feel I came up a couple of feet short because I'd changed to my downhill bike and the softer set up absorbed the kicky lip more than I expected".*

Nathan Rennie attempting to break the world record gap jump / Mark Watson / Red Bull

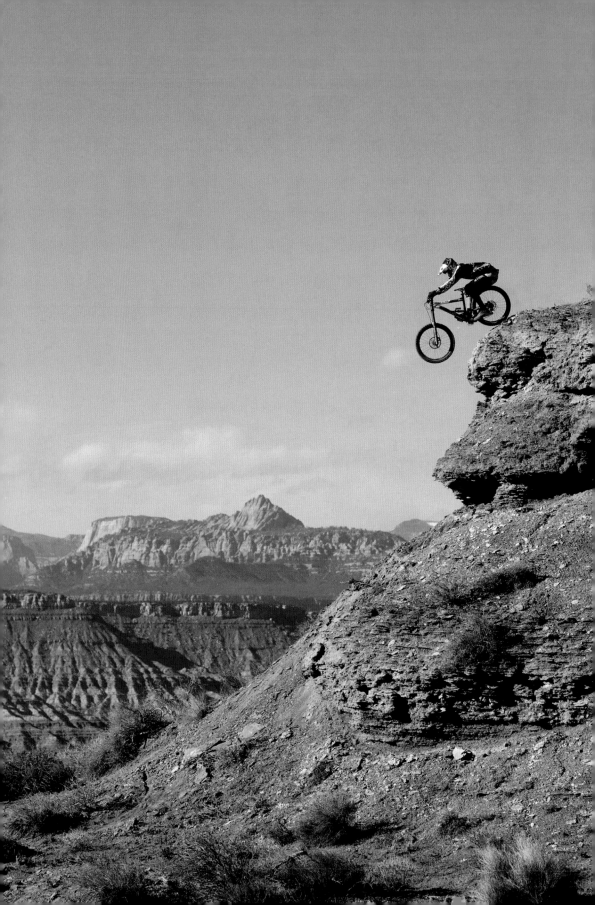

STEP DOWNS

This is probably one of the most impressive looking and most fun gaps you can do on a bike.

A step down can range from anything from a little two metre drop to catch a nice smooth transition lower down the trail to a savage road gap with a lip up on the edge of the embankment and nothing but tarmac to catch you until you hit the steep slope on the opposite side of the cutting.

A drop with a gap afterwards can look pretty daunting as you approach. On the run in, it's as if you're piloting yourself directly towards an abyss. A sense of vertigo can be exaggerated as the sky opens out in front of you and there's a split second of guesswork before you spy your landing spot a few metres away.

The main problem with a step down is that the landing site will usually be invisible until after you are airborne. This means there is no reference point to pick out as you approach. To cope with this you need to bring together everything you have learnt from doing lots of drop-offs and gaps. After that, gauging your speed is the Holy Grail. Only roll in for a step down once you're completely confident with your ability to judge what pace you need.

Utah will never be the same again: Gee Atherton drops in / *John Gibson / Red Bull*

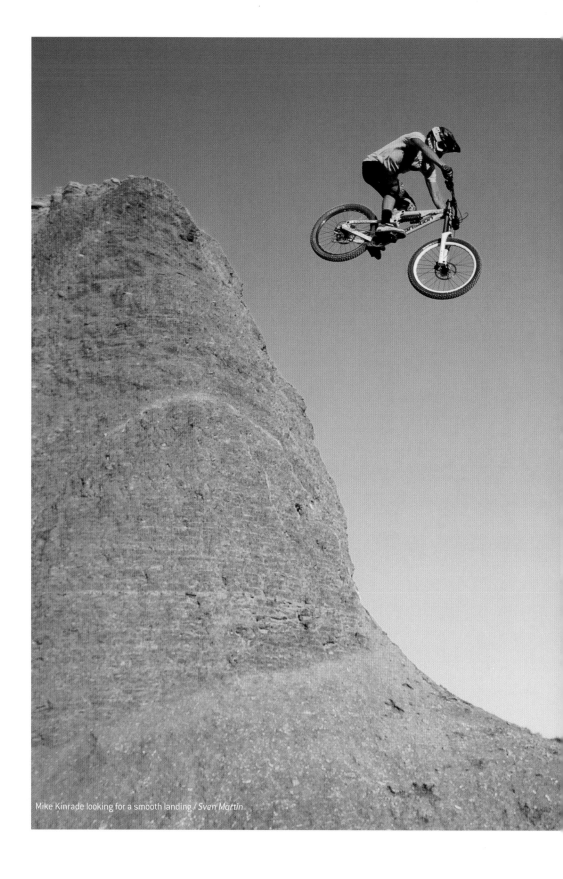

Mike Kinrade looking for a smooth landing / *Sven Martin*

REFERENCE MATERIAL

If the landing is totally blind, a quick reconnaissance walk is essential. Stand on the trail before the lip to check out the direction of flight and how you should hit the lip. Getting the angle of your take-off right is crucial. See if there's a reference point you can use on your run in: maybe there's a tall tree in the distance that would point you in the right direction or a mark on the trail that would help line you up. Pace out the approach to help you gauge your speed on the run in.

Your run in should be incident free. Try and keep it as clean and simple as possible. Stop pedalling before the lip so that you can get your feet level and everything nice and square on the bike. It's unlikely there'll be a compression to get pump from so if it's a big gap you might need to pop off the lip to get a little extra height.

LANDING

Absorb as much of the landing as you can through your arms and legs. Although your bike should be able to take the edge off the hit, your balance will stem from supple arms and legs. Likewise, if you take off and it's not looking too pretty, brace yourself for the landing. Don't remain too stiff or the chances of crashing and injuring yourself are high. You really just need to remain solid and regain control even though the forces of physics are trying their hardest to push you into the dirt.

Try and get the bike to touch down with both wheels as simultaneously as possible. Either a heavy front or back wheel landing can be hard to control.

For the racers, try and use the downslope to pick up as much speed as you can. Keeping a low trajectory off the lip and getting the bike down early will maximise the speed and allow you to hit it flat out without too many issues.

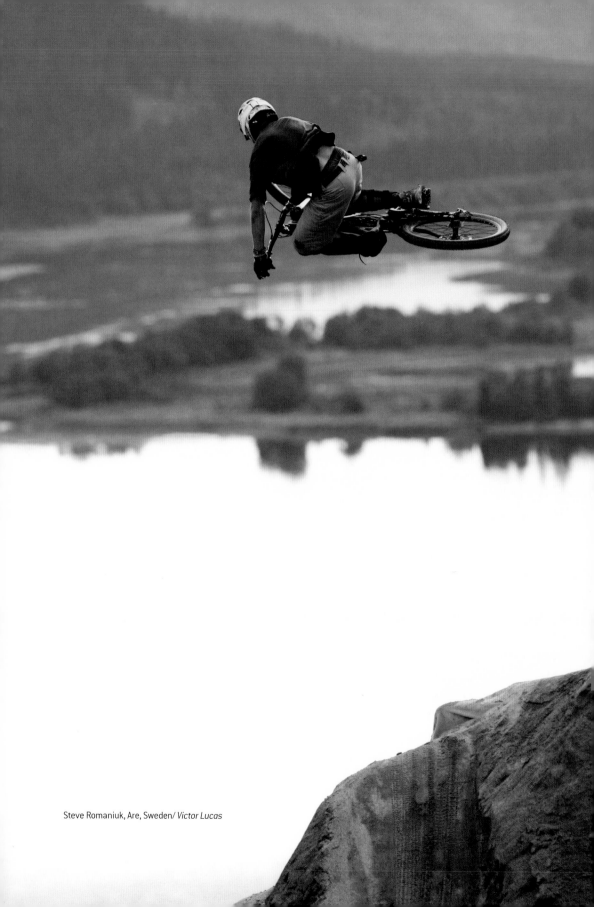

Steve Romaniuk, Are, Sweden/ *Victor Lucas*

HIP JUMPS

It's 2003 and the finals of the World Cup in Fort William, Scotland are underway. Chris Kovarik is on the hill and has smashed the current split time. Gazing up the mountain, thousands of spectators stare at the crest of the final chute awaiting his arrival and photographers gather in anticipation of catching a shot of him hip jump his bike into the finish arena. With more than ten seconds to spare, Kovarik appears against the skyline, the back wheel of his red Intense thrown out sideways towards the fans lining the course tapes, his front end dipped, forced like a motocross bike onto the landing a few feet to his left.

That jump sits at the very bottom of a gruelling monster of a course and needs a powerful thirty seconds of sprinting to clear it. Without the pump gained from its downslope, someone could lose the vital tenths of a second that often separate the top riders in the world. To get even more from it, riders have to try and turn the bike towards a landing that lies at a different angle to the kicker that sent them upwards in the first instance.

It's not just World Cup courses that have hip jumps; it may simply be a lip on the trail ahead followed straight away by a sharp turn to the left. Instead of slowing down and trying to get inside on the corner, the pro rider would look to hipping off the lip and making their turn wide at the same time. Scenarios like these crop up time and time again.

DIRECTOR

So what is the secret to getting the bike to change direction mid-air? To begin with it's worth getting a really mellow hip to practice on. Your take-off should trigger the whole move and start the bike turning. Rather than taking off straight and then turning, add a subtle turn into your take-off.

Make sure you're looking where you need to be going. Your head will lead the whole sequence so with a relaxed turn on the face, spot the landing and aim for that. With your head turning, the rest of your body will follow. Drawing a smooth curve from the take-off to the landing is what you're after so that the movement will flow evenly throughout your jump.

With your head turned, your shoulders should also start to move too. By dipping your inside shoulder it will feel a bit easier to lean into the jump and continue on your line. If the hip is pretty tight, you'll have get a bit more dynamic, so dip your shoulder more. A good tip here is to think about what your hands are doing. If you keep your inside arm stiff and solid, there's not much chance of putting the bike into a flat tabletop, so experiment with extending the arm on the inside of

PRO TIP: GREG MINNAAR

Make sure you know where you're going to take off and where you want to land. If you're hipping to the left you must lean a little to the left while you are taking off. Spot your landing and manoeuvre your bike into the appropriate position to land.

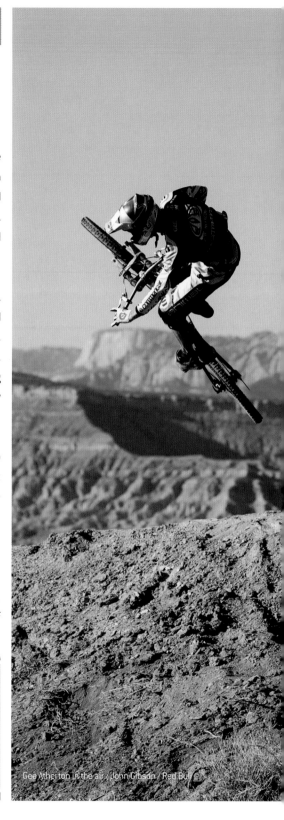

Gee Atherton in the air / John Gibson / Red Bull

the hip whilst rotating your outer hand over the grip - as though you're shutting the throttle off on a motorbike - and turn the handlebars away from you. With the extension of one arm and the bend of the other, you'll find the bike will be far more willing to lie flat and turning throughout your flight will seem far easier.

EXAGGERATION
THAT'S WHAT YOU NEED

If you're on the final approach to a 90° vert hip, exaggeration is the key. You'll need to get the bike pretty flat or sideways to get enough of a turn in. To do this, emulate the pictures you see in the magazines and get that flow into your jump. Staying relaxed throughout the whole process to keep it linked together smoothly.

Watching riders like Greg Minnaar and Josh Bryceland get it sideways or seeing Dan Atherton completely flat is inspirational and a technique that although looks like a trick, can be slipped into everyday trail riding to get more flow, link turns together and open up whole new dimensions to line choice and speed.

PRO TIP: GREG MINNAAR

I go out to my local trails a couple times a week. Hip jumps rely on your confidence on the bike, and the only way you'll get that is by practicing.

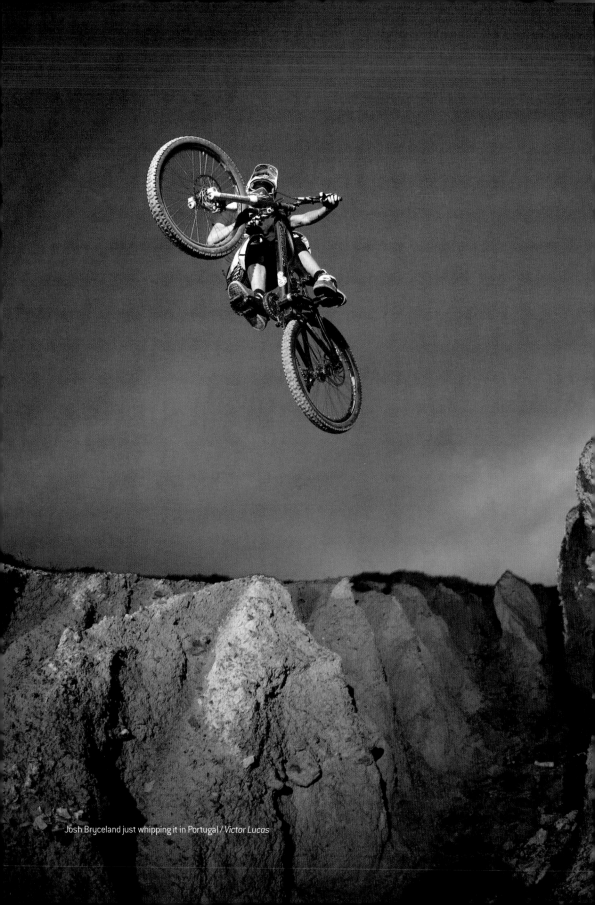

Josh Bryceland just whipping it in Portugal / *Victor Lucas*

WHIPS

The whip is one of the stalwarts of jumping.

Regardless of how many times you see a double tailwhip or 360° backflip, there's something about the effortless elegance of the way the bike moves that means the old whip will always remain one of the most respected things you can do. Done right, there's a certain synchronicity that belies any other move. Man and machine in harmony, from the second the bike is airborne to the time the front tyre scrubs back down on the dirt.

Yet the whip often eludes riders. Sure, getting the bike sideways isn't always that hard, but then making it come straight again can seem impossible. Impressive enough on a mountain bike but even more so when it's done on a 110kg motorcross bike and it's the MX riders that inspired **Josh Bryceland**, 2008 Junior World Champion. "*My real influence for learning whips came from watching motocross. I grew up watching all of these MX videos with my Dad and seeing Jeremy McGrath hanging off his bike going sideways just made me want to be like those guys*".

Josh learnt a lot from what the MX riders can do on their heavy bikes and he translated it into mountain biking. Now he can boost a lip and without any effort, pull his bike into a perfect whip with perfect fluidity and style.

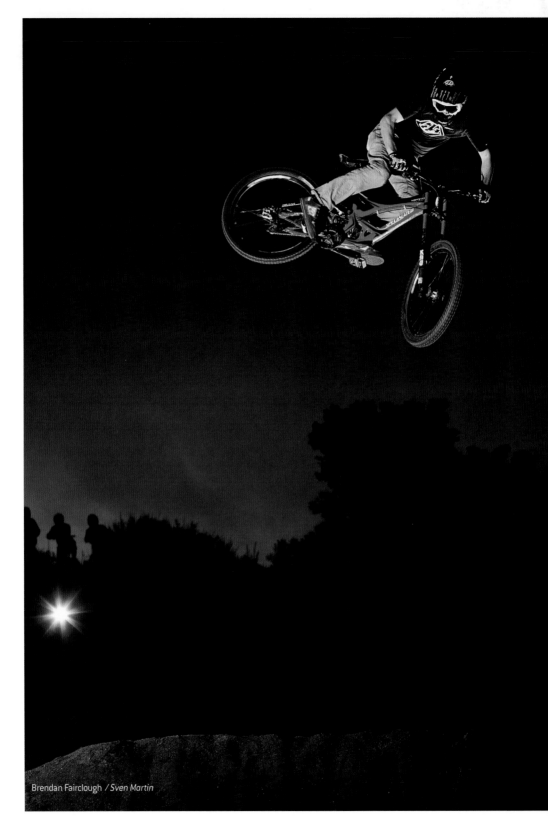

Brendan Fairclough / *Sven Martin*

GETTING YOUR MOVE ON

The hardest part by far is initiating the move. Avoid wrestling the bike into shape. Think of a whip as a linked sequence in which each move is initiated slowly and effortlessly. The whip is very much a whole body experience using your legs and arms together.

Just as with a straight jump, your approach is the key. As you hit the transition you need to get the ball rolling. When the bike leaves the ground, it should already have some momentum behind it to take it one way or the other, needing only the slightest bit of assistance from your legs to keep it going out.

The smoothness you introduce to your jumping will have a major knock on effect when it comes to creating shape and changing direction in the air. The less effort you use to haul the bike off the ground, the more you can put into getting your whips totally sideways and flat. Whether you turn the front wheel, keep it straight, pull the nose high or dip it in proper MX style, just find what works for your set-up and the jump you're hitting. Different riders do it in different ways, but the one key thing to consider is the shape of the lip. What will work on one jump may need a little tweaking to work on another.

PRO TIP: JOSH BRYCELAND

The majority of getting a good whip is in the set-up on the take-off. As you hit the lip, start turning slightly in one way or the other. This will get the shape started and then when you take-off just let your legs push the bike to either side. It's really as simple as that.

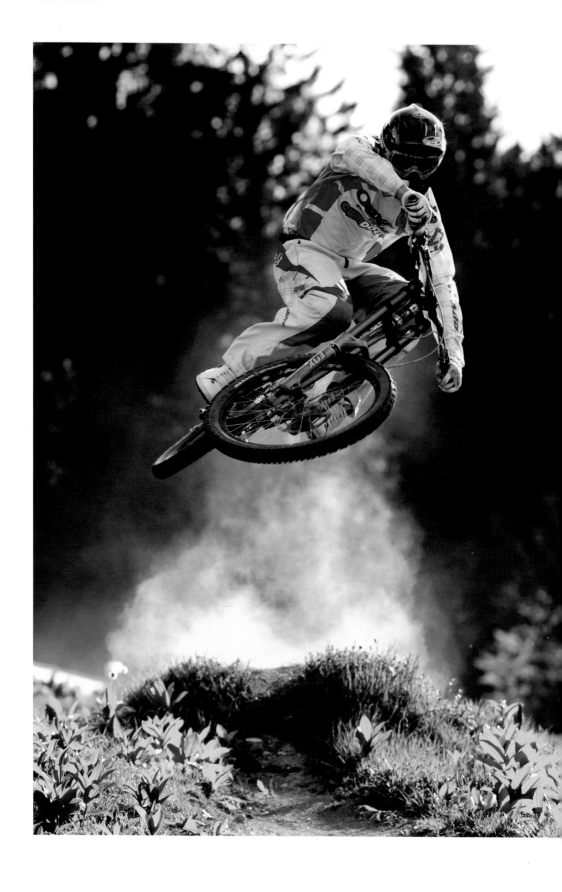

SCRUBS

A modified whip and a recent addition to all top riders' jumping arsenal is the scrub. Following on from the trademark trick of motocross legend James 'Bubba' Stewart, the scrub is all about being able to hit jumps flat-out without catching much air by absorbing the kick. Get these nailed and you'll be able to hit any lip full throttle without losing any speed.

FIVE TIPS TO SCRUBBING A JUMP WITH SAM HILL

1. Approach the lip as fast as you feel comfortable.

2. Set yourself up in the middle of the bike ready for take-off.

3. Lean the bike slightly to one side as you are heading up the crest. This will take a lot of commitment.

4. When your front wheel is at the top of the crest, turn the handlebars down to the same side your bike was slightly leaned to and flatten the bike underneath you. The lean in the air should be an extension of the turn you started on the ground.

5. Straighten the bike up for landing using your arms and legs and stay focused on the next section of the track.

Rowan Sorrell, Kranjska Gora, Slovenia / *Victor Lucas*

Cam McCaul's Super Flip during Crankworx, Whistler / Sven Martin

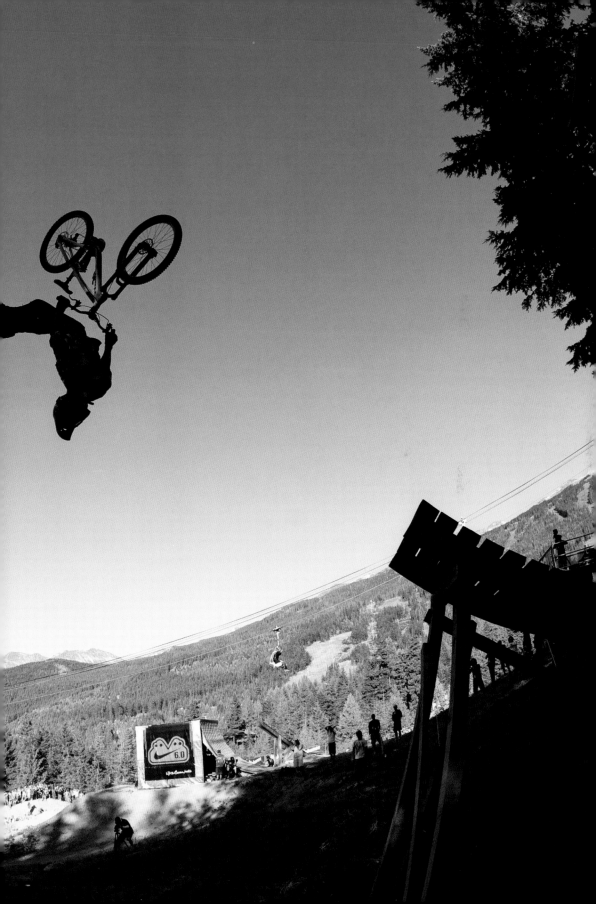

FLIPS

Once they were rare, but you'd now be in the minority at any major freeride or jump comp without a solid backflip in your bag of tricks.

What was once left to the BMXers has filtered into mountain biking and at the top end, riders are flipping drops, 70ft gaps and step-downs.

From the manic speed of the double backflip to the "so slow it's almost time lapsed" single flip over a cavernous gap, the guys are finding new terrain and extra combinations to add to what was once the humble, yet impressive backflip.

Andrew Taylor , Red Bull Rampage Flip / *Sven Martin*

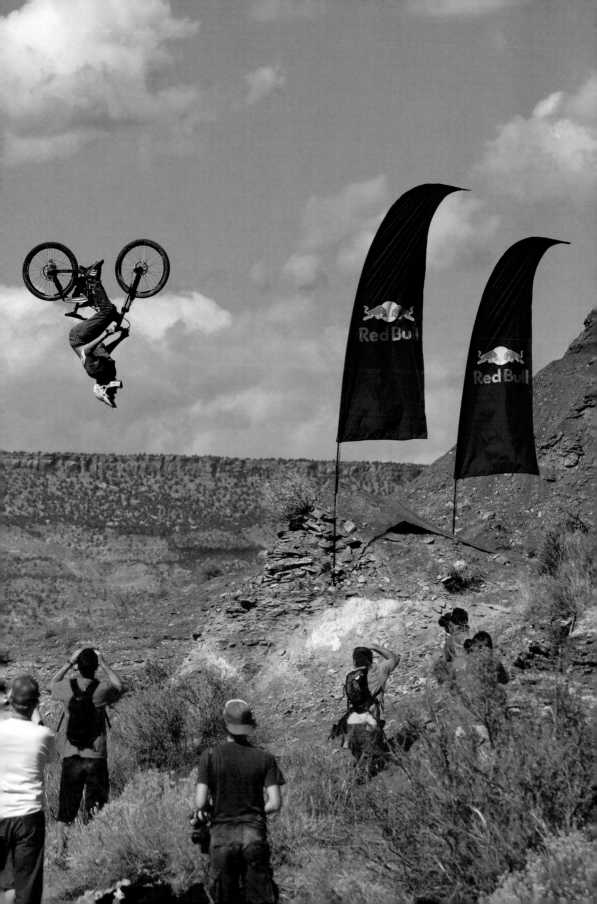

LIP SERVICE

Your chances of landing a flip will be hugely affected by the jump you try it on. To get the rotation, you need to build a jump that's got the kick to get you high enough to pull the bike over. At the same time, with such a steep lip, you're not going to be travelling very far so keep the gap short. **Cam McCaul**, one of the most progressive jumpers to emerge in the past few years recommends that you're choosy about the jump you learn on. *"First time you do a flip try and do it on a step up that's small enough to make the consequences pretty low. As you won't be able to control your flip speed, leave the bigger jumps to later and just find your orientation using a big landing that'll be easy to hit".*

FLIP THE SWITCH

Before getting carried away and trying jumps with higher risks, you need to learn to control the speed of your rotation. **McCaul** feels that, *"This will come with experience. To begin with, over rotate, under rotate, whatever. Who cares? Just learn how it all feels. On your starter jump with little airtime your flip is going to have to be fast and you are going to have to learn to exaggerate your body's movement. Once you've done this and landed a few you can start to try it out on bigger jumps. By the time you get to really big jumps with a good amount of kick it's crazy. When it's really long your flip will be crazy slow and it'll feel like you're not doing anything. All you do is change your weight onto the back of the bike to get it started, stay relaxed and peek up at the sky. That'll get you rotating nice and slow over the gap".*

Braun 26trix in Leogang, Austria / *Victor Lucas*

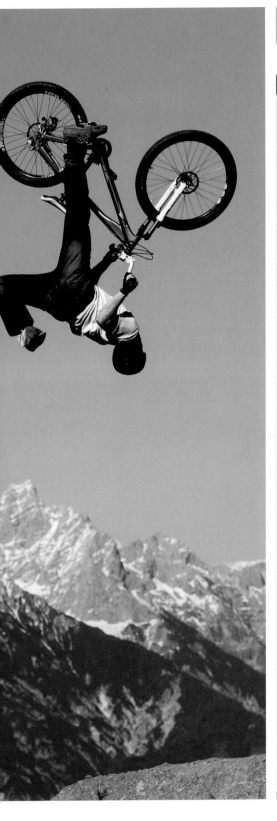

HOW TO FLIP DROP BY CAM McCAUL

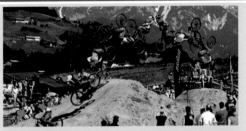

The first thing to think about is that you're usually coming off a considerably smaller lip than a normal drop so make sure you can flip all sorts of jumps first. There's way more at stake so you need to be confident you can control your flip speed and start your flip right.

Be a bit more exaggerated with your flip's rotation over a drop because you'll have to pop off it to get more out of the smaller lip.

Your pop on the lip will be like a bunny-hop, so take some speed off the run-in to get more vertical height without over-shooting the landing. You don't want to go too far, that would hurt.

It's not very natural without a big take-off so you'll have to exaggerate the flip with more body movement off the lip. Get used to this on smaller jumps first.

I usually cork mine out a bit so that I can see the landing a little earlier and it means I don't have to worry about hitting my head on the take off if it's a slow speed drop.

If you're under rotated because the drop is smaller than you thought, pull on the bars at the last second to get it round.

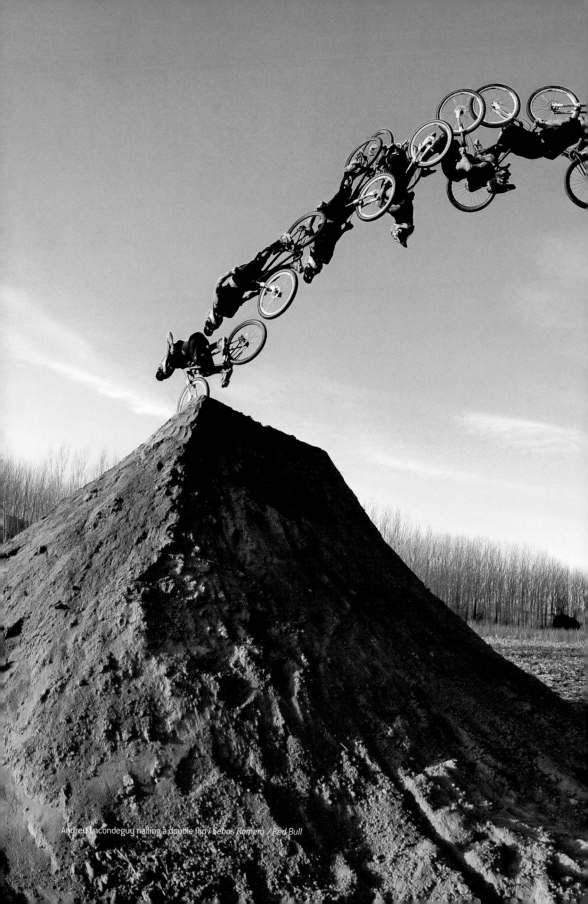

Andreu Lacondeguy nailing a double flip / *Sebas Romero* / *Red Bull*

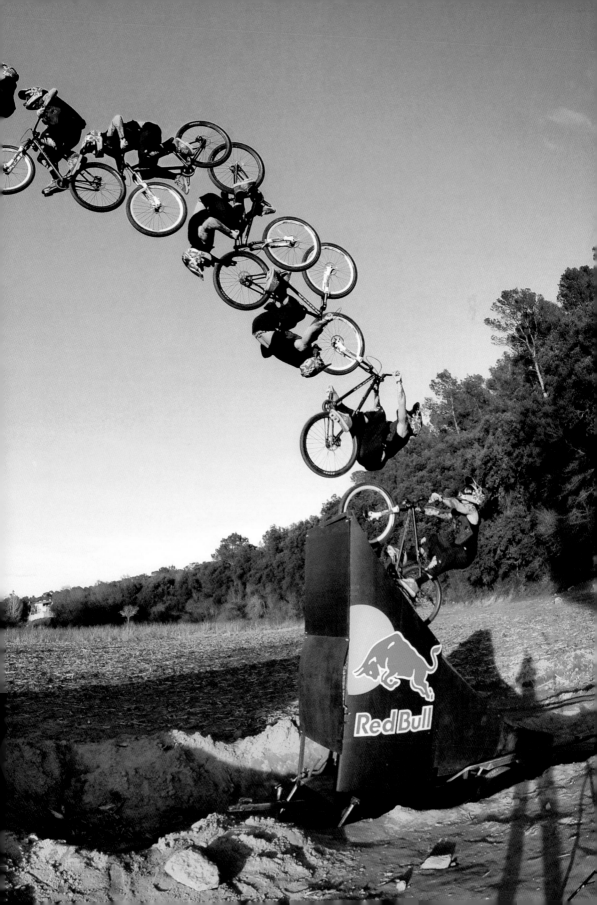

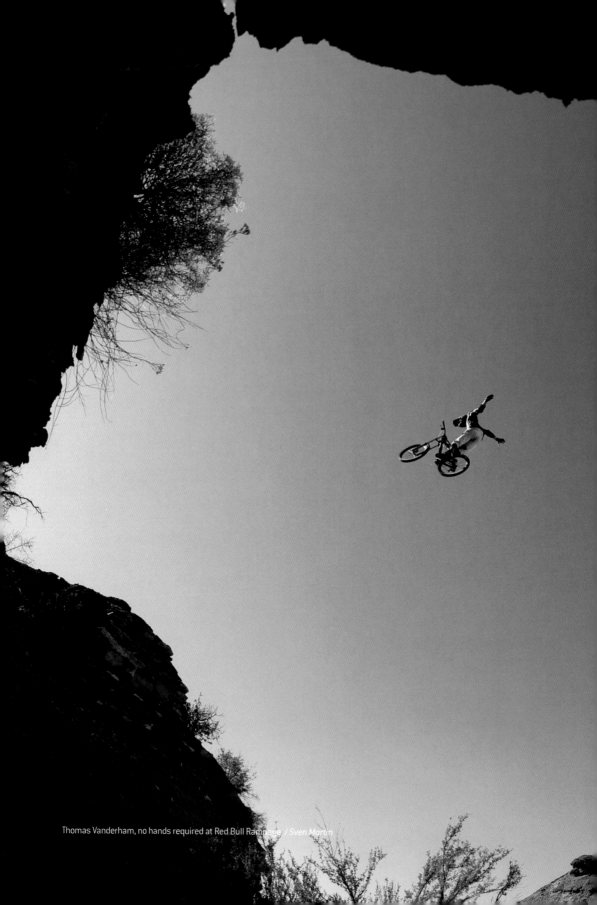

Thomas Vanderham, no hands required at Red Bull Rampage / *Sven Martin*

SUICIDE

Taking your hands off the bars is now a stock trick used by riders in most freeride comps. Regardless of whether you can 360° a drop, flip-whip a gap or crank-flip off a box, the simple, yet uber stylish no-hander still reigned supreme and won the best trick for Thomas Vanderham at the 2008 Red Bull Rampage.

Whether you stretch your arms out behind you in a Suicide or raise them above your head for an Old Skool No Hander, being able to lay one down over a gap can be one of the most simple yet stylish tricks possible.

For **Gee Atherton**, the no-hander is a stalwart of his trick regime. Although difficult to initially grasp, Gee feels that the no-hander isn't too hard. As he explains, *"It's a pretty basic trick once you have done it a few times, some people prefer to clamp their seat with their knees and throw their body and arms backwards. Others prefer to do a tuck no-hander, where they pull the bars into their lap and clamp the headtube with their knees. This is probably harder to learn but looks better in my opinion, with the front so high. Just watch out you don't loop out on the landing...."*

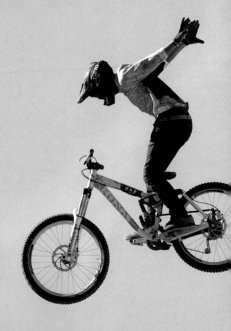

Graham Agassiz at Red Bull Rampage / *John Gibson* / *Red Bull*

Cam MCCaul / *Sven Martin*

360s

The 360 forms the basis for many other tricks and features in any number of freeride competitions and skateparks the world over.

The art of rotating throughout your jump isn't a million miles away from the techniques used by Tony Hawk on his skateboard, Shaun White in the snowboard half pipe or Dave Mirra on his BMX. However, as riding backwards out of a 180° is pretty difficult to do off road and near impossible at speed - by riding a mountain bike in reality you're going to have to get the full rotation done mid-flight.

360s are now being added to flips, whips, and drops but the fundamentals of learning where you are in your rotation is crucial to all of them. To develop your 'air awareness' it's useful to learn into a foam pit or on a trampoline. Only when you are confident you'll get the full way round and you know which way you're pointing should you try and throw one into your riding on dirt. **Danny MacAskill**, a man who's thrown 360s off everything from vertical drops to rock gaps, suggests learning onto something flat. "*Whether you're learning off a nice fly-off to a flat landing or you're trying to start with a 180° bunny-hop, learn to throw your head into the rotation and look around to spot your landing*".

Once you have a good understanding of where you are in the air and how to look through your rotation you can start to consider taking your new found trick onto bigger and bigger gaps. During the progress of developing your awareness when airborne **Danny MacAskill** suggests you "*start learning to carve up the take-off to initiate your spin*". Only then will you be able to add flow and style into your 360s.

One crucial element to remember is that once you throw your bike into its spin, you won't be able to stop it from rotating. To get over this you have to learn to get your timing spot on and how to match the effort you're putting in to the jump you're trying to land.

Over to **Danny** again for the landing - "*coming up a bit short with your rotation is ok. In fact even getting to 270° is cool. Just make sure you don't keep the front too high or you'll struggle to ride out of it. Instead, try pulling up with your feet and pushing down on your bars as you approach the landing*".

PRO TIP: DANNY MacASKSILL

" Always picture yourself landing the trick. I visualise all of the time and it helps when it comes to stomping my tricks first time. "

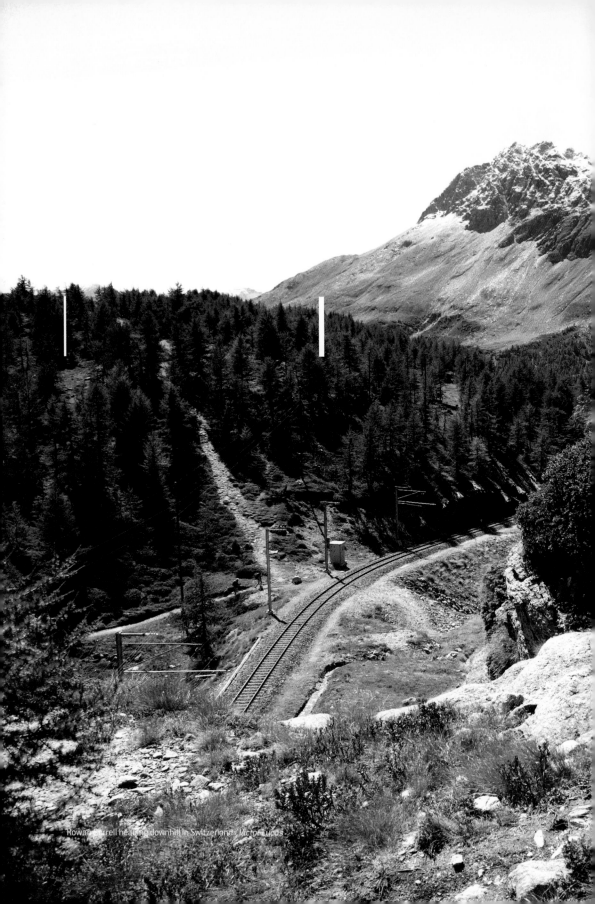

Rowan Sorrell heading downhill in Switzerland / Victor Lucas

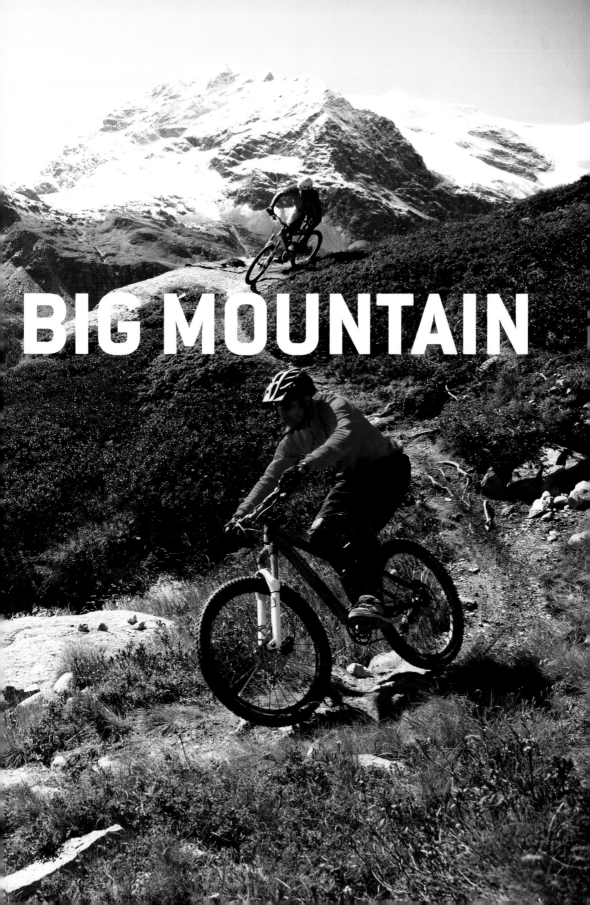

BIG MOUNTAIN

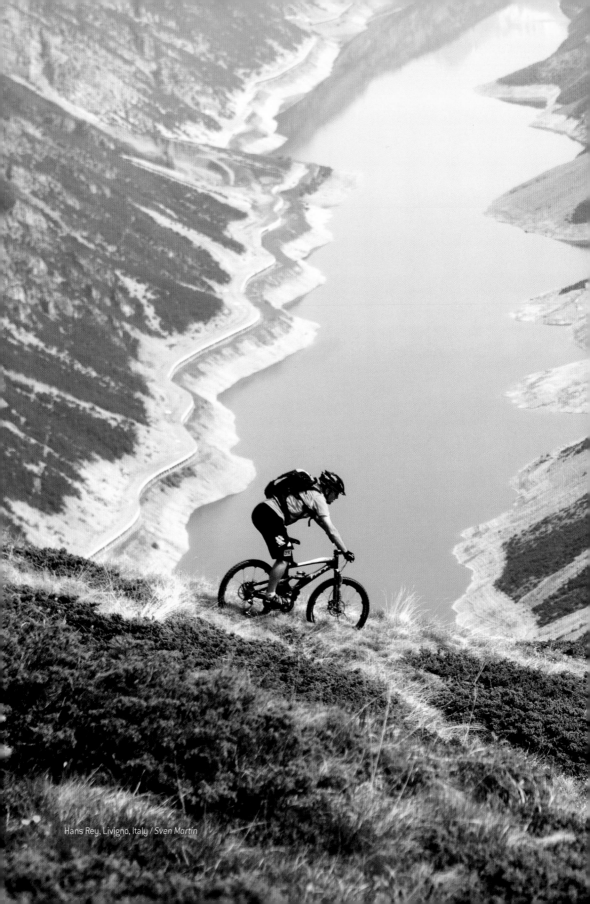

Hans Rey, Livigno, Italy / *Sven Martin*

BACK COUNTRY
The best trails are often in epic locations.

Maybe it's the feeling of remoteness, the sheer sense of scale that big country forces upon you or the isolation from the daily rigors of life that makes them so appealing. The sheer speed you can travel, the ground you can cover, the remote spots you can access.

With this beauty comes danger. Off the beaten track things can go very wrong, very quickly. Whether you're high on a ridge, in the middle of a dense forest or traversing across the side of an expansive valley. It might be fun, it might be beautiful, but it can bite. Hard.

Unlike other big mountain sports, the essential items most riders carry are beyond minimal. Too many are tempted to pack some fluids, a tube and pump and head out of the car park. Up here you can often run in to danger frighteningly fast and you're out of reach of everything but the air ambulance.

With the increased speed that you can carry over the wild, natural surfaces and the increasing technicality of the terrain modern trail bikes let us ride, having just a simple off can have pretty serious consequences. Even if the injury is minor, if you can't ride out, it may take medical help a while to reach you. What you carry can have a dramatic effect on the outcome of the situation.

Remember that although it may be warm when you leave, the weather systems in the mountains can change fast and leave you cold, wet and exposed. Try and think of what you might need should you have to stop. What would you be really glad to be carrying should you badly pretzel a wheel 40 clicks from civilisation, or find yourself babysitting a mate with a broken collar bone?

Being prepared can seem laborious. Why, when you're only going out for a half day ride should you need to pack a waterproof, survival blanket and first aid kit? Hopefully you'll never find out why but if you did need it, the extra few minutes filling your pack would be much appreciated. As British Army Sergeants are prone to preach: Prior Preparation Prevents Piss Poor Performance.

PRO TIP: RENE WILDHABER

Take into account that there's some luck involved in getting the bike in one piece down the mountain.

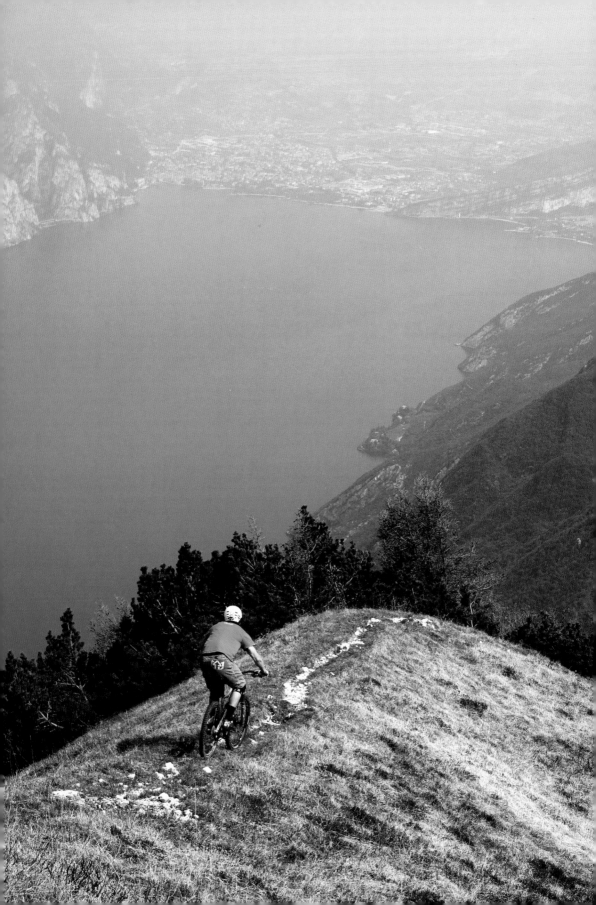

PLAN OF ATTACK

Don't just plan where you want to ride, think about how you could get out fast should the weather close in, or how you would handle an emergency. Your mobile would not be a lifeline if you were too deep in the wilderness to pick up a signal. Even if you could call, in a remote area help could well be a long time coming, so could you cope?

You and your bike should also be prepared for the challenge of Big Mountain riding. Are you fit enough? Do you have the skills? Big rocks and hard terrain demand strong tyres and solid components: choose your equipment accordingly. Don't take a feather to a gunfight.

Get yourself confident on big rock, steep chutes, loose surfaces and off-cambers. Man-made trail centres let you switch off and flow down the trail. In the mountains, you've got to be at the top of your game to take whatever gets thrown at you. If you've never ridden the trail before, expect nasty surprises. The wilds are no place for poor riding ability. Being unable to ride the trail will hinder your progress and expose you to more danger.

Rowan Sorrell heading down the Colma di Malcesine / *Victor Lucas*

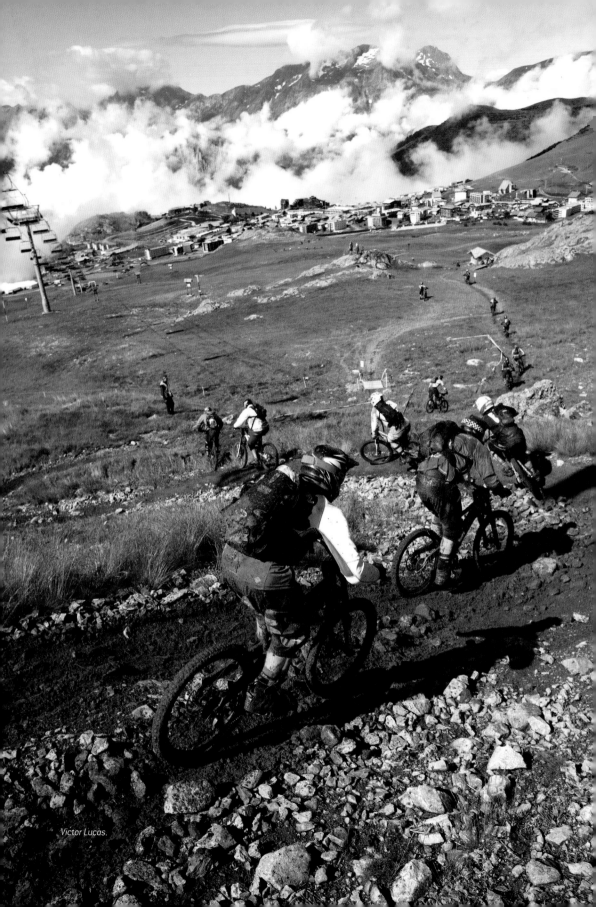

Victor Lucas.

CONDITIONS

The day starts off sunny. There are clouds in the blue sky high above the Alpine ridges, but it's warm and it looks like the finals of the 2007 World Cup in Champery will be on dry trails in mountain sunshine.

Mid afternoon rolls in and all hell breaks loose. Torrential rain and storms smash into the mountain and the course goes from tough but dry to a near impossible river-cut rut down the sheer mountainside. The riders on their way to the top have done their morning qualifying in the dry. Some are still running dry tyres and there aren't many waterproofs around.

In racing, bike set-up and mental preparation are key, but in Champery in 2007, suddenly all that ground-work was washed away in the rain. The challenge that separated the simply excellent riders from the ultimately superior was how to face this new situation without any prior preparation. How to face it and still win.

For the pros, being able to deal with rapidly changing track conditions is vitally important. With the sport generally held in mountainous terrain, the weather can do a 180° quicker than it takes to catch the chairlift to the top.

PRO TIP: TRACY MOSELEY

When conditions are getting tough. and that can be extreme wet, cold or heat, the first thing you need to do is make sure you look after yourself. This means you either need to be dry, warm or in the shade. Always take on enough fluid and food to be able to function. Always have enough clean and dry kit so that you are never sat around in the wet and cold. As soon as your body isn't working properly you're out of the game.

THINK AHEAD

Sometimes the conditions will make certain lines impossible. If you're a racer, keep this in mind when you're practicing and make a contingency plan. This could be as simple as choosing a tough off-camber line to use in the dry but having a look at an easier option in case the heavens open. By building this picture of the whole course, you won't have any nasty unexpected surprises come finals time.

Even if you aren't racing, be aware that the ideal line to take on a dry day won't be the same as the one you might have to take during a torrential mid-summer storm.

The wet specialist, **Sam Hill** agrees that changing your approach to line choice may be a good idea. *"Usually the only thing I would change for the wet would be to put on mud tyres. Everything else I would keep the same as what I am used to. I have a lot of confidence with the mud tyres on and know what they are capable of so I try and just ride them like I would ride with a dry tyre. However, if there's a line out there that might cross heaps of roots then I would rethink my line in that section if it was wet and take a safer option."*

PRACTICE

Experience should prepare you for what to expect so go out and train in as many different conditions as possible. One New Zealander on the World Cup circuit used to head out on rock-hard dry-pattern tyres in the pouring rain just to practice what they handled like. The better you know your bike and how far you can push it even in hellish conditions, the better rider you will be. If you are racing, it can make the difference between being just one of the pack or out in front.

In horrendous conditions, attacking can often be the answer. Hesitation and apprehension will often be punished with a face full of mud or dust. Greater experience of what to expect helped the guys at the top of Champery in '07 and it will help you out too when things take a turn for the worse.

PRO TIP: SAM HILL

I always try to attack the course whatever the conditions, but I guess the best thing to do is try to read the conditions during your run. If it's too loose, back it off a little. If you're getting traction everywhere and feel like you could step it up a little more, then do that.

MIND SET

Your frame of mind can make the difference between sliding on your back down the trail and nailing it like you are on rails. Stopping yourself from getting nervous is the hardest part, but as **Sam Hill** said in an interview after his Champery victory: *"I just hit it like it was dry."* That incredible mindset allowed him to excel in adversity and showed what determination and a complete lack of self-doubt can achieve.

Tracy Moseley adds, *"Your mental attitude can take a big strain in adverse conditions and it's often in these situations when you can win a race before you have even sat in the saddle. You've got to have a positive outlook and stop the elements from getting to you. It's the same for everyone on the*

hill that day and the person who deals with it the best will come out on top, every time."

For some, this level of confidence comes naturally. Many top athletes around the world have an unfaltering view of themselves that allows them to deal with the pressures they come across on a day-to-day business.

Victor Lucas

For mere mortals, the way you approach these conditions can be practiced. Put a positive slant on every thought. Rather than thinking *"That rut's new, it's going to knock me off balance"* try and think *"that rut will give me grip and support."* By kicking any negativity out of your head, you should feel like you can ride your trail as you do, regardless of whether it is snow, mud or dust, high winds, thick mist or dazzling sunlight.

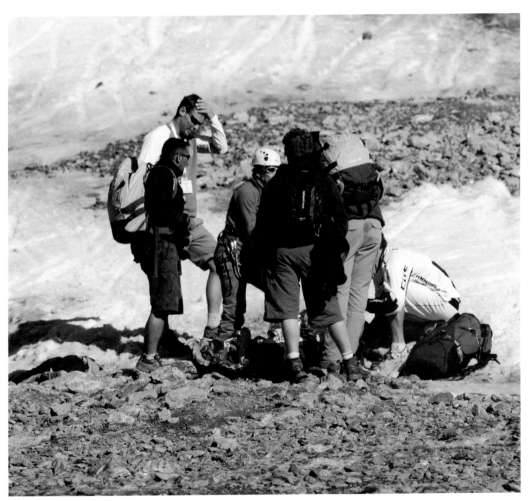

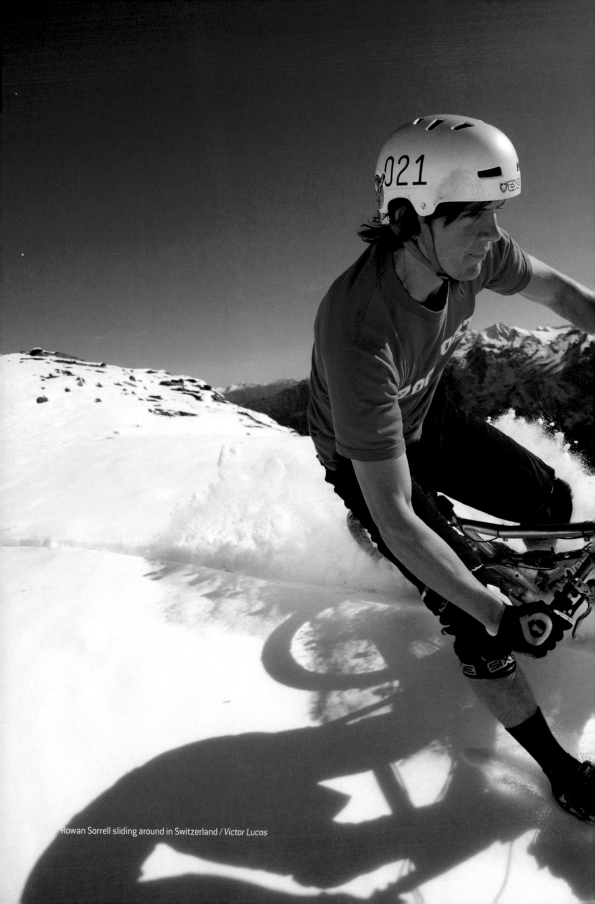

Rowan Sorrell sliding around in Switzerland / *Victor Lucas*

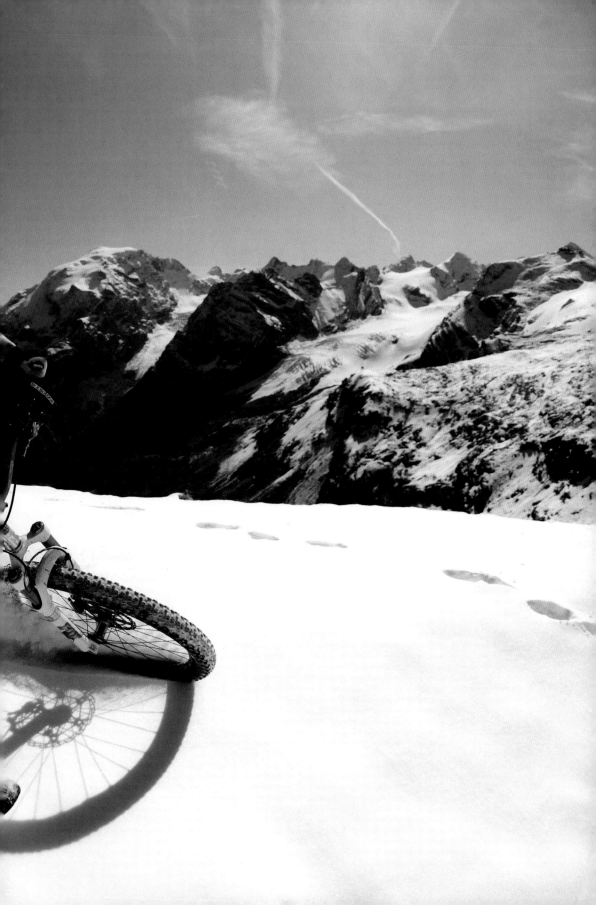

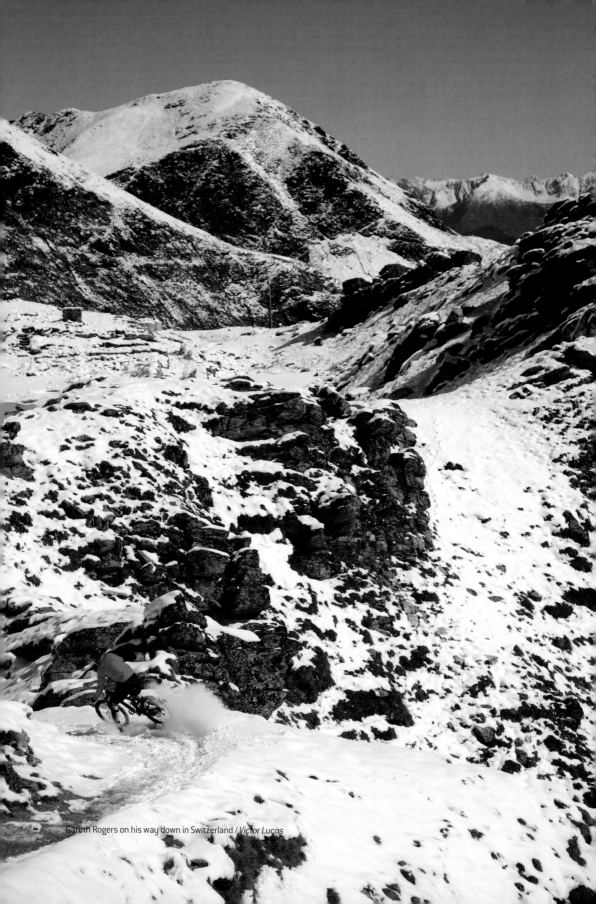

Gareth Rogers on his way down in Switzerland / *Victor Lucas*

SNOW AND ICE
Mountain bikes, snow and ice aren't always a great mix.

Unfortunately for some of us, we either brave the conditions and embrace the white stuff or leave the bike in the garage all winter. Winter aside, you might even come across a solid, icy drift high up in the mountains in June. You might even go one step further and enter one of the races like the Mega Avalanche or Mountain of Hell that start on a snowfield. Regardless of whether your snowy excursion is by chance or on purpose, there's a number of specific skills you need to master if you want to stay upright and keep moving forward.

CROSSING DRIFTS

The remnants of winter often linger on hillsides for months. After a heavy snowfall, you may still have to cross deep drifts into spring or higher up - mid-summer. It's not that uncommon to come across an old patch of snow by surprise so try and plan your route before you hit it. If the weather is warm or wet take extra care. The snow will likely be soft and there's nothing more sudden than the over-the-bars soft snow can produce.

Assess the area before your tyres hit the snow as once you've hit it, most of your control will be lost. Try and aim in the direction you want to finish up and avoid steering too much. If the bike slides and changes direction, you'll probably have to slide and go with it. It would be rare for a rider to win the fight for control over snow.

Moderate speed is your friend and braking is by far the worst thing you can do. Enter at a decent rolling speed and lay off the brakes. Pedalling gently is no bad thing so if you lose speed, add a pedal before it's too late.

To avoid your front wheel digging into soft, deep snow, you need to hold your body weight back over the rear wheel. Get your hips back and low - as though you are trying to sit on the back tyre. It may feel like your front wheel has gone light and you can't steer but if the snow is soft, trying to surf the front wheel across it is your only option. It's better to float across the top than stick straight in.

If it gets too deep and you're not going anywhere, save your energy, get the bike on your shoulder and hike your way out. Sometimes it makes more sense to conserve your energy and walk it. If the snow is hard, use your bike as a brace and lean on it. Conversely, floundering around in soft snow wastes time and energy so create solid footholds with a good kick and shoulder the bike.

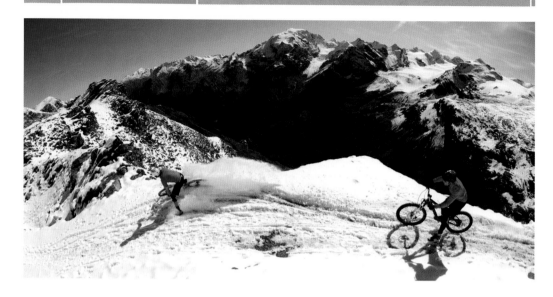

CLIMBING

Climbing in the snow can be a frustrating task. Fresh snow can provide a lot of grip and if it's shallow, cut your own tracks. This will avoid you getting cross-rutted and losing balance or slipping on hard snow. If the conditions are wet or the ice is slippery then you'll have to remain patient. Regardless of the snow type, select the lowest gears available and take your time. Find a rhythm and stick to it. Stopping will break your momentum and getting moving again can be near impossible. Likewise, climbing in the snow is a calorie-sapping venture so pace yourself from the start. It's rare to find a chance to catch your breath as you will have to work to keep the wheels rolling at all times.

Stay seated as much as possible. Your rear tyre is your friend and you have to avoid losing grip at all costs. Scan the trail ahead for any inclines, icy patches or ruts that may hinder your progress. If you see something that may cause you to stall, try a quick burst of speed to help carry you through the troublesome area. Keep your power delivery smooth and avoid any hard stomp on the pedals that will make the rear wheel spin.

DOWNHILL

If the conditions are right, descending on snow is one of the most fun experiences on a bike. Under the azure blue skies that only the freshest of winter days bring, letting it all hang out with what can seem like limitless boundaries is a moment to make the most of. In order to stay upright and enjoy your time on the snowpack there are a few rules you have to follow.

RELAX

You'll have far less control than you'll be used to. Snow doesn't offer anywhere near the same grip that dirt does unless you're running a seriously spiked tyre. Relax, go with the bike and don't fight things too much. You may have to brace your arms to keep things straight from time-to-time but if your rear wheel slides – let it. Get into the habit of riding with the bike and slope, not against them. The more you fight, the harder it will become.

Above:

Rowan Sorrell & Gareth Rogers on the snow in Switzerland / Victor Lucas

Right: Start of the Megavalanche in Alpe d'Huez, France / *Victor Lucas*

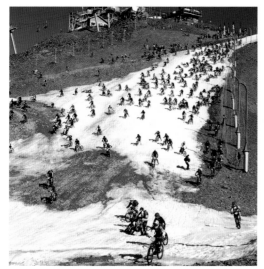

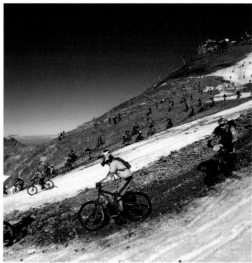

FEET OFF

If you know it's going to be a snowy ride before you set off, dig out the flat pedals. Not only will you avoid the hassle of cleats getting clogged with packed snow but you'll also find the freedom to hang a foot off on descents.

It's more important that you keep moving forward than it is staying neat and tidy. Trail your foot in the snow, hang out a leg for extra balance and be ready to dab if a slide comes from nowhere. This will help you relax and help keep you upright.

BRAKES

Much like mud, wet roots and loose corners, braking whilst on the snow isn't going to offer you much stability. If you have to slow down, drag your back brake whilst trying to keep your front wheel straight and afloat. Try and keep every movement, including your braking subtle and controlled. Panic braking, handfuls of front brake or any attempt to stop quickly will likely end with you on the floor.

TURNING

Keep your lines as straight as possible if you're on a soft snowfield. With your weight over the back it'll be hard to steer anyway so keep your forearms braced and guide the bike rather than force it in the direction you want to travel. If you're on a trail and trying to follow a line use the slippy nature of the snow to assist your turns. Instead of turning tightly with the front wheel, initiate the turn and then back off, letting the back wheel slide. Lean into the turn and stay relaxed. At this point taking a foot off will assist your balance greatly. If the slide gets a bit too much, turn into it. As you would in a car. A bit of Colin McCrae style can go a long way in tough, wintery conditions.

PRO TIP: RENE WILDHABER

On snow put your seat down and spread out one leg. It's way easier to keep your balance this way.

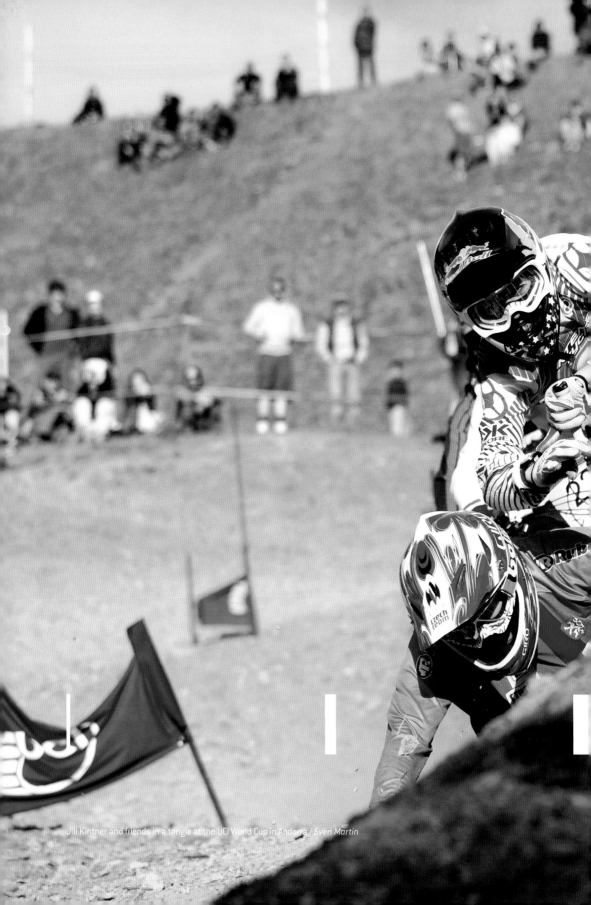

Jill Kintner and friends in a tangle at the UCI World Cup in Andorra / *Sven Martin*

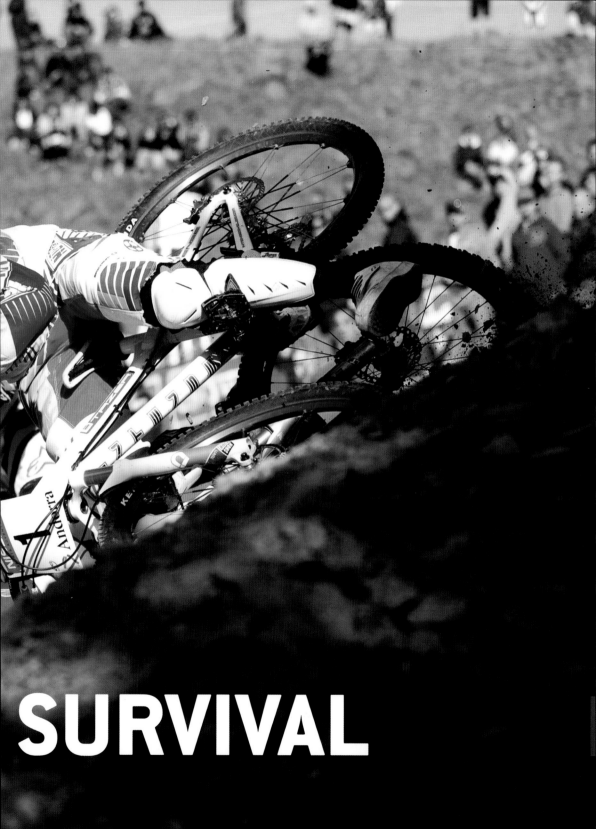

SURVIVAL

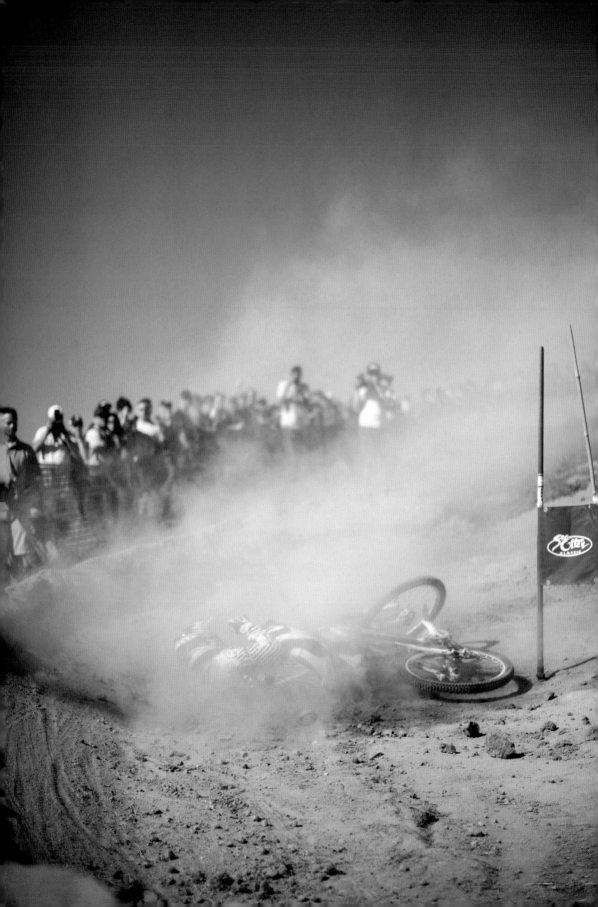

CRASHING
Ride a mountain bike and you will crash at some point.

You can't expect to play with gravity and win every time. Whether it's an annoying slow-mo comedy side fall as you fail to unclip your pedals in time when you stop, or a huge metal-snapping stack because you've come up short on a massive jump, falling off your bike is as sure as taxes. It's frightening, it's painful and it can be expensive, but you don't have to be a passenger when it all goes wrong: crashing can be controlled. There's a lot you can do to reduce the chance of that clumsy fall leading straight to the accident department of your local hospital.

NIPPING IT IN THE BUD

Most crashes can be avoided. In many cases you crash because you have hit the brakes. It may be counter-intuitive, but grabbing a handful of brake could be exactly what makes a face full of dirt inevitable. If you've read the technique sections on roots, rocks, corners and berms you should have noticed an overwhelming theme: don't brake when you need grip and balance. A rolling wheel has more grip and breaking a wheels forward motion will alter the balance of the bike and rider. If you are already on the ragged edge, braking may be just what sends you over.

That's all good physics and sound advice, but easier said than done. Faced with imminent doom, grabbing the brakes is a hard-wired survival instinct most riders find almost impossible to resist. It is difficult and can take painful practice, but in many situations the best thing you can do is ignore your primal gut reaction for self-preservation, relax and ride on through.

THE DISMOUNT

If a crash is inevitable it doesn't have to end in pain. You can choose to get off before you're thrown off. Control is the answer.

If you leave it too long the point of impact will be determined for you. It could be a nice soft bank, but chances are you will make contact with a rock, a tree trunk, or at best, a huge forest of nettles. If you read the situation and make a jump for it you will have voluntarily avoided the bike-led impact and regained some control of the situation. This can be the crucial factor. Often choosing to bail out will end painlessly

PRO TIP: CAM McCAUL

I think about how I crash a lot and that's how I avoid a lot of injuries.

Greg Minnaar taking a spill at the Sea Otter Classic / *Gary Perkin*

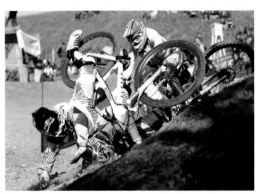

whereas holding on and hoping for for best will put your chances of survival in the hands of the gods. Another thing to consider is that when a crash is unavoidable the last thing you want near your soft vulnerable body is a load of metal, so throw the bike away.

Cam McCaul has had his fair share of crashes yet is calculated and planned in his approach. *"I think about how I crash a lot and that's how I avoid a lot of injuries. In the best-case scenario, I can see a crash coming and bail mid-air. That way I can work on staying upright in the air and control how I land. I've only just broken my first bone even though I've had hundreds of crashes. This approach has let me get away with this much so far."*

IMPACT ZONE

Hopefully your travel to this point will have been controlled at least to some extent by you, but even if you've been caught off guard and thrown, what you do when you hit the ground will be the deciding factor between riding home and sitting on the sofa in a sling for three weeks.

Dissipating the energy and speed of the crash is absolutely crucial. Hitting the trail like a sack of potatoes will only lead to injury and time off the bike. **McCaul** says he takes tips from the urban free running scene. *"I try and land just like the Parcour guys. They go into a somersault when they land to spread the force. By rolling it stops all that impact going straight into your collarbone. Instead of landing facing forwards and smashing your face into the ground, I try and land like I'm on a surfboard, feet first but facing sideways and then roll onto my shoulders."*

PRO TIP: CAM McCAUL

❝ The best way to practice landing with the right body parts first is to get on a trampoline and learn some body-awareness. By doing that you'll learn how to get yourself upright and not get too confused when you're spinning and flipping all over the place. ❞

Crash at the UCI World Cup in Andorra / *Sven Martin*

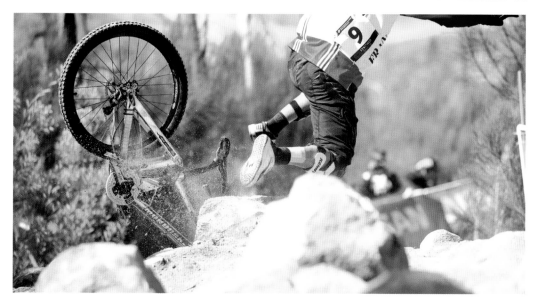

How to hop off in a hurry / *Sven Martin*

TRAIN

How fit you are can determine how seriously you are injured in a crash. The fitter you are, the greater the chance of survival. Body size can also be a factor. As one of the bigger riders, **Chris Kovarik** feels that, "*If you are a smaller rider it might help to bulk up a little to help protect yourself if you crash*". Your muscle bulk will add something to how protected you are in an accident but won't go the whole way to keeping you injury proof. Doing as McCaul does and rolling out of crashes needs a certain level of flexibility and strength.

Stiff joints won't react well to being bashed and stretched so if you feel like tension is inhibiting your free movement, get on a flexibility programme or try yoga. As yoga increases your levels of flexibility and postural strength, it can be an invaluable tool to use if you need to work on this area of your performance.

Your lack of flexibility may be down to older injuries and it's worth making sure that you tape, strap or brace any weak areas that may be susceptible to further damage. However, don't rely on artificial bracing if simple strengthening exercises can do the job. By only riding in a brace you may start to become too reliant on the external support, causing you to lose strength and stability in the joint itself. Keep on top of old injuries and find an understanding sports physiotherapist to give you the low down on how to keep in shape.

Prehab instead of rehab is now taken very seriously among sports institutes and professional athletes. By finding weaknesses and discovering potential injury sites early on, a lot can be done to future proof your body and avoid serious injuries further down the line. The simple rules - stay healthy and look after yourself. See a good physiotherapist if you have any slight niggles and get them treated while they are still small niggles, not chronic conditions.

Gee Atherton / *Sven Martin*

THE COME BACK KING: RETURNING FROM INJURY

"Our greatest glory is not in never falling, but in rising every time we fall."

Confucius was right, but in our sport the falls can be hard and the comeback long and difficult. In recent seasons, injury rates among top riders has been steadily rising as the number of genuine title challengers increases, the winning margin narrows and boundaries are pushed.

It's not just the pros: developments in bike technology are allowing us all to travel faster down trails that are constantly becoming more technical. A major injury, though by no means inevitable, is a real possibility. The pain, the treatment and the monotonous hours of rehab are enough to deal with, but even with that conquered, getting back to your previous level will require a solid state of mind. Sometimes your nemesis may just be the conditions you fell in or the actual section of trail itself. At the other extreme you may suffer a complete crisis of confidence that undermines everything you try to do on a bike. Both are surmountable.

Generally, poor performance following a smash is down to damaged confidence. Downward spirals are easy to get into; one minute you're on top of your game and the next you're in severe pain. Six months down the line, you are unfit and unable to talk yourself into hitting the same lines that you were dancing down

before the crash. Any unsuccessful attempts compound your negative self-image and before you know it you no longer ride tough routes, you don't race any more or you find yourself actually getting off your bike and walking through sections you would have previously ridden with ease.

The first thing many top riders do after a crash is get back in the saddle and ride the section that bucked them as soon as they can - sometimes they do this while they are still bleeding. By confirming to themselves that they can in fact do it, their confidence may only take the slightest of knocks, that's if there's any knock at all.

Apart from the bash your confidence takes in a crash, there is also the mental tedium of rehabilitation to deal with. Being stuck at home doing simple strength building exercise while your mates are out riding the

PRO TIP: GREG MINNAAR

Take the time to heal up properly. Recovering from an injury can be long but it's super important if you want to perform with confidence. There are no short cuts in recovery.

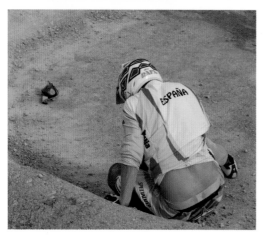

Rafa Alvarez after a tumble at the World Champs in Canberra / *Gary Perkin*

trails is not likely to place you in a good frame of mind. Especially after a bad injury, it is easy to be negative and think that your pre-injury form is gone forever and the long, uncomfortable road to recovery will never end. **Steve Peat** has had some big injuries in his career but returns to the podium every time. The drive to make that return to the top is set deep within him. *"My biggest motivation is that I have sampled the top of the podium a few times and I really like that feeling. I also enjoy riding my bike and racing my bike, so for me the motivation is naturally there to come back as quick as I can. I don't like to milk my injuries and have people feeling sorry for me. Get back on it and enjoy."*

GET UP AND DUST YOURSELF DOWN

Rehabilitation is a mind game. Yes, treatment, therapy and retraining damaged muscles are vital, but put your head right and the whole process gets easier.

Appropriate psychological strategies have been shown to improve healing and increase rehab rates. There are three fundamental tactics used by many elite athletes when they are recovering from injury.

1. TARGET IT

Set yourself targets and goals. Aim for something and the likelihood is that you will get it. Use these throughout your rehab and then continue when you get back on the bike. Next thing you know, you'll be right back where you were. Just keep them simple and achievable.

2. VOICE IN MY HEAD

You can often be your own best coach, but it's how you speak to yourself that counts. Keep all those inner-thoughts encouraging and beneficial. Positive self-talk will go a long way to getting you back in the saddle, with that injury quickly becoming just a bad memory.

3. IMAGINE ALL THE PEOPLE

The well-known US sports psychologist, **Linda Bunker** once said, *"Winners see what they want to happen; losers see what they fear."*

Visualisation is very important for successful rehabilitation and return to form. Although Linda makes it seem competitive sport focused by using the terms 'winners' and 'losers', the same can be said for recreational riders regardless of ability. Think about how to do something rather than how not to do it, stay relaxed and your confidence will return. Your past form won't be far behind.

PRO TIP: DANNY MacASKILL

When out injured my mind ticks over more than it does when I'm riding. I spend my days daydreaming about tricks and what I want to do. Although I may be a bit rusty at first, I always come back energised with my mind at 100%.

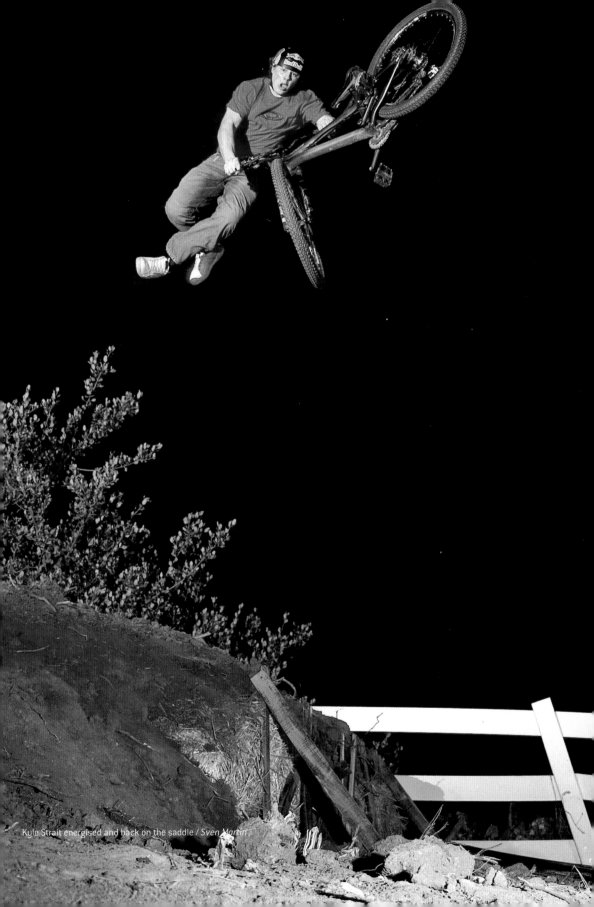

Kyle Strait energised and back on the saddle / *Sven Martin*

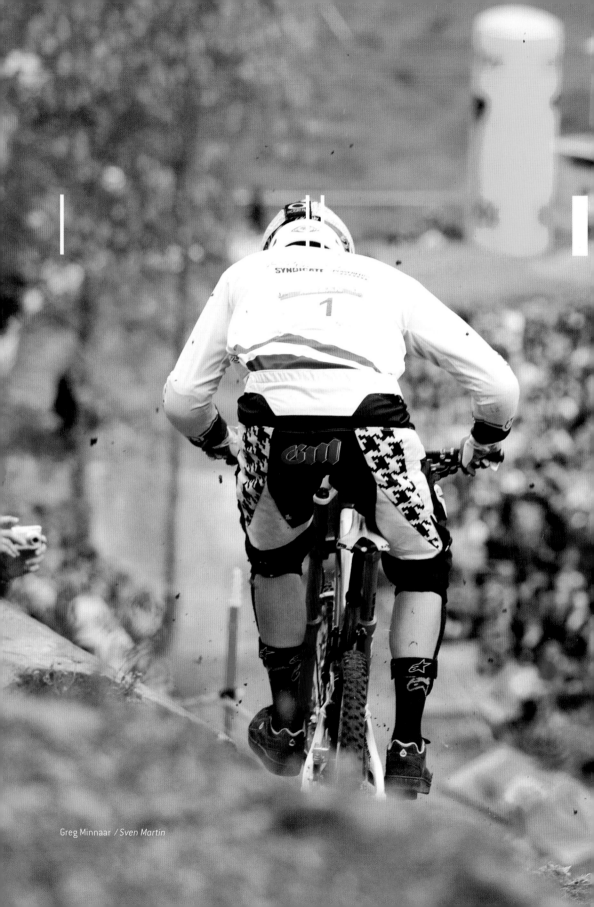

Greg Minnaar / *Sven Martin*

COMPETITION

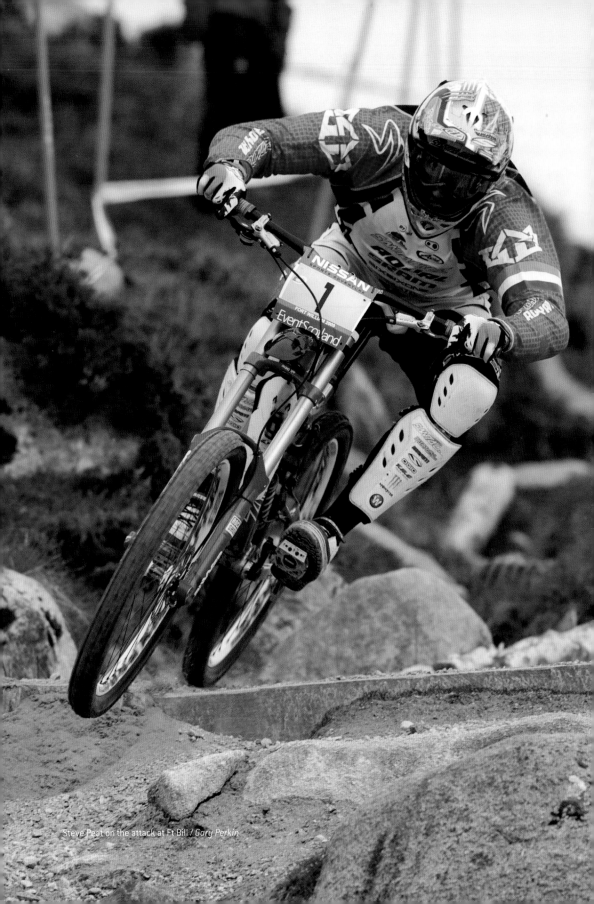

Steve Peat on the attack at Ft Bill / *Gary Perkin*

HITTING THE BIG TIME
What separates the normal riders from the greats?

How do some go from winning a Junior race in a muddy field to standing on the top step of a World Championship podium? These questions get asked time and time again. Whether it's from the aspiring young riders pushing week in week out to win their local series or the recreational rider, stuck on a Blue route and feeling in complete disarray as to how the riders immortalised on film in his DVD cabinet do what they do.

Bobby Behan, Specialized World Cup team manager, has seen his fair share of talent and knows what to look for when searching to sign future champions. *"There are many attributes one can look for and a rider must aspire to have in order for an athlete to reach the top level. There's no substitute for natural talent, so obviously an important work ethic coupled with the natural ability to compete against the world's best is paramount."*

A rider's mental approach to their sport is one of the most highly regarded assets and **Behan** believes that an in-built desire to win is crucial. *"Personally, a lot of top athletes I have met over the years have great self-belief, confidence, determination and an in-built level of self discipline, especially the latter in more endurance based disciplines, where long training hours can wear someone down. I feel that at the sharp end, the mental side in many cases separates the premier athletes from the mid-pack rider."*

If mental toughness, personal application and determination are the key to reaching the top, what gives one World-Class rider the edge over another on any given day? Psychologists talk of athletes entering flow states and situations whereby a gold medal winning performance becomes easy, almost feeling like the natural thing to do. Achieving this perfect homeostasis within your surroundings is what you need to do to get to the top.

Whether this mental state can be manufactured or not will be debated for years to come, but regardless of the process, the need for a focused mind is certain. **Behan** adds, *"The mental side can really be a factor when it comes to separating athletes at the top end of racing. This, in my opinion, can be the difference*

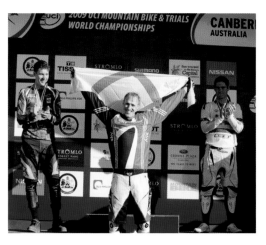

Steve Peat after his 2009 win in Canberra / *Gary Perkin*

between second and fourth. It takes a unique person mentally, who can push day after day, while also having the confidence of knowing when to back off. It also takes a special person to push that extra little bit come race day."

Psychology aside, you have to think about what other areas you need to build on. It's one thing having a strong mind; it's another having a body that will support it.

Taking the step into the Pro ranks is a big leap to make and often riders who surpass all expectation in juniors, fail to make the grade. **Ruaridh Cunningham** had to take on Pro after winning the Junior World Championships in 2007.

"I learned a lot in my first year pro and I'm sure I'll continue to learn. The intensity of riding is just a different level. You no longer compare yourself to the fastest juniors, instead you're up against the World's best and that's not easy. Skill will only get you so far and you have to transform your training to make the step up. If you want to battle with the top riders in the world you have to act like them. Training becomes your priority and you have to give everything 100%."

PRO TIP: **RUARIDH CUNNINGHAM**

If you want to battle with the top riders in the world you have to act like them.

Scramble at the start of an XC race in Schladming / *Gary Perkin*

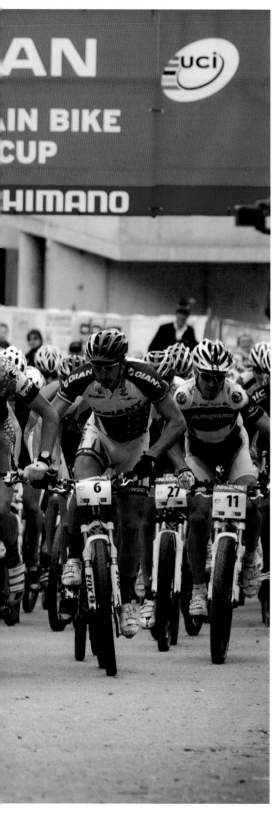

BEFORE THE EVENT

Thousands of screaming fans line the tapes using everything they can to make more noise. Old forks legs are recycled into tubular instruments of sound. The cacophony of cowbells, air horns and megaphones fill the air. Underneath the blanket of noise, mechanics, managers and riders prepare for battle. Sometimes there's money at stake, sometimes it's points, medals and championships. Sometimes only pride is on the table.

Cleaning a run can be hard enough on its own, without the added pressure that big events bring. There can be a lot to lose, sometimes more than there is to win; yet excuses must be left aside. When the beeper, gun or gate goes, everything has to work - and work faultlessly. Some would argue that this is where the top coin is earned. Handling the immense pressure, performing under stress and still nailing the race is without doubt the toughest thing anyone has to do in mountain biking.

The ability to switch it on at the right time is a skill that the top riders plan and prepare for. Standing behind the tape, watching the carnage of second day practice unfold at the 2008 World Cup finals, a photographer commented on a rider who'd just anni-hilated a vicious technical section. Looking on pas-sively he said *"Well, he's winning practice."* It was true, the rider was having his day, unfortunately though, it was the wrong day and come the finals his name appeared half way down the results sheet. Why then was this speed not transferred when it counted?

A lot comes down to pressure and how it's dealt with. Putting together a world class performance under these conditions is often what makes the

greats stand above the loose cannons. Seldom do the top riders lose their bottle and get things wrong. But, when things do go rubber up, it's often because the heady mix of competition and testosterone has come in too concentrated a solution to control.

Behan again: "*You need to expose yourself to other competitive levels before you take the big lunge and enter a World Cup. This will give you a measure of what to expect and handle the pressure better. For cross-country, one of the biggest issues is the start because of the sheer number of riders. Set yourself a realistic goal. For example, when Burry Stander first started out his aim was not to get lapped!*"

PRO TIP: JOSH BRYCELAND
2008 Junior World Champion

The hours and minutes before your race are often far harder than the race itself.

 Music helps me a lot at races while I think about good times and really good results I've had to boost my confidence and help me feel good about myself. That way I can get really confident while I prepare for my run..

1. BUILD UP

Sometimes the build up can span months. For Olympians, four years of focused and dedicated effort is required. Thinking of one performance for that long can build the pressure and stress to mind-bending levels. Goals and smaller steps along the way help to break the process down, but the lingering image of a start line, months away are never far from away. Cristoph Sauser has competed at three Olympics and in 2008 smashed the field to win the UCI Cross-Country Mountain Bike World Championships. In the intense heat that decimated most of the field and forced Julien Absalon, four times World Champion and twice Olympic gold medalist into retirement, Sauser powered on to deservedly take the rainbow stripes.

2. ATTITUDE AND FITNESS

Speaking of his legendary gold medal winning performance, **Sauser** put a lot of his race down to mental state. "*You have to be 100% prepared both physically and mentally to win such a big race. I get into a zone that's hard to describe and I have no formula for how I do it. I do no mental training but the racing and adrenaline make it come naturally to me.*"

After his World Championship win, **Ruaridh Cunningham** said that just before the start it all suddenly became clear just what he had to do. "*It became simple, I had to corner fast and pedal hard.*" He obviously did as he went on to win, yet in the months beforehand the pressure had been hard to deal with. "*I knew I could win it and as it was on home soil, I was nervous about the event six months beforehand. I was leading the junior World Cup and qualified fastest on the Saturday. I knew what it would take to put down a winning run. In my warm up I listened to music and stayed relaxed. When I reached the start line I was prepared,*

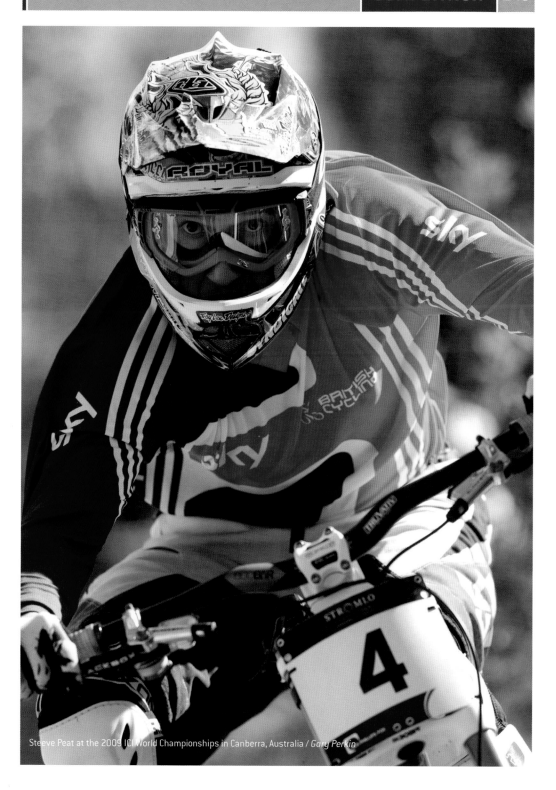

Steeve Peat at the 2009 ICI World Championships in Canberra, Australia / *Gary Perkin*

I'd spent nearly 12 months working towards that run and I sure as hell wasn't going to throw it away." Like Bryceland, **Cunningham** still *"listens to music at the start to take my mind off any doubts".*

For others, getting into the right mindset is entirely visual. Knowing a course is crucial and at any big event, riders will spend hours learning every line, every corner and where the limits are. Re-riding the course in your mind can confirm where you need to go and focus you on what you need to do, pushing all the thoughts of fans, points and prize money to the side.

McCaul is one rider who finds accurate visualisation of his ride will set him up for success. *"First I make sure I want to do something and if I do, instinct takes over. At the Rampage I had no practice but I really wanted it, so I pictured my run and saw it working perfectly. If you can play it out in your head then it'll go the same way when you ride. I always do that before a contest run. I'll see the whole thing through and it stops me worrying about it."*

View of the course in Vallmord, Andorra / *Sven Martin*

3. WALK THE LINE

Getting to the start line in the best shape is often a real challenge. Depending on the competition you're in, you may have a few hours or even a few days of practice beforehand. Even if you're an event veteran, it can be easy to get knocked off kilter or start doubting yourself. The best policy is to do what you think is best and stick to it. A slower line that you're riding well is quite often faster than a fast line that you ride apprehensively.

Peat, Hill, Atherton, Sauser and the rest will all be self-assured during pre-event practice. If they think it's right, in their minds, it is. This confidence is one of the attributes that got them to the level they operate at.

During training for the 2008 World Championships in Val Di Sole, Italy, my assistant coach, an experienced guy in cross-country himself, told me that even although he didn't know who the top downhillers were, he could tell by their body language during training. As an outsider, it was obvious to him that the riders who paused, looked, decided and carried on were the ones to watch. The little groups huddled together conversing intently and changing their minds every ten seconds were screaming indecisiveness and stood out as rank outsiders. He was right and he could tell me who a big name was even when they were standing course side with their helmets on.

Regardless of your discipline, make up your mind and stick to it for the finals. At the end of the day, you know best.

5. KNOW YOUR CLOUDS

A bit of meteorology never hurt anyone. As all wise mountain men know, being able to read the sky can pay dividends. If you're at a venue for a few days beforehand, note whether there's any routine to the weather systems. You never know, it might rain bang on 3pm every day or it might always dry up at noon. Whatever the weather's doing at the time, second-guessing what might happen later is a talent that could put you on the top step of the podium. The better you know the clouds, the more exact you can be with tyre choice, clothing, line choice, feeding and race strategy. Changes in the weather can really mess with people's heads; think a few hours ahead and your route to the top will be far quicker.

6. WARM UP

It's unlikely you'd do a weights session cold, so why would you race without warming up properly first? In terms of competition, use the warm up to increase circulation and muscle tissue warmth but also to get you moving and fired up before you reach the start line. By standing around, getting stiff, the only benefit will be to those you're racing against. For short, sprint events like downhill, it's been shown that a warm up including short bursts of high intensities will improve the power output of your muscles. The gains are obvious, so learn a routine that works for you and start using it in the final fifteen minutes before the gun.

4. REPLICATE THE EVENT

To be at your best you've got to know what to expect and have prepared for it. There's little point in aiming to win a 24 hour race without having trained your body to ride at 2am. Likewise, at World Cups if you're getting up at 7am on Finals Day, don't sleep in all week.

How you organise your feeding, rest, practice and everything else should be designed to replicate the event. It's also worth noting that regardless of what advice you're given, finding something that works for you is the most important. Everyone works differently and your routine should reflect this. The fine-tuning of your program and the thought that goes into each detail is the keystone to transforming success in training to medals on the track.

PRO TIP: BOBBY BEHAN

❝ *Train your body clock and other systems respective to the timing of the big day.* ❞

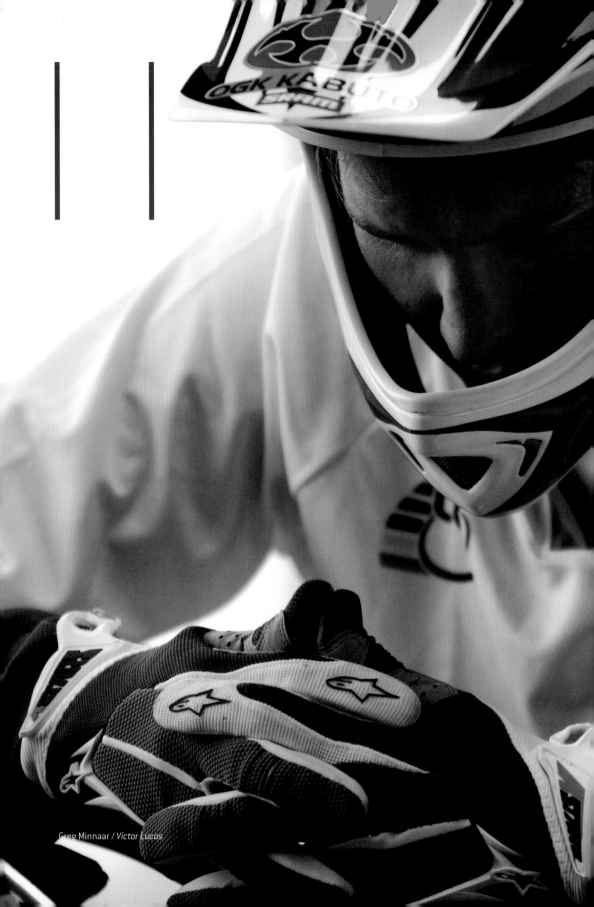

Greg Minnaar / *Victor Lucas*

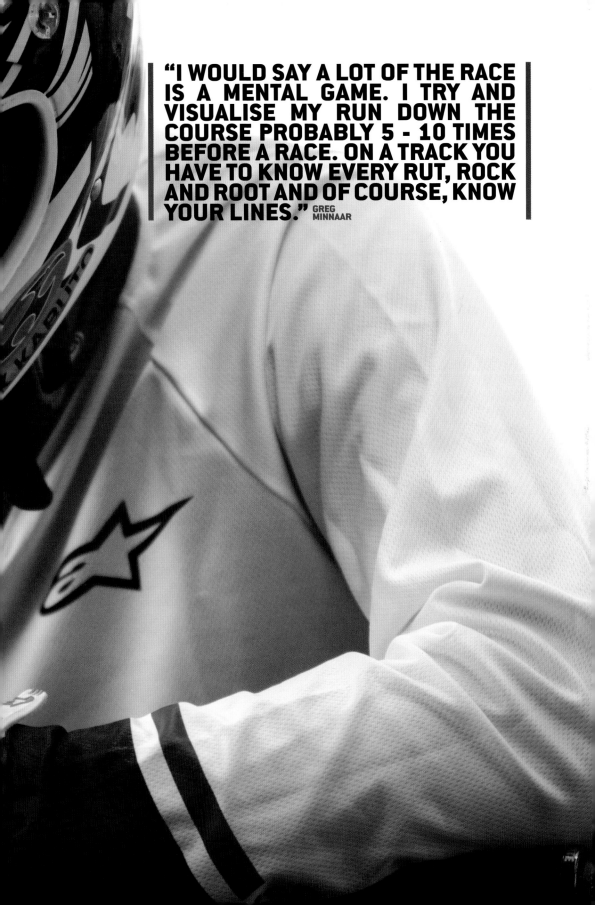

"I WOULD SAY A LOT OF THE RACE IS A MENTAL GAME. I TRY AND VISUALISE MY RUN DOWN THE COURSE PROBABLY 5 - 10 TIMES BEFORE A RACE. ON A TRACK YOU HAVE TO KNOW EVERY RUT, ROCK AND ROOT AND OF COURSE, KNOW YOUR LINES." GREG MINNAAR

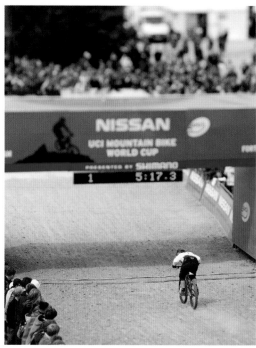

DURING THE EVENT

1. OBSERVE EVERYTHING

Getting flustered is easy at events. You've probably been to the toilet a hundred times and still need to go. You might be pacing up and down, checking and re-checking your shoe laces. It affects different people in different ways but if you're prone to a bit of stress, make sure you know exactly what you're doing.

Know your start time, wear a watch, be aware of the times the course is open and closed, where different things are and how to get what you need. The last thing you need is to hit panic stations and have to rush around with two minutes to go. The amount of people that don't know the basics is astonishing, work them out for yourself and you're already one up come finals time.

2. TALK QUALIFYING

If your event has a semi final, a qualifying or a seeding, have a think about it. If you're a rookie, keep it simple and just aim to get into the final bunch. If you're looking for that something extra and you have a good grasp on the field, use it to your advantage. At World's, some downhillers will run slow to get a more favourable start position out of the spotlight and pressure the final runners come under.

For other events, plan through your race strategy beforehand so you know what to do or what to expect out on the course. Whether it's hard off the front, a slow build up, or you need to be ahead of someone at a crucial point, having an idea of the way the race will go will help you prepare mentally and race efficiently.

From left to right: Sam Hill / *Sven Martin*

Finish Line at Fort Williams / *Sven Martin*

Gee Atherton in the start box at Fort William / *Sven Martin*

3. ON CUE

Sometimes you need to find that extra percent on the start line. You need to shift up a gear and squeeze all that practice into one go. Your placing in the final is the only record on the result sheet so you need to make it count. To help channel all your energy, it might take something to cue your mental processes. Here are some things riders have used to separate the training from the race...

FANCY DRESS

Gloves, goggles or shoes have all been used to make a rider realise that this ride is different from the others. It may be white gloves or white shoes. Gold goggles or different colour shorts. Whatever gets used, putting on that special item of kit will start to get you thinking and preparing for the race ahead. The trick here is to only use your chosen piece for racing so you make the instant link between wearing it and what lies ahead.

TOP TUBE ART

Sometimes the little things in life mean the most. Although a picture can say a thousand words, a word can save you a lot of time. A few riders scrawl phrases on their top tubes to glance at before the final beeper goes. The phrase always has meaning and can give you the extra focus when you need it. Short and sweet is the best policy for catchphrases. Keep it personal and let it spark the same feelings every time. It might work, it might not. But if you've exhausted everything else, try it out.

Dan Atherton getting ready / *Sven Martin*

AFTER THE EVENT

THEME TUNE

A lot of athletes now wear headphones before competition. Not only will it stop by-standers from bothering you and putting you off your final prep, you can also listen to music that stirs up some energy in you.

A theme tune can work for some as a cue to getting hyped up. Find a song that works for you and listen to it before your ride. By entering into this routine, you'll gain more confidence and feel more in control of your surroundings.

FINE TUNING

After all is said and done, don't just pack up, go home and wash your kit for the next round. Instead, think about your race. If the event publishes lap and split times, compare them to your competitors and work out where you gained and lost time. This is invaluable data to feed back into your training. For example, if you lost all your time in the flatter, sprint sections of the course, work on your power. If you gained all your time on the climbs but went backwards in the technical sections, get out and drop some seconds off your technical riding.

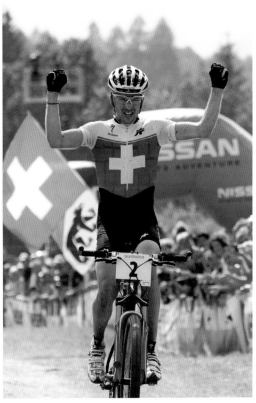

Christoph Sauser reflecting on a tough XC race (above) and winning the World Champs at Val Di Sole (Right) / *Gary Perkin*

SECRET TO SUCCESS

The ultimate feedback is film. Football managers, golfers and many other sports use video playback. If you can get yourself filmed or get a video from the event you'll probably see things you never thought you would; it is by far the best way to directly evaluate your ride. Your own feeling and experience is one thing, actually seeing your performance is another. The most common one is a rider saying that they sprinted across the line, or pedalled flat out only to see twenty other riders sprinting far faster than they were on the film. Without seeing it, it's unlikely you'll ever fully grasp what you were actually doing during the race.

We've now discussed everything from training and nutrition to attitude and technique. However, there's one last thing that needs to be mentioned. Whether you want to win your local club race or a World Cup, you always need to make sure you're enjoying yourself. Countless top riders, from Steve Peat to Danny MacAskill will tell you that when they are having fun, they are riding well, and vice versa. We partake in sport to challenge ourselves, achieve personal goals and most of all - for the sheer fun of it. That should never be forgotten. So, next time you're out on your bike make sure you sit up, take in your surroundings and smile. You're part of a great sport.

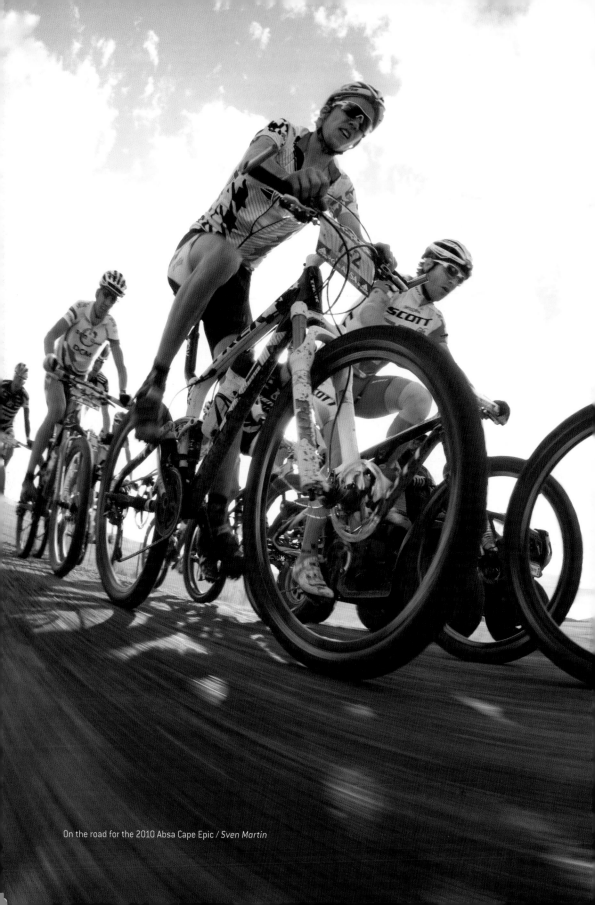

On the road for the 2010 Absa Cape Epic / *Sven Martin*

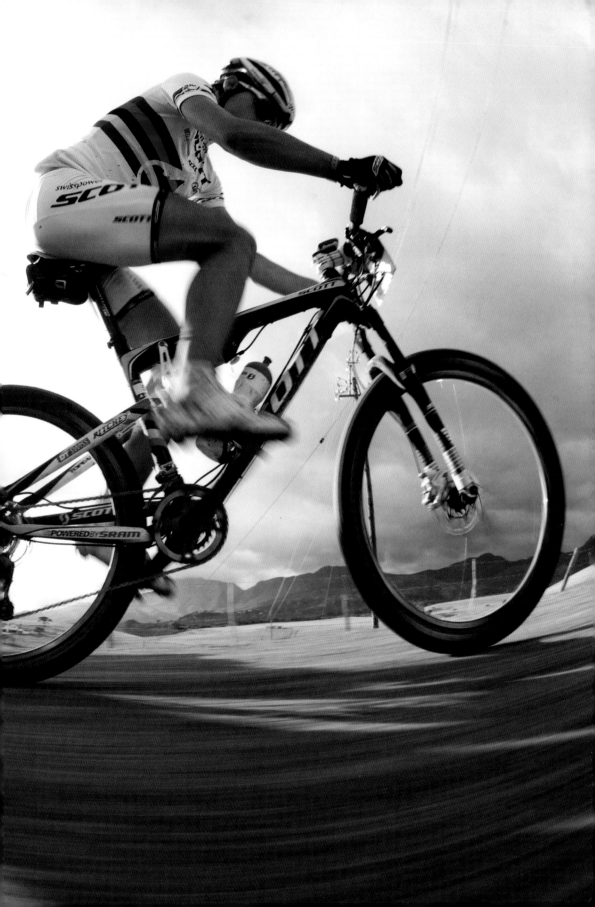

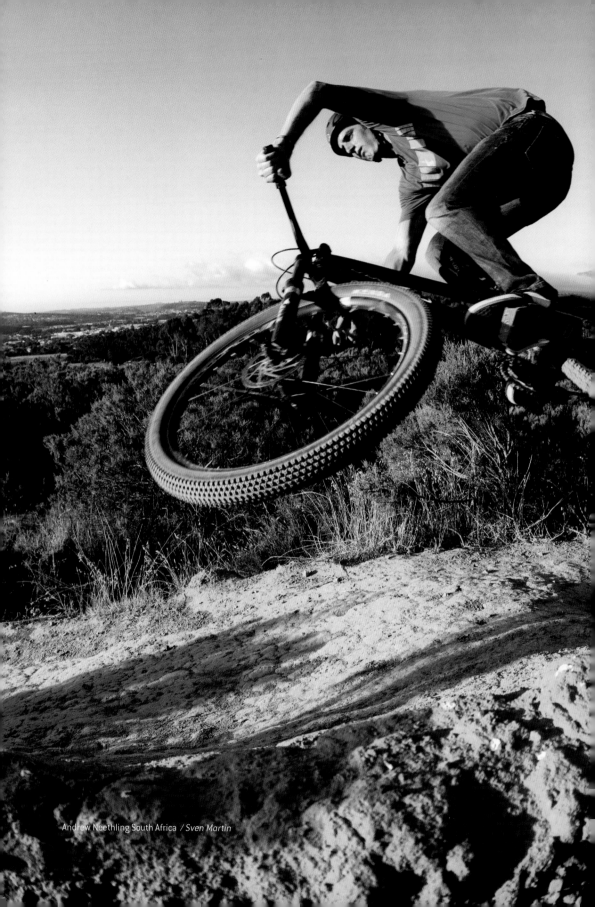

Andrew Neethling South Africa / *Sven Martin*

Published by Wavefinder Ltd

When not on your bike, check out our Wavefinder surf guides and Snowfinder ski guides to help you find all the best spots and slopes around the globe.

info@wave-finder.com

www.wave-finder.com

Publisher of the award winning Pocket size Wavefinder and Snowfinder guides

Wavefinder guides:
Australia
USA & Hawaii
Indonesia
Mexico
Central America
UK & Ireland

Snowfinder guides:
France
USA
Austria

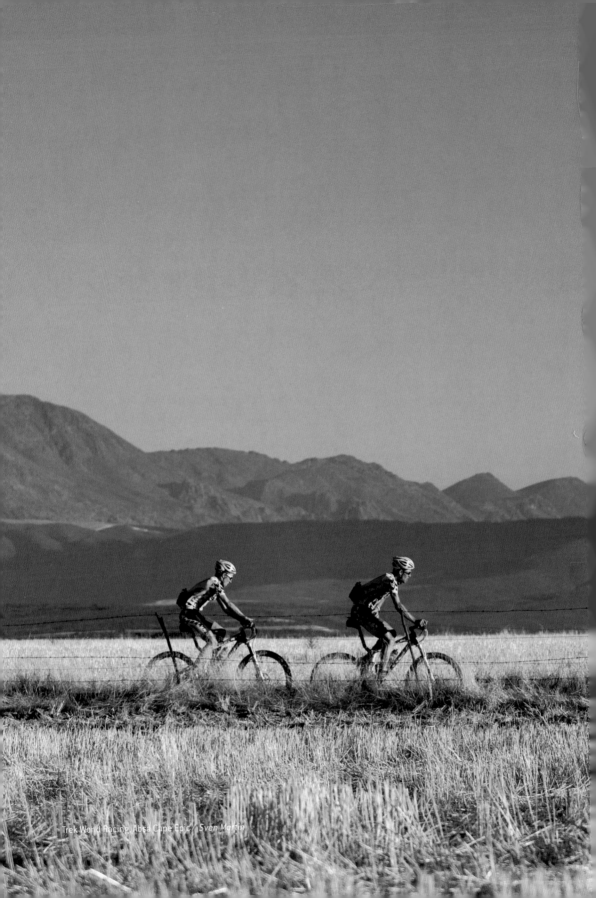

Trek World Racing, Absa Cape Epic / Sven Martin